KT-548-013

DEAN CLOSE SCHOOL

LIBRARY

This book must be returned by the latest date stamped below.

ART DECO

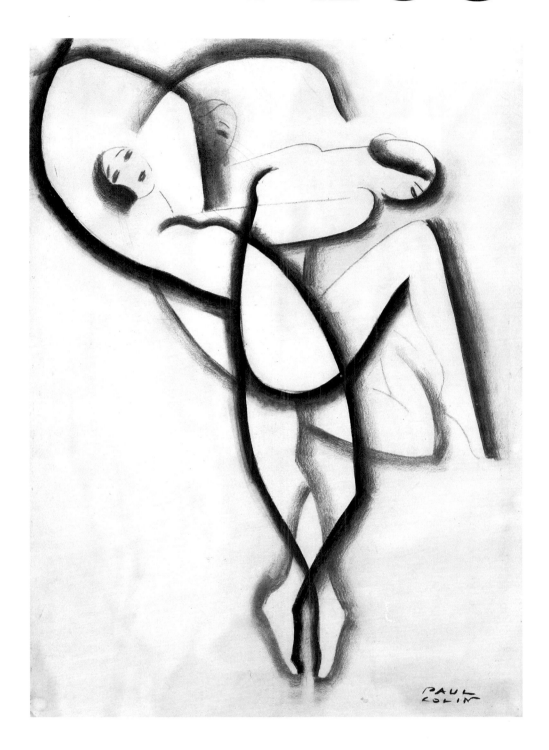

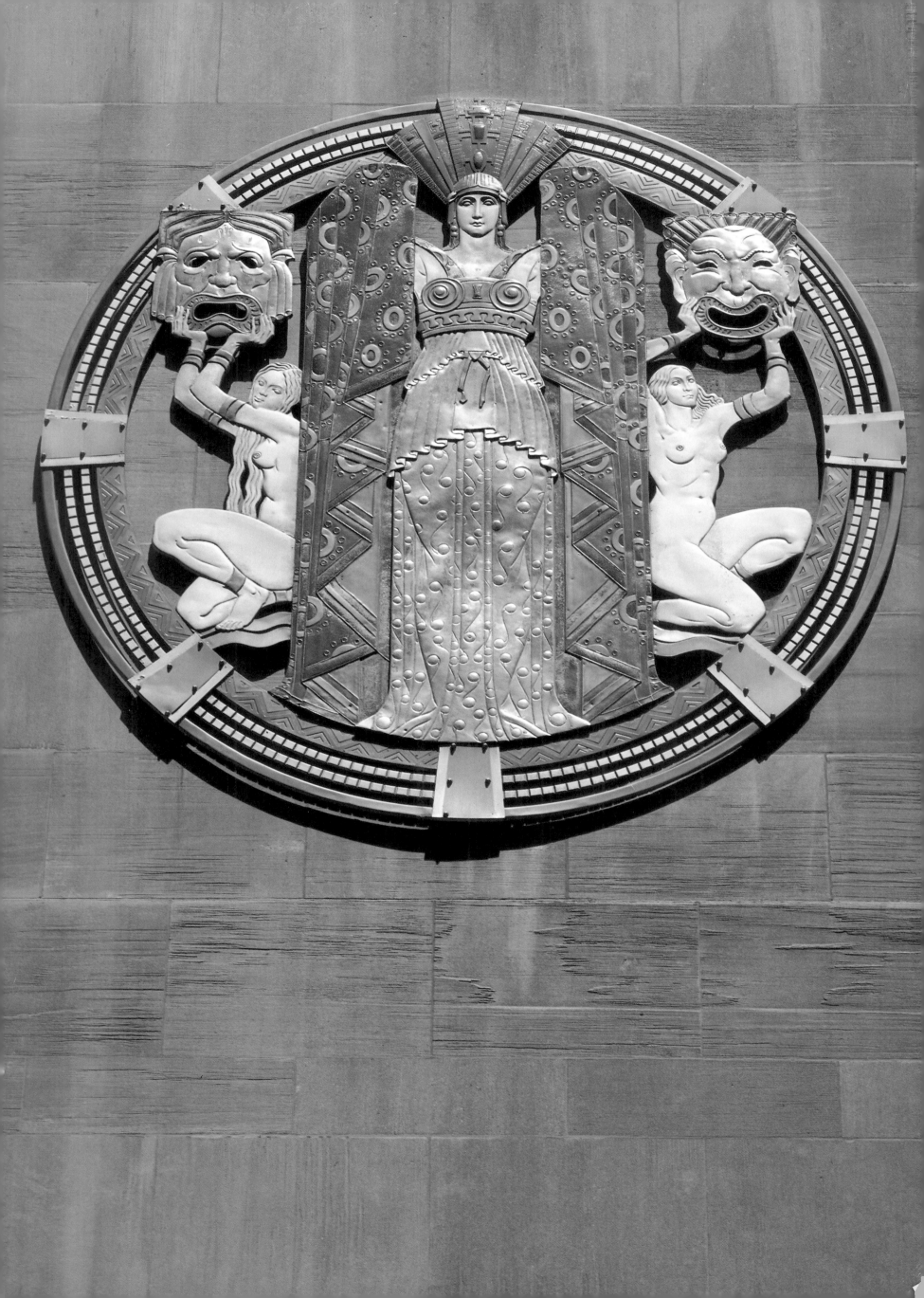

ART DECO

EVA WEBER

JG
PRESS

Reprinted 2004 by
World Publications Group, Inc.
455 Somerset Avenue
North Dighton, MA 02764
www.wrldpub.com

Copyright © 1989

All rights reserved. No part of this publication may be
reproduced, stored in a retrieval system or transmitted
in any form by any means, electronic, mechanical,
photocopying or otherwise, without first obtaining the
written permission of the copyright owner.

ISBN 1-57215-351-2

Printed and bound in China by
Leefung-Asco Printers Trading Ltd

10 9 8 7 6 5 4

PAGE 1: *Sketch by French designer
Paul Colin, who specialized in
dance and entertainment posters.*

PAGE 2: *Hildreth Meiere,* Drama
*plaque (c 1932) at Rockefeller
Center's Radio City Music Hall in
New York.*

ENDPAPERS: *Design from a wood-
engraved lithograph by Paul Nash.*

Contents

Art Deco Style on Show
6
Exuberant Architecture
20
Furniture and Interior Design
56
Sculpture, Painting and Photography
86
Index
110
Acknowledgments
112

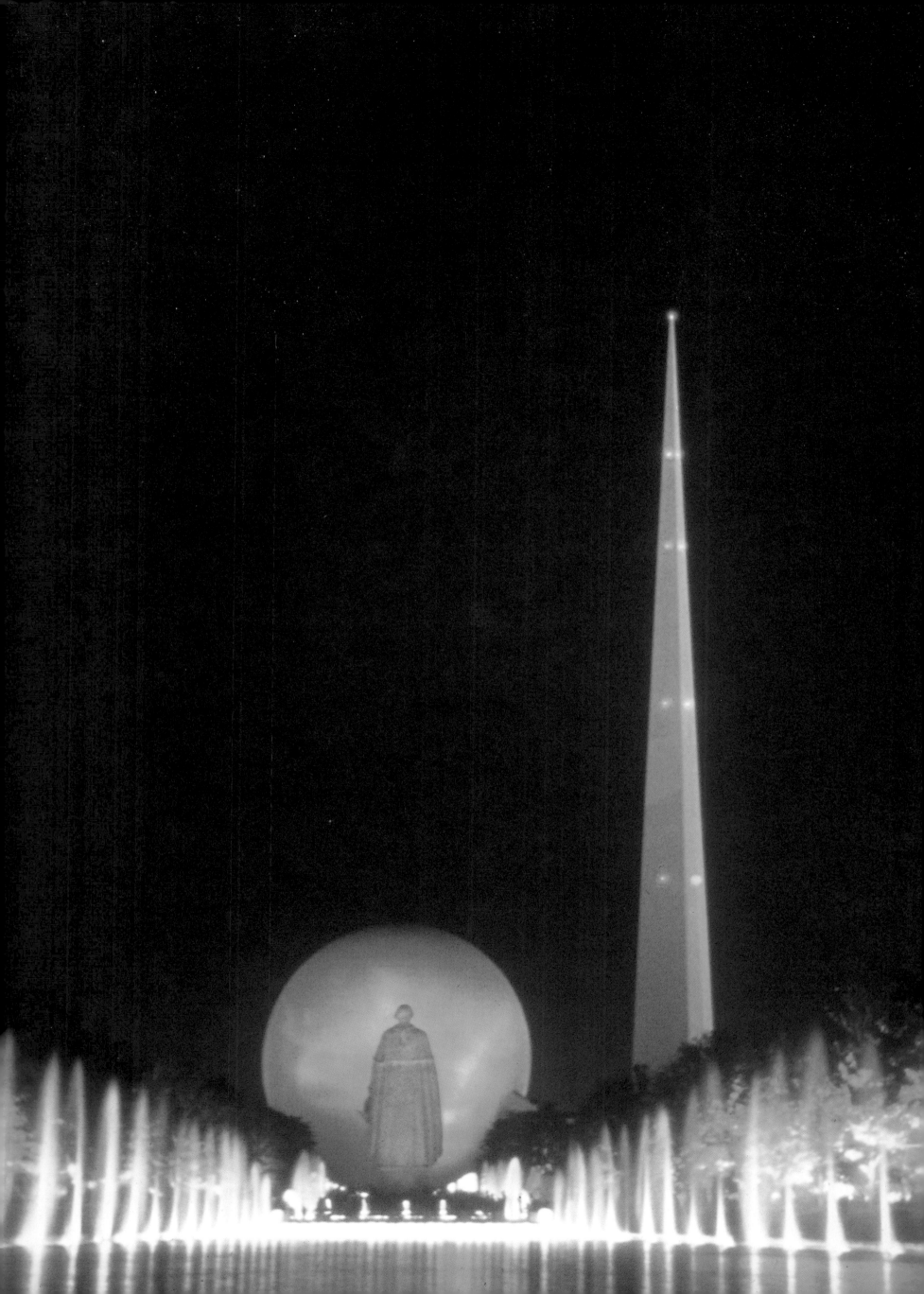

Art Deco Style on Show

LEFT: *New York's Trylon and Perisphere were the most memorable international exposition symbols since the Eiffel Tower. This 1939 World of Tomorrow fair brought the Art Deco era to a close*

Art Deco was a decorative arts style that held a mirror to its times. Its distinctive stylistic characteristics and imagery reflected a complex era of rapid artistic, social and technological change. Although its climax came in 1925 with the Paris *Exposition Internationale des Arts Décoratifs et Industriels*, Art Deco essentially spanned the first four decades of the twentieth century. The style began to evolve shortly after 1900 as a reaction to Art Nouveau, gathered speed with an infusion from the avant-garde art movements of Cubism and Futurism, drew renewed inspiration from ancient and primitive art, was purified and streamlined by the ideas of the functionalists and sought a return to traditional values during the political and economic turmoil of the 1930s.

During the 1920s and 1930s, international expositions provided a major showcase for the Art Deco style. Although they were primarily vehicles of nationalism and commercialism, the fairs also stimulated experiment in the arts and design. Most major architects, artists and designers – many of them important to Art Deco – were involved in the planning and execution of projects for these extravaganzas. Smaller exhibitions organized within the context of these expositions brought together the latest decorative arts, painting and sculpture, much of which also had close affinities with Art Deco. In addition, the expositions disseminated posters, written and pictorial materials and other souvenirs that required the services of graphic artists and others to create designs that reflected the particular style and content of each exposition. These expositions not only summed up current artistic trends but, in a broader sense, expressed, both overtly and implicitly, the concerns and aspirations of the times.

Now hailed as the climax of the Art Deco style, the 1925 Paris *Exposition des Arts Décoratifs et Industriels* had originally been proposed in 1912 for 1915 in order to inspire French designers to develop work equal to that produced by their German contemporaries. Around the turn of the century, while French design languished in the waning years of Art Nouveau, the Germans had started to produce refreshingly modern stylizations based on neoclassicism. An added impetus had been the establishment in 1907 of the German *Werkbund,* an association of designers and manufacturers. Participants in the 1909 Munich *Werkbund* exhibition were invited to show at the 1910 Paris *Salon d'Automne,* where they caused a sensation with their elegant, modernistic well-made pieces. While outwardly critical, the French went on to adapt and combine the new German ideas with motifs from Cubism and the Russian Ballet, and to produce abstract versions of floral ornament derived from Art Nouveau. In the years before World War I, German designers led the way, as demonstrated by the 1913 Leipzig and the 1914 Cologne *Werkbund* exhibitions. There, Bruno Taut's steel and glass pavilions were prototypes for the later experimental exposition architecture of the 1920s and 1930s. Equally important were the works of Josef Hoffmann and his Vienna *Werkstätte* colleagues.

When the 1925 Paris exposition finally took place after a ten-year delay caused by World War I and its aftermath, the Germans were not represented and the United States declined to participate because it had no appropriate work. Twenty-one nations and the French colonies erected pavilions and displays on a 55-acre cruciform site on both sides of the Seine in central Paris. Even the connecting Alexandre III Bridge was lined with the specially built shops of René Lalique, Sonia Delaunay and others. A light and water show below the bridge provided spectacular effects, while moored barges were transformed into floating restaurants and theaters, and Paul Poiret displayed colorful Atelier Martine interiors on his three boats. The Eiffel Tower was the site of the Citroën company's dramatic light shows which alternated shimmering geometric arcs and circles, comet and star extravanganzas and an animated zodiac, with automotive advertising.

The specially designed gateways to the exposition grounds set a mood of fantasy. The modernistically monumental main entrance, the *Porte d'Honneur,* was framed by fluted columns topped with frozen fountains. Architecturally most characteristic of the opulent 1920s style were the design pavilions of the four great Parisian department stores – Galeries Lafayette's *La Maîtrise,* Au Bon Marché's *Pomone,* Louvre's *Studium,* and Printemps' *Primavera.* The characteristic features of these pavilions included zigzag architectural setbacks, the use of unusual materials, the incorporation of decorative wall paintings, and ornate metal and glass worked in geometric and floral patterns. Exquisite metalwork by Edgar Brandt and decorative glass by Lalique were to be found all around the fair.

The displays by French interior decorators, or *ensembliers,* were among the most admired at the exhibition. Foremost was Jacques-Emile Ruhlmann's elegant *Pavillon d'un Collectionneur,* though

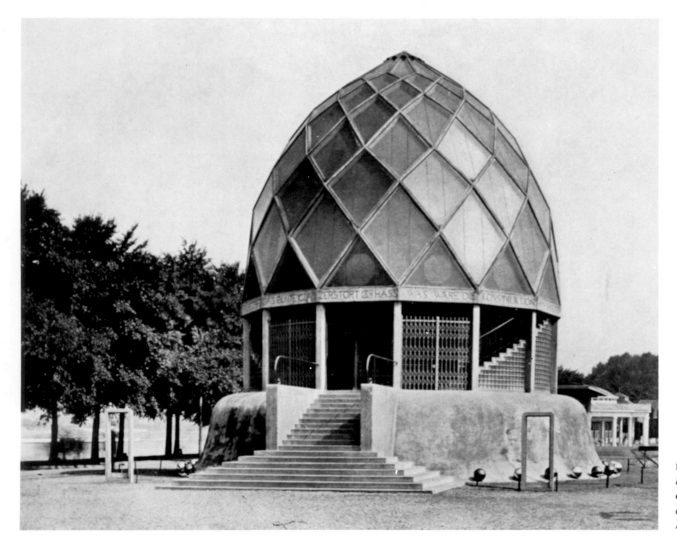

LEFT: *Bruno Taut's glass pavilion at the 1914 Cologne* Werkbund *exhibition was to inspire the designers of 1920s and 1930s Art Deco exhibition structures.*

RIGHT: *Louis Boileau's richly embellished design for the* Pomone *pavilion at the 1925 Paris exposition epitomized French Art Deco. The design studio's director, Paul Follot, assembled the stylish interiors.*

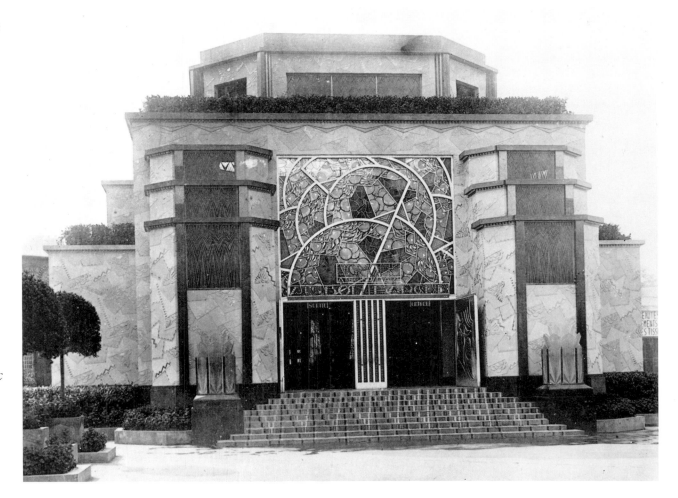

BELOW: *Topped by the characteristic frozen fountain motif, the Porte d'Honneur by Henri Favier and André Ventre was the Paris exposition's main ceremonial entrance. The metalwork was by Edgar Brandt and René Lalique provided the molded-glass reliefs.*

equally luxurious and impressive was the collaborative *L'Ambassade Française* with 25 rooms by such top Art Deco designers as Jean Dunand, André Groult, Pierre Chareau, Paul Follot, Maurice Dufrêne and others. In such modernist settings, French virtuosity in furniture design, lacquerwork, ceramics, glass, textiles, metalwork and decorative painting and sculpture dazzled fairgoers. The pavilions of leading manufacturers such as Baccarat, Christofle, Luce and Sèvres also displayed the latest in modern design. Art Deco and related design were also on view in some foreign displays, among the most notable being the influential Scandinavian wares of Sweden's Orrefors glass and Denmark's Jensen silver, Austrian *Wiener Werkstätte* wares and Italian works by Gio Ponti.

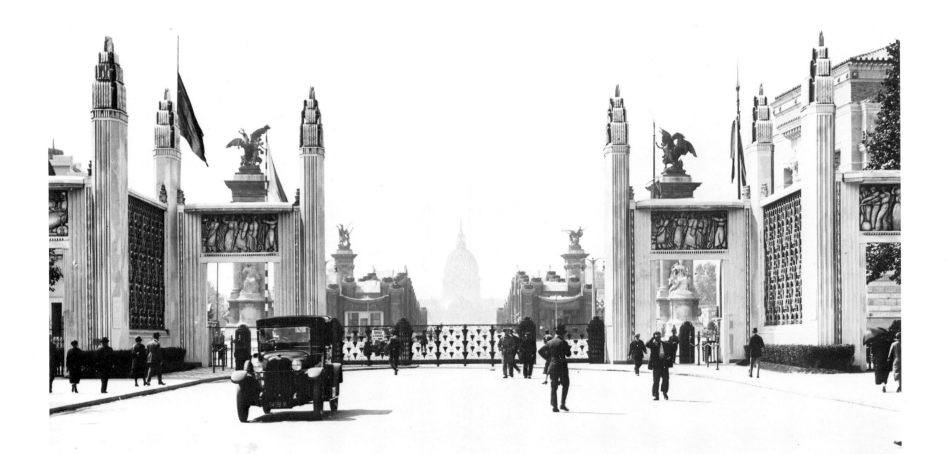

RIGHT: *Robots, seen here as sculpture at the 1925 Paris exposition, were introduced in Kapek's 1923 play* RUR. *Man as machine was to recur as a persistent motif throughout the Art Deco decades.*

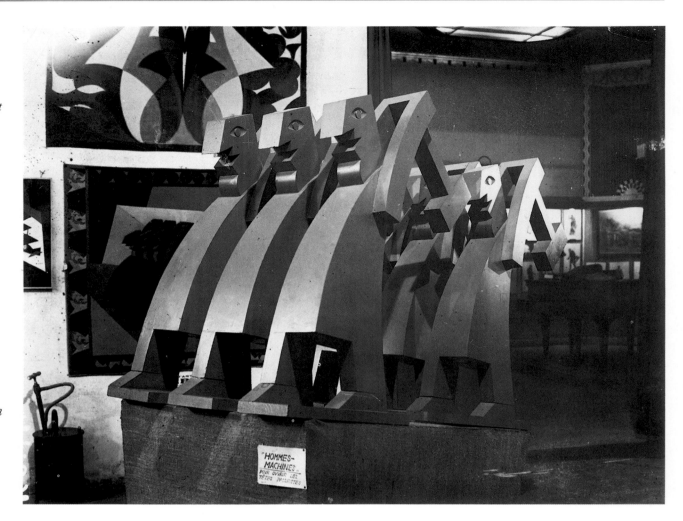

BELOW: *The elegance of Joseph Czarkowski's 1925 Polish pavilion demonstrated the international scope of Art Deco. The architect also designed a number of the tapestries and rugs displayed within, along with the work of other Polish decorative artists.*

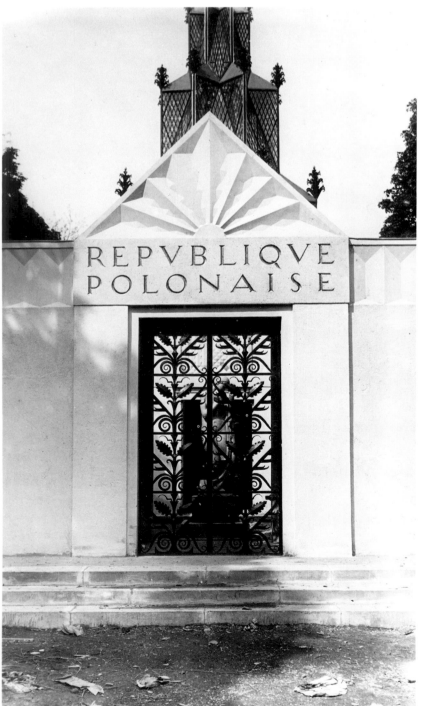

Opposed to all this dazzling opulence created for the monied elite was Le Corbusier's 'machine for living in,' the concrete, glass and steel *L'Esprit Nouveau* pavilion, constructed despite the vehement protests of the fair committee. The exposition administration concealed this stark villa behind fencing that was reluctantly removed only minutes before the fair's opening.

Also in the functionalist mode was Robert Mallet-Stevens's tourism pavilion with a cruciform clock tower. Here, though, ornament was permissible, and included stylized sculptural relief panels by the Martels and a continuous clerestory window glazed with a Cubist representation of a view seen from a speeding car. Painter Robert Delaunay expressed the exaltation of many when he heralded the Paris exposition as the triumph of Cubism. The fair demonstrated how much the decorative arts had been energized by this iconoclastic art movement.

Though the opulent French Art Deco style did not appeal to everyone, the influence of the Paris exposition was far reaching. Numerous articles and reports by observers, along with a 1926 traveling exhibition of the exposition highlights, fueled competition among leading department stores to introduce the style to the United States. Over the next years, dozens of displays inspired by the exposition circulated nationwide and sold items by Chareau, Leleu, Ruhlmann, Hoffmann, Puiforcat and others. In a relatively short time, the exposition led to the transformation of the fashionable domestic and commercial environment.

In the following decade, two subsequent international Paris expositions highlighted the work of Art Deco designers. The first was the 1931 *Exposition Coloniale Internationale* which showcased the cultures and artifacts of·the French colonial empire. The displays ranged from reconstructions of monuments such as Angkor Wat to mud huts and native costumes, juxtaposed with primitivistically styled modern pavilions and the usual extravagant illuminations and colored fountains. Primitivism (a European response to the arts of Africa, the South Pacific, Far East and the Americas), had been a source of inspiration for Cubist artists and avant-garde designers since the beginning of the twentieth century.

Designers such as Marcel Coard, Pierre Legrain, Pierre Chareau and Jean Dunand had produced primitivistic Art Deco variations during the 1920s. The furniture specifically designed for this exposition incorporated a variety of exotic woods imported from the colonies – amaranth, bilinga, bubinga, Macassar ebony, palissander,

LEFT: *The 1925* Pavilion d'un Riche Collectionneur *designed by Pierre Patout served as a sumptuous setting for Ruhlmann's luxurious furniture. The relief panels were by Joseph Bernard and Jules Jeanniot executed the stone sculptural group.*

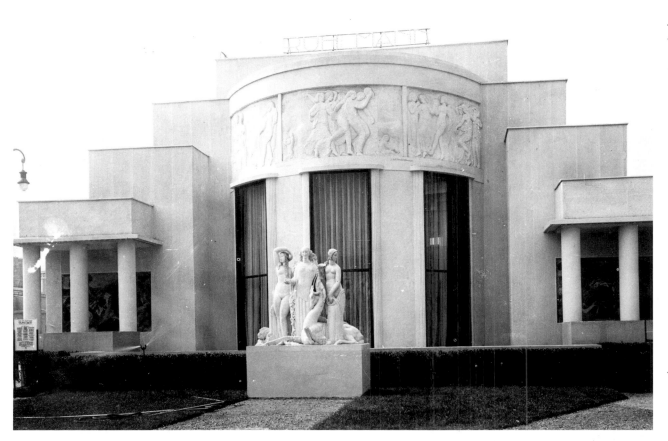

BELOW: *Paul Follot's display cabinet was exhibited at the 1925 Paris exposition. The use of stylized floral motifs on furniture and in other media reflected the origins of Follot and other French Art Deco designers in the Art Nouveau tradition.*

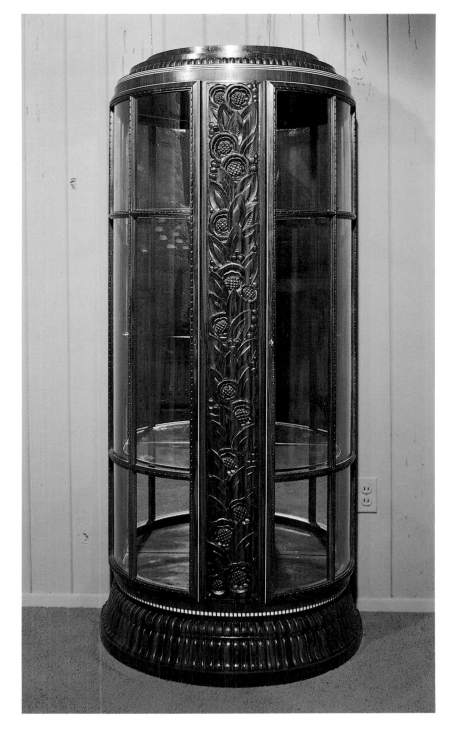

red padouk and wacapo, as well as mother of pearl and ivory set into lacquer. Appropriate interiors were designed by Ruhlmann, Leleu, Cheuret, Groult and Djo Bourgeois among others. René Lalique again designed lighting and fountains, and Dunand showed inlaid metal and lacquer screens, while Edgar Brandt, Claudius Linossier and Raymond Subes were among the metalworkers represented. A wide range of ceramics, glassware and textiles by leading Art Deco designers was also on exhibit. Despite the recent stock-market crash, the luxurious French Art Deco of the 1920s was still much in evidence at the *Exposition Coloniale Internationale*.

Nor had it become obsolete by the time of the 1937 *Exposition Internationale des Arts et Techniques*, which sought to foster the manufacture of attractive, useful mass-produced goods through the collaboration of art and technology. This functionalist emphasis was allied to an idealistic desire to counter the widespread negative effect of the economic Depression.

In architecture, the classical moderne variant of Art Deco had become prominent, not only in the newly built *Palais de Chaillot* and the Museum of Modern Art, but also in the monumental classicist pavilions of Germany and the Soviet Union, which confronted each other threateningly across the Champs de Mars. These pavilions were about the only ones ready on time. The contemporary joke that at least the Eiffel Tower was ready underlined the delays caused by the labor unrest typical of these years. Though some of the fair's planners had seen the exposition as a tribute to socialism and radicalism, the labor unions did not co-operate.

Architectural surfaces were once again enlivened with stylized reliefs and sculptures, and many of the interiors still featured elegant veneers, stylized murals, exotic materials and other Art Deco ornament, although a more somber note was introduced by the display of Picasso's *Guernica*.

Graphics and publicity were provided by Cassandre and Carlu, and among the well-known 1920s designers participating were Dunand, Groult, Süe, Follot and Leleu. Ruhlmann's successor André Arbus designed an elegant music room furnished with Art Deco interpretations of neoclassicism. A functionalist antidote was provided by Mallet-Stevens who designed the *Pavilon de l'Hygiène*, the *Palais de l'Electricité* and the *Pavillon de la Solidarité*. One of the most popular buildings was the immense *Palais de l'Air*, where contemporary and futuristic planes simulated flight above appropriate paintings by Robert Delaunay.

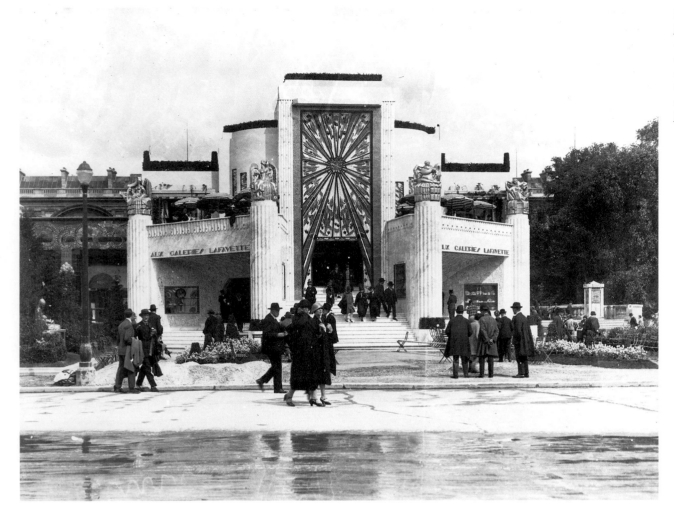

LEFT: *The Paris 1925* Maîtrise *pavilion by Hiriart, Tribout and Beau displayed the characteristic sunburst design over the entrance. Aux Galeries Lafayette and other important Parisian department stores led the effort to promote and popularize the Art Deco style.*

The alliance between French art and industry heralded by the 1937 fair still lay in the future; in the exhibits and the pavilions, the decorative and the functional did not so much interact as merely coexist. This underlying conservatism undoubtedly reflected the political uncertainties of the decade, which was to end in another world war.

During the 1930s, the Americans sought to equal and even surpass the Parisian expositions, beginning with the 1933 Chicago Century of Progress exposition and ending with the 1939 New York World of Tomorrow fair. The Chicago exposition was first proposed in 1927, when the prosperity of the 1920s was still at its height. Intended to commemorate a century of Chicago's existence as a city, the fair also was an opportunity to demonstrate the lessons American architects and designers had learned from the 1925 Paris exposition.

Architect Raymond Hood was selected to head a design board to plan the exposition layout and structures. Hood, himself the designer of several monuments of Art Deco architecture, was assisted by other Art Deco designers including Harvey Wiley Corbett, Paul Philippe Cret, John Wellborn Root, Hubert Burnham, Lee Lawrie and Ralph T Walker. The arrival of the Depression led to the abandonment of the more costly proposals; Norman Bel Geddes, for example, had several

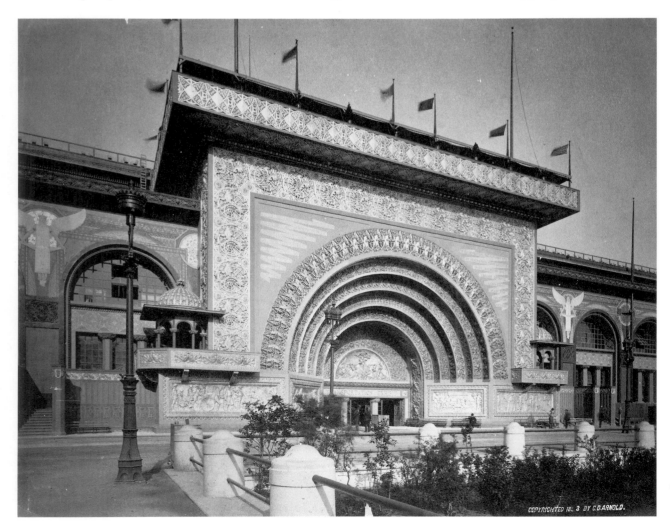

LEFT: *At Chicago's 1893 Columbian Exposition, Louis Sullivan's orientalist Transportation Building stood out as a pioneering prototype for Art Deco amid the 'White City' of predominantly classical revival style.*

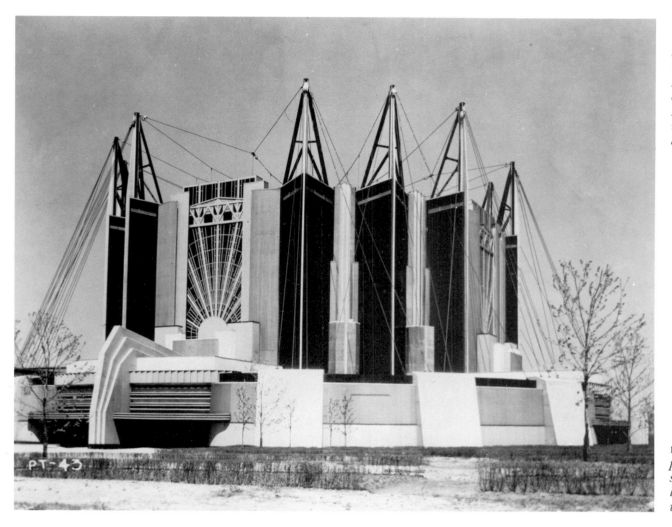

BELOW: *In Chicago, the imposing pylon gateway embellished with stylized heroic figures and sphinxes led into Raymond Hood's waterfront Electric Building.*

projects rejected, including one for a dance restaurant built on four islands interconnected by bridges and illuminated by tubular neon arches, and another for an underwater aquarium restaurant.

According to all accounts, the design commission achieved its goal of creating an exposition 'radically different' from earlier fairs, especially the Chicago 1893 World's Columbian Exposition where the Beaux-Arts-style 'White City' was relieved only by Louis Sullivan's orientalist Transportation Building. The 1933 buildings incorporated a variety of Art Deco motifs including skyscraper-style setbacks, Cubist-influenced volumes and cylindrical shapes, decorative geometric surface patterning, stylized relief sculpture, an innovative use of glass and other machine-age materials, and modernist interiors. The diversity of architectural forms was unified by the use of brilliant coloristic effects. Joseph Urban, the fair's director of color, and Walter D'Arcy Ryan, its director of illumination, arranged a sequence of 23 vivid hues painted on the pavilions, which were illuminated at night by an elaborate choreography of floodlights and neon, transforming the fair into a magical spectacle – the Rainbow City.

Among the fair's notable architectural designs were Cret's Hall of Science, Albert Kahn's General Motors building (which contained a complete automobile assembly plant), Holabird & Root's Chrysler building, Nicolai Faro's *Time, Fortune and Architectural Forum* building , which was surmounted with colossal photomurals, Kahn's cylindrical Ford Motor building symbolically designed to resemble an automobile gear, and George Fred Keck's 12-sided House of Tomorrow. Elroy's Ruiz's Owens-Illinois Glass Company building, with its setback skyscraper-style tower was appropriately constructed of multicolored glass blocks.

The Travel and Transport Building (by Bennett, Burnham and Holabird) mounted a green body on a yellow base, and steel trusses painted blue supported the building's suspended dome by means of cables linked to 12 towers, in much the same way as suspension bridges were erected. The walls were of sheet metal bolted and clipped together. The Travel and Transport Building was enlivened by the characteristic Art Deco rising sun motif, along with a band of geometric patterning. Among Raymond Hood's designs was the Electric Building, with its great curved court that resembled a dam with water flowing over it, an effect enhanced by the use of blue neon light. The dam was flanked by sculptural relief panels of gigantic stylized Art Deco figures representing atomic energy and stellar energy.

On the lagoon side of the court, a pylon gateway was decorated with Aztec-style geometric patterns and sculptural relief figures representing light and sound. The participating companies frequently used architecture as a symbolic and often not very subtle way of promoting their product and services to potential customers among the fair-going audience.

At the time, the Chicago fair buildings were hailed as the ultimate in modernism. Only in retrospect did it become apparent that the exposition's architecture was fundamentally backward-looking. It was

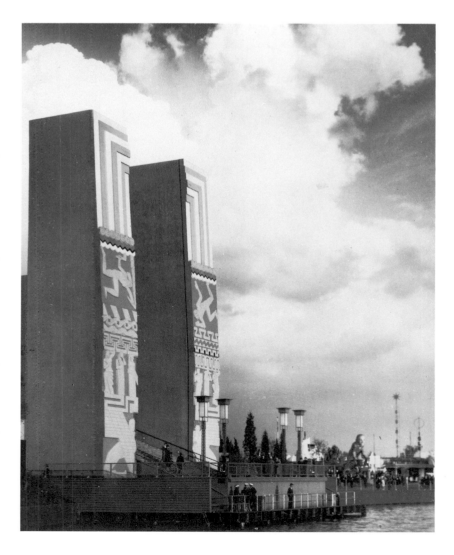

RIGHT: *In Chicago, General Electric's 'House of Magic' exhibit was accompanied by the monumental didactic murals typical of 1930s Art Deco.*

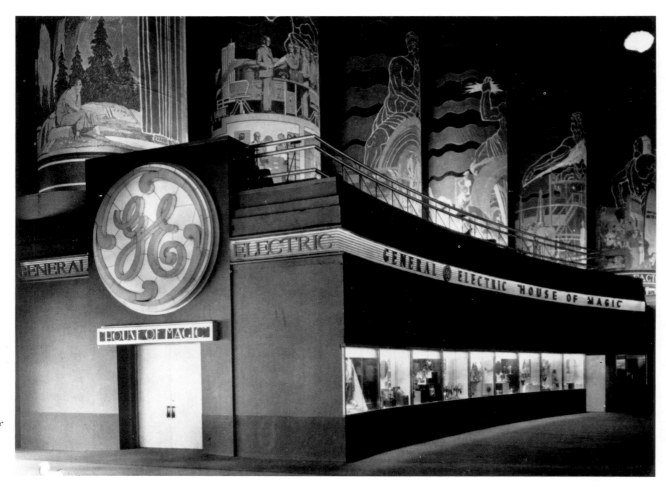

RIGHT: *In Chicago, General Electric's 'House of Magic' exhibit was accompanied by the monumental didactic murals typical of 1930s Art Deco.*

BELOW: *At the Chicago fair, atomic energy was allegorically idealized as a beneficial force. Admiration of technology and the machine was a strong current of the era's visual arts.*

closely tied to the polychromatic Parisian-influenced zigzag deco style of the 1920s, at a time when the streamline style had already become the trend of the future. Indeed, the streamline style was introduced to the public at the Chicago fair in its original industrial context as a feature of aerodynamic transportation vehicles. The experimental version of the Burlington Zephyr – a high-speed, diesel-powered train of lightweight stainless steel construction, designed to travel at up to 100 miles per hour – made its debut in the fair's second season. Public interest was overwhelming; over 700,000 visitors waited in line to tour the Zephyr. Another high point was Buckminster Fuller's teardrop-shaped airflow three-wheeled Dymaxion car (the name derived from the words 'dynamism,' 'maximum' and 'ions'), which appeared in 'Wings of a Century,' a pageant recounting the history of transportation.

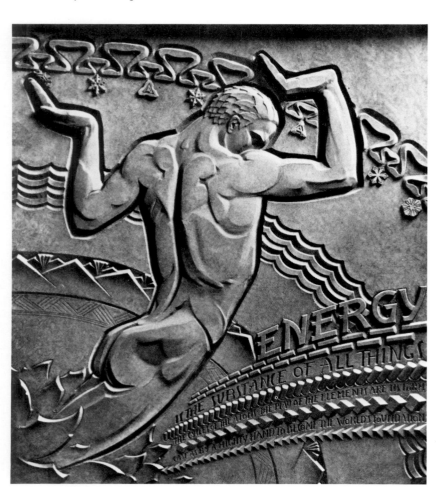

Financially the fair was a resounding success, although it received mixed reviews. Many architects who did not participate, including Frank Lloyd Wright, were severely critical. Ralph Adams Cram saw the fair as incorrigibly ugly, 'a casual association of the gasometer, the freight-yard and the grain elevator.' More charitable observers saw the vividly hued, bustling exposition as optimistically symbolizing a way out of the Depression. Despite the differing aesthetic judgments on the fair's architecture, the Chicago exhibition did offer a valuable opportunity to test new engineering and industrial building methods and to experiment with new construction materials. Thus the economic restraints imposed on the fair by the Depression led to advances in building technique that ordinarily would have taken decades to evolve.

The two American expositions that took place at the end of the decade in San Francisco and New York were quite different from one another in intent and outward appearance, though both granted a prominent place to Art Deco architecture, sculpture and related design. Located on the man-made Treasure Island in San Francisco Bay, the 1939 Golden Gate International Exposition's exotic fantasy architecture focused on the cultures of the Pacific, for which San Francisco was the major embarkation port and air terminal. The California fair was, in part, a celebration of the completion in 1937 of the Golden Gate Bridge, which surpassed by 700 feet New York's 1931 George Washington Bridge, capturing the record for the world's longest suspension bridge.

The architecture of the San Francisco fair was more closely allied to the tradition of ephemeral exposition architecture, which in earlier fairs had often sought to re-create past utopias. It was reminiscent of the 1931 Paris colonial exposition structures. The Golden Gate Exposition evoked some vanished pre-Columbian paradise or Oceanic Shangri-la, an effect achieved through the combination of stylized, primitivistic sculptures of monolithic figures with architecture related to the Mayan style, an Art Deco variant popular in California. Characteristic of the exposition structures were Blackwell and Weihe's sculpturally adorned Elephant Towers. These stepped, ziggurat-shaped towers were reminiscent of the skyscraper-style setbacks of the late 1920s while also suggesting the architecture of Southeast Asian temples.

Streamline-style Art Deco made a low-key appearance in the commercial exhibits, which generally were grouped together in larger, shared pavilions. Among the most striking of these were the United States Steel Corporation display designed by Walter Dorwin Teague

RIGHT: *A climax of the Chicago fair's second season was the introduction of the Burlington Zephyr, the nation's first diesel-powered streamlined passenger train.*

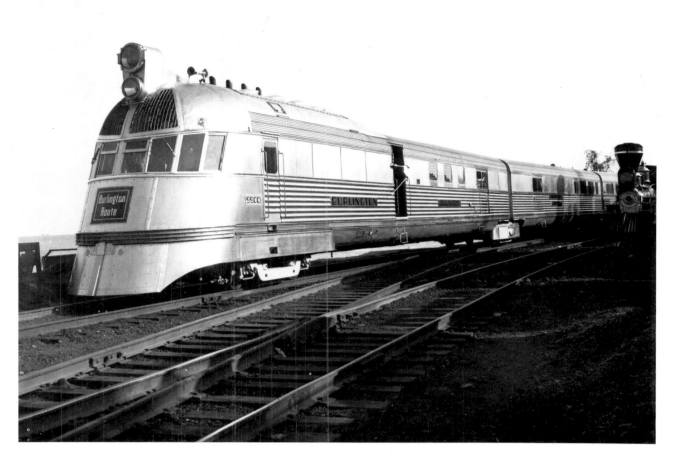

BELOW: *The 1939 New York World of Tomorrow fair featured futuristic streamline-style architecture, as seen in the Helicline ramp leading to the Perisphere.*

and the Dow Chemical Company exhibit by Alden Dow, which made extensive use of glass-block construction with dramatic illumination. Other pavilion ensembles were designed by Gilbert Rohde, Kem Weber, Rena Rosenthal and Paul Frankl. And the true architecture of the future – the austere and ideologically functional International Style – was present in Timothy Pflueger's federal complex of box-shaped, glass-walled buildings.

There was a widely held view that the San Francisco and other 1930s expositions were escapist fantasies which insensitively ignored the harsh social realities of the Depression era. Escapist they were, and as such they played an essential role in raising morale and offering hope for the future. Like the Hollywood comedies and Busby Berkeley dance extravaganzas of the 1930s, the expositions help to relieve the pervasive gloom.

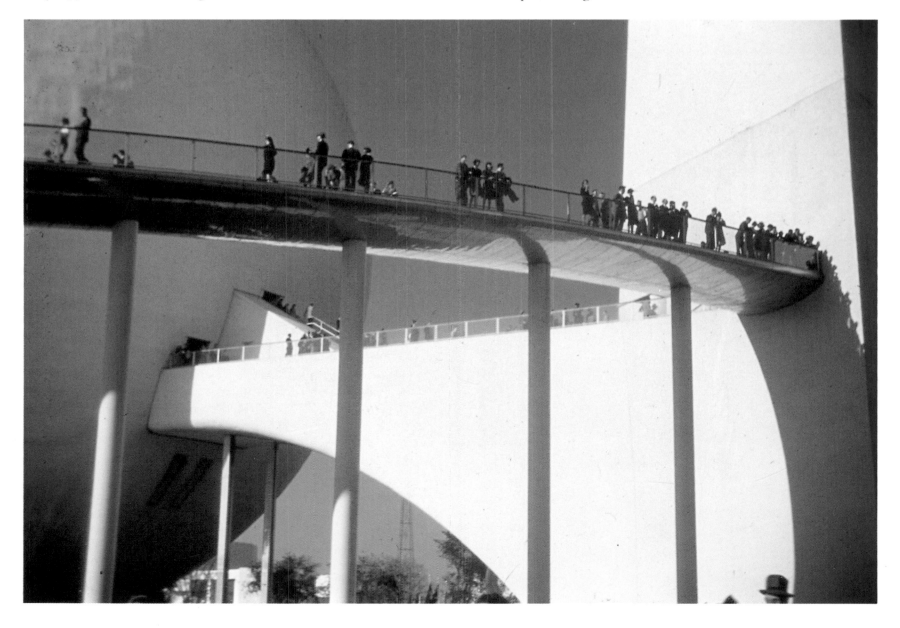

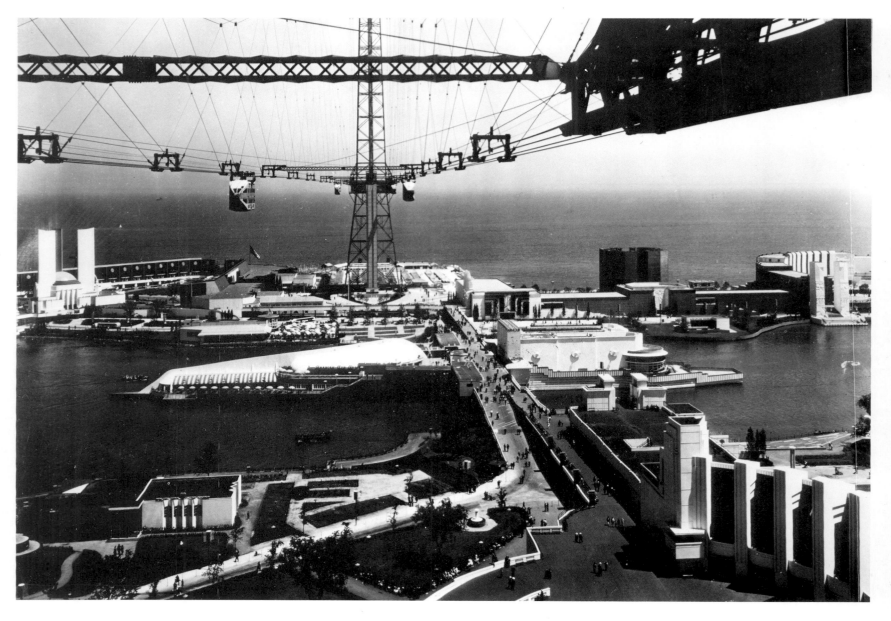

ABOVE: *The Skyride offered a dramatic view of the Chicago's fair's spectacular Lake Michigan setting.*

LEFT: *Ephemera and other fair souvenirs left a vivid record of the New York exposition.*

RIGHT: *The actual Trylon and Perisphere, at fair's end, were dismantled to provide 4000 tons of scrap metal for the war effort.*

The 1939 New York World's Fair, which showcased the streamline style, was far more ambitious in its physical expanse and thematic intent. Its chosen theme was the 'World of Tomorrow,' and it attempted to investigate the idea of a totally planned social environment. This futuristic industrial utopia was facilitated by machines and symbolically realized through the use of streamline-style architecture and design. Among the fair's planners and executors were the nation's leading architects and interior designers, including Norman Bel Geddes, Henry Dreyfuss, Raymond Loewy, Walter Dorwin Teague, Egmont Arens, George Sakier, Gilbert Rohde, Donald Deskey, Russel Wright, Albert Kahn, Harvey Wiley Corbett and Ely Jacques Kahn. Hugh Ferriss, highly regarded for his romantic renderings of Art Deco skyscrapers, was appointed official architectural delineator, while graphic designer Joseph Binder was commissioned to create a now classic Art Deco design that became one of the most widely displayed posters of modern times. And the roster of participating painters and sculptors was a most impressive one, including most of the leading practitioners of Art Deco, as well as many who were to become famous in the postwar years.

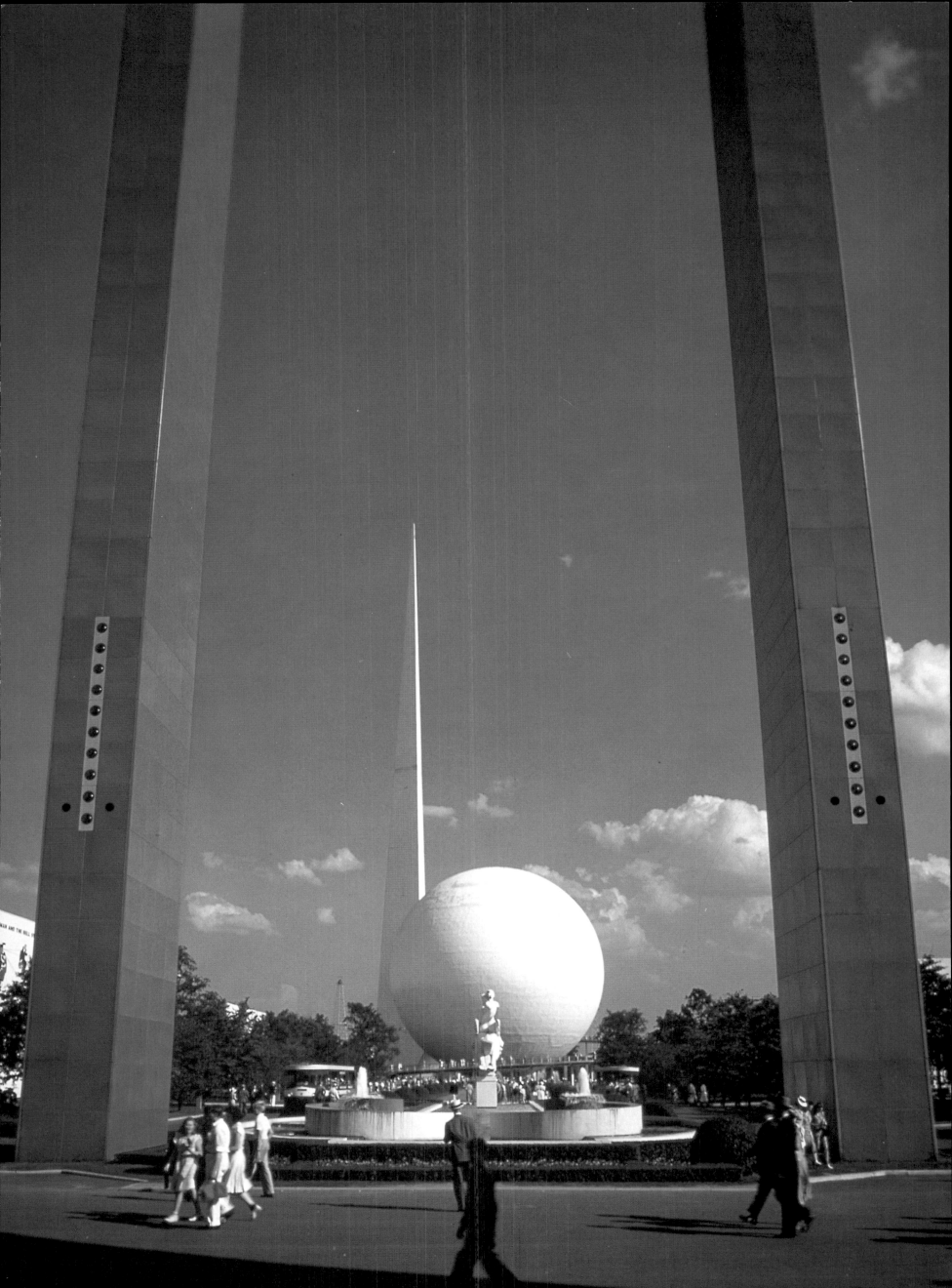

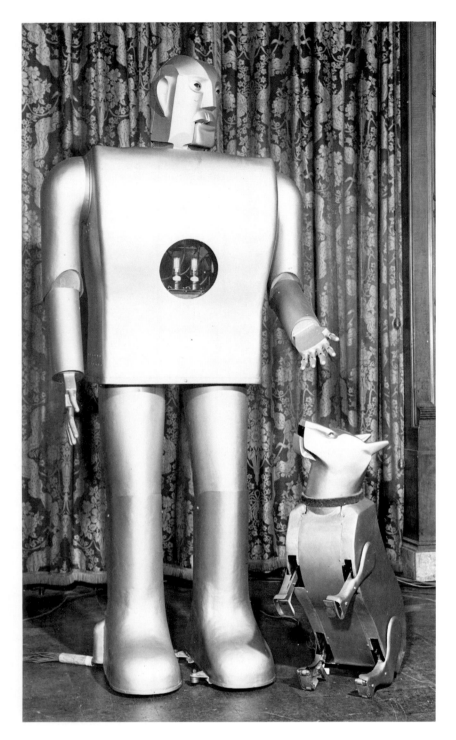

LEFT: *At New York, Westinghouse's Electro the Moto-man and dog Sparko.* RIGHT: *New York's fountain was the site of light and water shows.*

By far the most imposing structures of the fair were the stark white 610-foot tall Trylon (triangular pylon) and the 180-foot wide globe known as the Perisphere, along with its 950-foot long spiral ramp, or Helicline. The symbol of the fair, this colossal Cubist grouping designed by Wallace Harrison and J André Fouilhoux, owed much to Boullée's late eighteenth-century neoclassical fantasies. Visitors rode what was then the world's longest escalator part way up the Trylon and entered the Perisphere where they viewed Democracity, an enormous futuristic multimedia diorama. At night the exterior of the Perisphere served as a gigantic screen for multiple projections of changing colors and moving clouds, as well as of representational images tied to such special events as Thomas Edison's birthday. Architectural historian Lewis Mumford quipped at the time that the Perisphere was a 'great egg out of which civilization is to be born.'

The most impressive aspect of the fair was its streamline style architecture, which evoked a science fiction film set. The most dramatic examples of streamlining were to be found in the Transportation sector: Albert Kahn's sculptural General Motors pavilion, the site of Bel Geddes's Futurama exhibit; William Lescaze's Aviation Building; the Chrysler pavilion framed by twin finned towers; and Ely Jacques Kahn's Marine building, from which jutted two looming ocean liner prows so that it resembled a three-dimensional Cassandre poster. Art Deco styling was also adapted for many smaller commercial structures, which were frequently emblematic of their product. The Schaefer Center, for example, sported horizontal streamline-style banding and was topped by a tower in the form of a stylized frozen fountain reminiscent of the 1925 Paris exposition, here, however, it referred to the beverages offered within. Classical

moderne architecture was seen in the Theme Building and the monumental Soviet pavilion. Its tower, surmounted by the statue of a heroic worker, soared almost as high as the Trylon. Totalitarian monumentalism in the classical moderne style was also offered by the monolithic Italian pavilion.

Much thought by the participating industrial designers had gone into planning the logical sequence and organization of the buildings, effective pedestrian traffic flows and psychologically compelling multimedia display techniques to promote the utopian ideals, technological advances and new consumer products that were the core of the exposition. Ironically, the totalitarian rulers of the era were using related techniques of psychological control and behavioral conditioning to achieve their political aims.

Visitors to the exposition were predominantly enthusiastic. The 'World of Tomorrow' theme provided an alluring fantasy at the end of a dreary Depression decade; the new consumer products and technological marvels on display – including robots, a speech synthesizer, the superhighways of the Futurama exhibit, television and labor-saving household appliances – appeared accessible to many and seemed to promise a brighter future.

The new ideas in architecture and design introduced at the fair were actually quite limited in scope. As most of the temporary futuristic buildings were made of traditional exposition plaster and stucco, there was little opportunity to investigate new materials and construction techniques. Of the 15 model homes on display in the Town of Tomorrow, two-thirds were in traditional styles, with colonial revival a favorite. What imaginative design solutions there were had been applied to the exposition's accessory structures such as the Aqualon fountains, which resembled outsized radio vacuum tubes filled with swimming goldfish. As at earlier fairs, one of the most exciting aspects of the New York fair was the lighting design, this time featuring fluorescent tubing in an innovative variety of machine aesthetic fixtures. The lights were not restricted to interiors but were also incorporated into exterior building walls to achieve dramatic night-time effects.

The New York World's Fair was not just the grand finale of the streamline style; it also provided a final public forum for the imagery and themes of Art Deco in general. The exposition was the result of architects, designers and artists working in collaboration as they had done on so many earlier Art Deco projects. Once again the artists and designers expressed America's love affair with the technology of the modern age in allegorical representations and stylized versions of airplanes, locomotives, ocean liners, automobiles, bridges, radios, electrical power networks and factories. Present too were those mythologized images of man confidently occupying his niche in the cosmos and, more mundanely though still heroically, in the workplace. It was quite possibly the last time that man would be seen as so at home in the technological age, so optimistic about his future and so certain of his place in the universe.

The architectural critics of the period found little to admire in the exposition's futuristic architecture. They condemned its crass commercialism, its hybrid nature, its superficial modernity and its decorative touches. The foreign pavilions, however, many of which were executed in the austere International Style, received their wholehearted approval. This attitude was to become the status quo for the academic and critical architectural establishment over succeeding decades. In the aftermath of the Museum of Modern Art's 1932 International Style exhibition, functionalist proponents of the style were able to suppress to a remarkable degree most divergent and pluralistic tendencies in modern design. It is only in recent years that 1930s exposition architecture, and Art Deco architecture in general, has become a subject of professional appreciation; serious study now focuses on its complex symbolic implications and on its reflection of the historical milieu and cultural values of the decades between the two world wars.

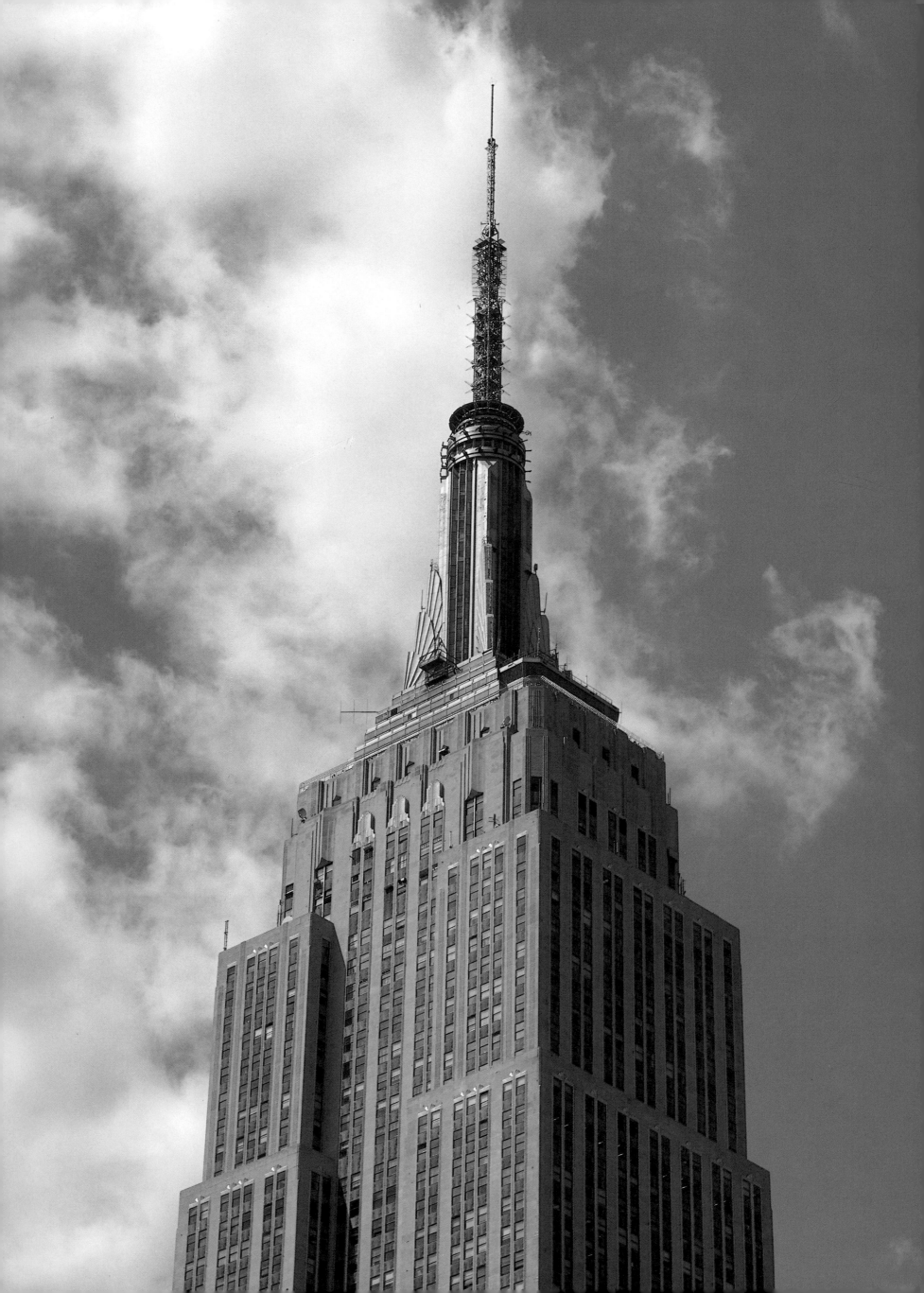

Exuberant Architecture

LEFT: *Shreve, Lamb & Harmon's Empire State Building (1931) ended the era of zigzag-style skyscraper construction in New York City.*

A true flowering of Art Deco architecture took place in the United States; America led the way in the large number of monumental and secondary buildings erected, in the sheer exuberance of their ornament, in the number of architects successfully working in this style and in the range of regional and stylistic variants explored. Impressive Art Deco buildings were also erected in Canada, Mexico, South American countries, Australia and even in Shanghai, China. In Europe, apart from the use of the style in exposition and theater buildings and shop fronts, a much smaller and more conservative group of Art Deco buildings was produced. On the continent, modern architecture soon came to be dominated by the anti-decorative functionalists led by Le Corbusier, Walter Gropius, Ludwig Mies Van der Rohe and the Dutch practitioners of *De Stijl*. Britain built a somewhat larger number of Art Deco structures, some influenced by American developments, others by those in Scandinavia. It should be noted that the Art Deco architectural style, whether in its classical moderne, zigzag, skyscraper style or streamlined manifestations, was not the only style of the decades between the wars. Although popular, it co-existed during these years with various historical revival styles, as well as with the austere International Style of the functionalists.

Apart from the obvious precedents set by experimental exposition pavilions, the roots of Art Deco architecture – with its characteristic use of abstraction and stylization, rich ornamentation, coloristic effects and dramatic massing of simplified geometric forms – were multiple. In the later eighteenth century, neoclassicism as practiced by such revolutionary architects as Claude Ledoux and Emile Boullée of France and Karl Schinkel and Friedrich Gilly in the Germanic states began a radical abstraction and stylization of the forms and motifs of classical architecture.

Various buildings following this trend were produced throughout the nineteenth century by architects from the Beaux-Arts tradition. Exotic ornament combined with flat surfaces and dramatic masses were seen in Egyptian revival buildings from the 1820s, especially in England and the United States, where the style was often used in cem-etery gates and prisons. The use of color and ornament promoted by John Ruskin was exploited in buildings in Gothic Revival and orientalist styles in the later nineteenth century. In England architects of the Arts and Crafts movement began to produce modernized, abstracted renditions of medieval styles.

Art Nouveau, around the turn of the century, was the direct modern antecedent of Art Deco. In the late 1880s Antonio Gaudí produced a few geometrically abstracted buildings in Barcelona – in particular, the *Colegio de Santa Teresa* (1889-94) – that preceded his more famous sinuously organic buildings. Art Nouveau, like Art Deco, sought to base ornament on other than historical sources. A reaction to the opulent decadence of French and Belgian Art Nouveau arose with the rectilinear stylization of Charles Rennie Mackintosh in his 1897-99 Glasgow Art School and in Vienna with Josef Olbrich's 1898 Sezession Gallery, followed by Otto Wagner's Steinhof Church and Post Office bank, and Josef Hoffmann's 1905-11 *Palais Stoclet* in Brussels. These architects based their pioneering modernism on a stylization of classical forms. In Amsterdam, Hendrik Berlage's Exchange building (1898-1901) and Kromhout's American Hotel (1898-1901) were massive picturesque buildings with stylized sculpture and decorative brickwork. And in Finland Eliel Saarinen designed the Helsinki railroad station (1904-16). With origins in romantic nationalism, the Scandinavian version of Art Nouveau, and with its stylized sculpture and its unique tower, Saarinen's design was to inspire numerous Art Deco buildings.

RIGHT: *Saarinen's Helsinki station (1904-16) included Emil Wikstrom's* Guardians of Transportation.

BELOW: *Hoffmann's 1905-11* Palais Stoclet *in Brussels was an important Art Deco forerunner.*

FAR RIGHT: *Bertram Goodhue's design for the Nebraska State Capitol (1922-32) reflected Saarinen's innovations.*

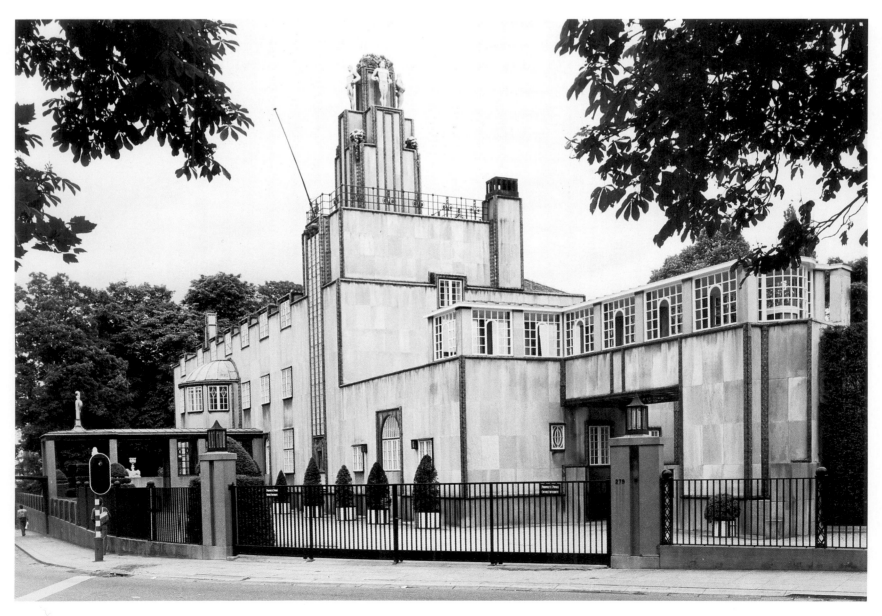

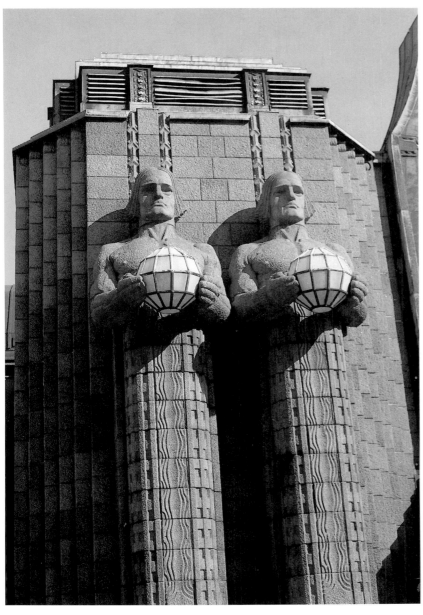

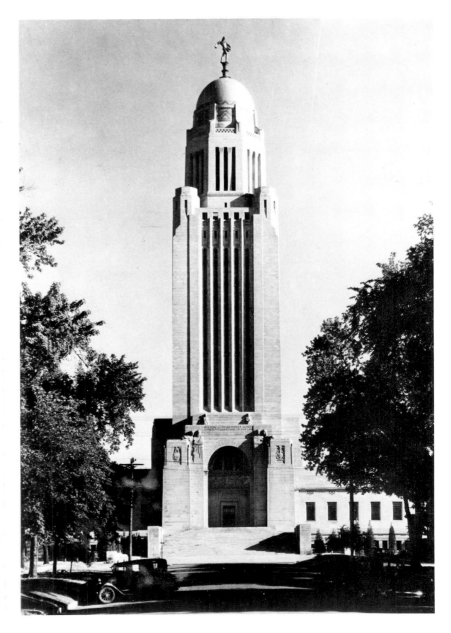

Art Deco architects also drew inspiration from the German Expressionists with their monumental, complex, romantic and symbolic buildings with jagged contours or, conversely, flowing organic lines. Another source of ideas were the sculpturally picturesque and ornate structures of the Amsterdam School, built in the early decades of the twentieth century. Examples of Expressionist and Amsterdam School architecture were published in the United States in the early 1920s.

But not all the modernist innovations took place in Europe. Frank Lloyd Wright, that great original of American twentieth-century architecture, designed the remarkable proto-Art Deco Fricke and Willitts houses (1902), the Larkin Building (1903-06), and the Unity Temple (1906). Quite unlike anything seen before, his designs and photographs of his buildings were published in Europe in 1910-11, astonishing the architectural avant-garde there. Wright, deeply interested in symbolic architecture, integrated ornament and total design of interiors, was a student of that pioneer and theorist of modern architecture, Louis Sullivan. Sullivan's inventive uses of architectural ornament were a significant precedent for Art Deco architects. In addition, Wright came from the Midwest, where the innovative architects of the Prairie School flourished during the early decades of the twentieth century. They also placed a high value on inventive ornament combined with abstraction of form.

The crowning achievement of American Art Deco, the zigzag skyscraper style, did not evolve until the mid-1920s. Earlier examples of American Art Deco architecture appeared in the form of classical moderne buildings. Classical moderne is also known as neoclassical moderne, stripped classicism, PWA (Public Works Administration) Art Deco, PWA moderne, and even Greco Deco. It was a style often used for civic buildings and banks, though it was used in other contexts as well. In the 1930s it became the official style of European totalitarian rulers, and was also used in many American New Deal buildings, and as such is discussed in the later chapter, 'Totalitarianism and the New Deal.' With its familiar monumental forms, classical

moderne represented permanence, solidity and dignity – particularly desirable qualities in times of social, political and economic turbulence. Of the Art Deco architectural variants, classical moderne was the most popular.

Representing a synthesis of the traditional and modern, the classical moderne style was characterized by classically balanced masses with an emphasis on symmetry and horizontality. The exterior columns customary to historical classical styles were replaced by flattened piers which were sometimes fluted, but usually lacked capitals or bases. The monumentality of the buildings was enhanced by flat, simplified wall surfaces, usually executed in or faced with stone, granite, marble or terrazzo. Stylized relief and freestanding sculpture frequently adorned the exterior, although to a more limited degree than in the zigzag style; usually the entrance areas were embellished while the other wall surfaces remained unadorned. At times the classical moderne interiors were surprisingly flamboyant, with a profusion of murals, relief sculpture, mosaics, ornate metalwork, attractive modernistic lighting fixtures, and with the walls and floors executed in a variety of unusual materials including marble and exotic, often contrasting, wood veneers. The imagery of the artwork was usually symbolic of the function of the building or of its region and the local history of the area.

Early examples of classical moderne buildings were found among the designs of architects of the Beaux-Arts tradition. Notable were McKim, Mead & White's Whittemore Library and Bowery Savings Bank of the early 1890s; Albert Kahn's Detroit Hudson Motor Car Company office building (1910), his orientalist National Theater (1910) and his Detroit News Building (1915); and Burnham & Root's 1911 Columbus Memorial and Rock Island Savings Bank. (The style was seen as appropriate for banks because its monumentality symbolically suggested a decorated strongbox.) The eclectic Kahn, who came to be known as the giant of American industrial architecture, later provided skyscraper deco buildings for Detroit, as well as streamline-style pavilions for the expositions of the 1930s.

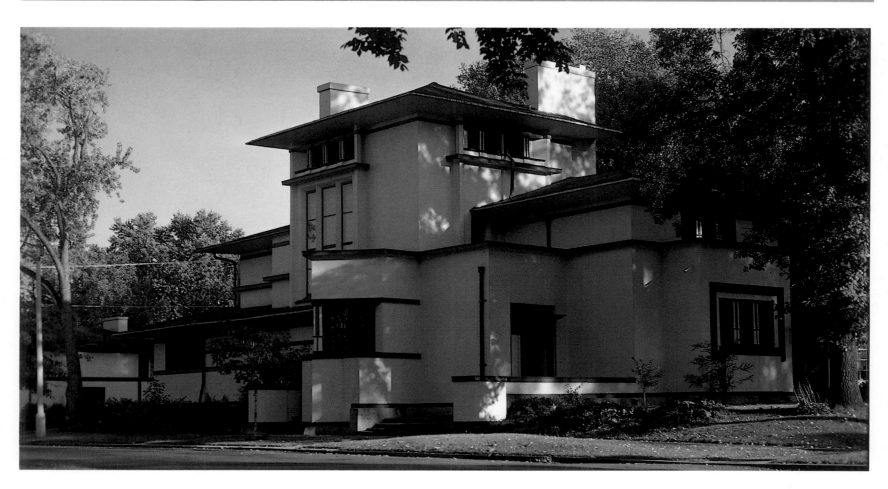

But it was Bertram Goodhue's bold design for the Nebraska State Capitol in Lincoln (1922-32) that fundamentally established the prototype for governmental construction in the classical moderne style. The Capitol building was an innovative amalgam of modernistic and classical, of skyscraper and temple, with a stable, simplified mass, an arched entrance and a dramatic, soaring golden-domed tower. Goodhue's design, which won the 1920 competition, was tied to modernist architecture in the Scandinavian and Germanic countries, and was therefore an appropriate choice for Nebraska, where so many immigrants from northern Europe had settled. Influenced by

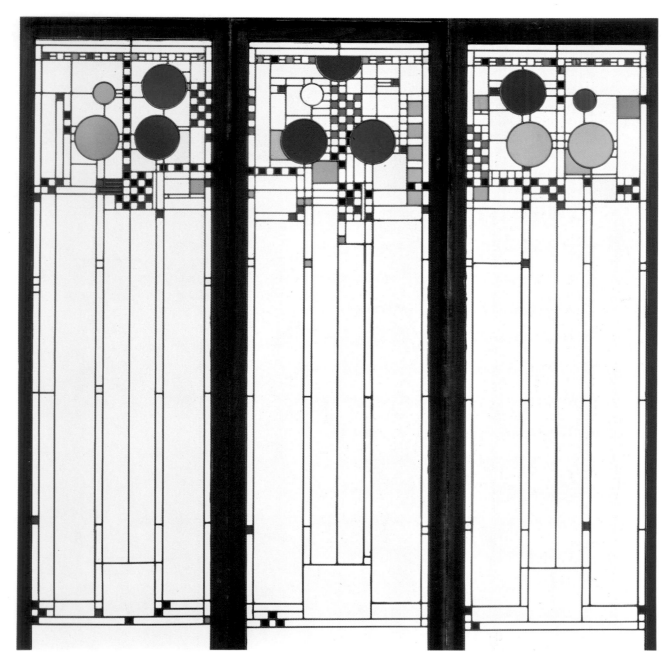

ABOVE: *Frank Lloyd Wright's Fricke residence was another important prototype of the Art Deco architectural style.*

LEFT: *Wright's concern with the unity of architectural and decorative design led to such masterpieces as his 1912 stained-glass windows for the Avery Coonley Playhouse.*

RIGHT: *In New York City, William Van Alen's 1930 Chrysler Building is the archetypal Art Deco skyscraper of the zigzag era.*

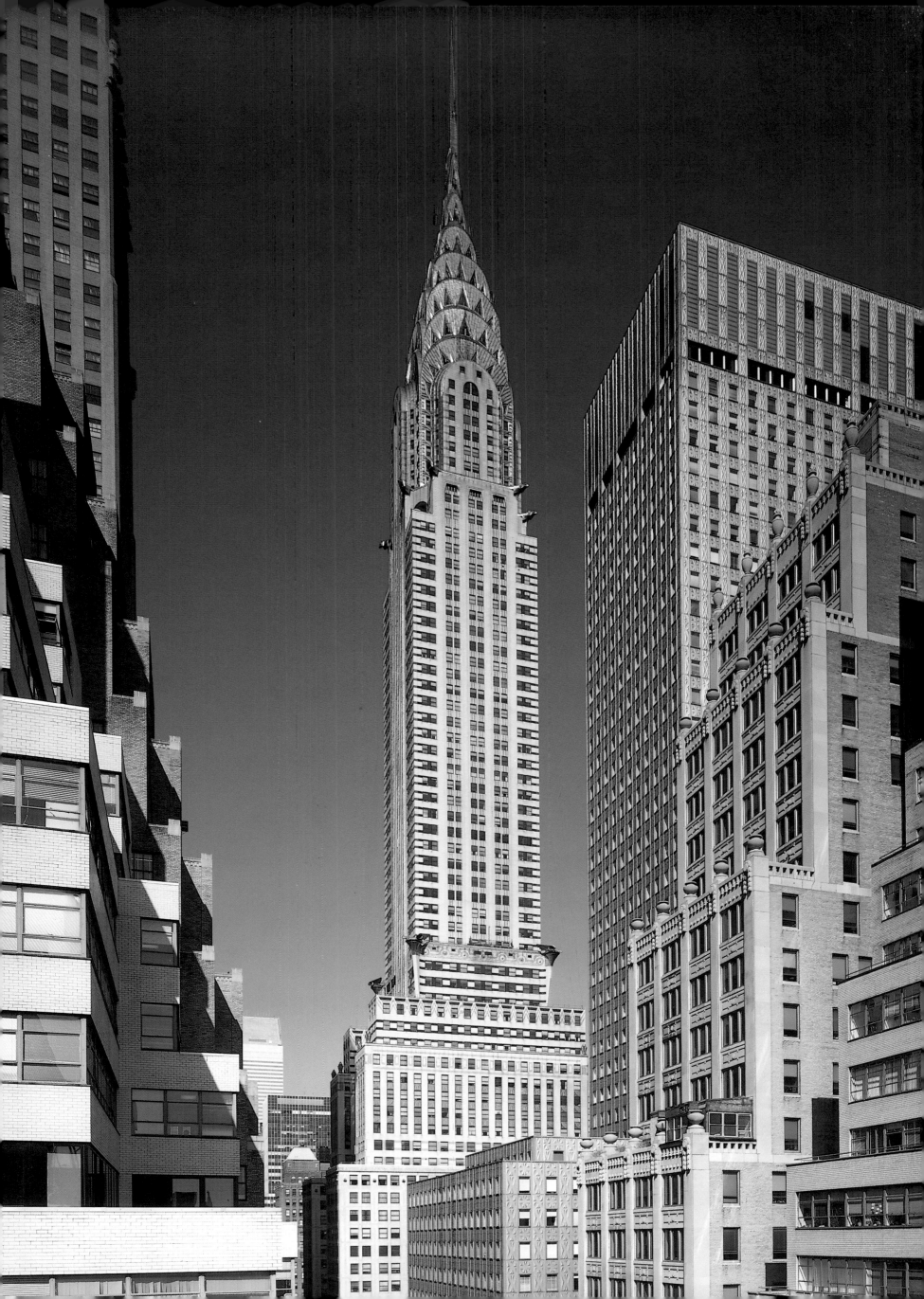

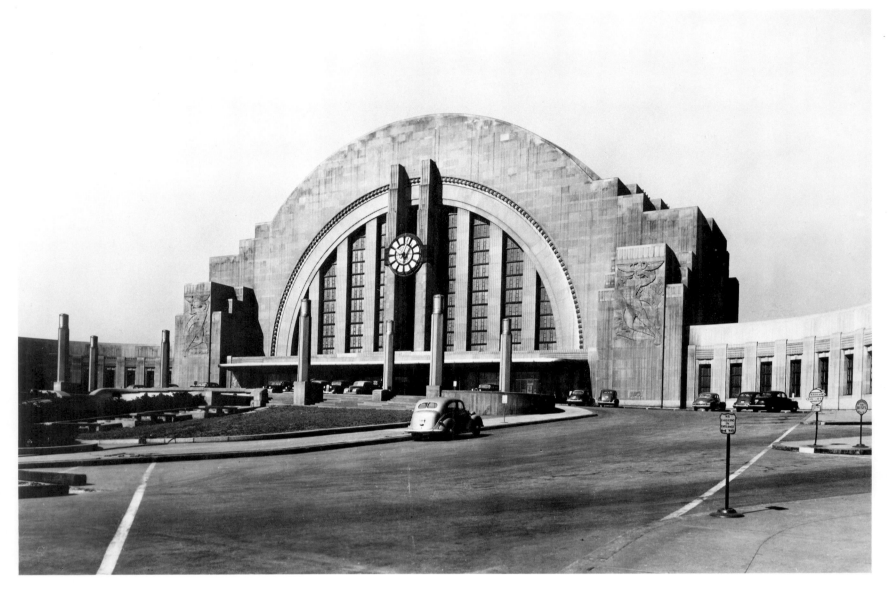

Eliel Saarinen's Helsinki station, the exterior of the Nebraska Capitol incorporated stylized stone carvings and low reliefs. This ornament was restricted to the four entrances and contrasted with the plain wall surfaces. Goodhue personally supervised the artistic program of the building, choosing not only sculptor Lee Lawrie, but also Augustus Vincent Tack to paint murals and Hildreth Meiere to design colorful mosaic ornamentation for the ceiling vaults. Following Goodhue's death – reportedly hastened by aggravations associated with the Nebraska project – the work on the illustrative murals, mosaics and friezes adorning the ceremonial chambers went on for 40 years.

Government buildings influenced by Goodhue's Nebraska design included the 1933 Louisiana State Capitol in Baton Rouge, Los Angeles City Hall, and the North Dakota Capitol in Bismarck. Other important civic structures in the classical moderne style included the Oregon State Capitol and the city halls of Buffalo, St Paul, Kansas City, Nashville, Houston and Oklahoma City. And with the public works programs of the Depression years, the style came to be represented in hundreds of post offices, libraries, schools, courthouses, museums and other civic structures across the United States.

Among the leading classical moderne architects was Paul Philippe Cret. His most important commissions, many of them completed in collaboration with other architects, included the Detroit Institute of Arts (1922), the Philadelphia Rodin Museum (1929), the Folger Shakespeare Library in Washington (1932), the dramatic Hall of Science at the 1933 Chicago Century of Progress exposition and the Federal Reserve Building, also in Washington (1937). Classical moderne was appropriate for war memorials, and Cret designed a number of such monuments including those at Providence, Rhode Island (1927), Cheateau Thierry, France (1928) and Gettysburg, Pennsylvania (1937).

When his firm was hired to tackle problems of interior design, Cret became quite ornate in his use of Art Deco detailing. A prime example was Cincinnati's classical moderne Union Terminal, designed by Roland Anthony Wank of Felheimer & Wagner in 1933. Brought in as a consultant to the railroad, Cret was responsible for enriching the interior with such modernist accoutrements as mosaic

murals and a glittering rotunda ceiling by Winold Reiss, tooled leather jungle motif murals by Pierre Bourdelle, a tearoom decorated with Rookwood tiles and, by Cret himself, specially designed aluminum and leather furniture, ornate metalwork and elegantly streamlined elevator interiors. In his work for the railroad from 1933 to 1945, Cret's firm designed the interiors of 64 different railroad cars for Philadelphia's Edward G Budd Company.

Characteristic of the roaring twenties, the flamboyant, jazzy version of Art Deco known as the skyscraper or zigzag style was comparatively short-lived compared to classical moderne; most zigzag style buildings were completed between 1925 and 1931, though its typical ornament lingered on in classical moderne and streamline-style settings throughout the 1930s. Though zigzag geometric stylization had isolated pre-World War I American precursors – in Frederick Scheibler's Pittsburgh apartment houses and in Chicago's Franklin Building by George Nimmons – the leading impetus came from abroad. The ideas of German architect Gottfried Semper were influential; he advocated the ornamental symbolic stressing of building entryways, roof lines and 'curtain walls' with patterns resembling woven textiles. These concepts came to life in the opulently embellished entrances, luxurious elevator lobbies and decorated pinnacles of Art Deco skyscrapers, and made the buildings visually attractive to the public at street level as well as from a distance.

Key European modernistic influences came from the French Art Deco designers influenced by Cubism and the Russian Ballet, the elegant abstractions of the *Wiener Werkstätte* and from German Expressionist architecture and set design. More indigenous contributions came from pre-Columbian architecture and from the imagery of the machine age. An eclectic recombination and stylization of these diverse motifs achieved a look that was not only aggressively modernistic but also symbolically futuristic.

The actual form the skyscraper took in the late 1920s was determined by two earlier developments. The first was a 1916 New York City zoning ordinance that mandated building setbacks, to be determined by the width of the street. This kind of stepped-back contour resembled a ziggurat topped by a tower. The second decisive event

was the 1922 international architectural competition to design a new building for the Chicago Tribune newspaper company. The winning design by Americans John Mead Howells and Raymond Hood was for a Gothic Revival skyscraper, complete with flying buttresses at the summit. Chosen from 263 submissions, this design reflected the then-current trend for skyscrapers in gothic and classical styles. But it was the design that won second place, by Eliel Saarinen, that attracted the most interest. Though also gothic in conception, the Saarinen design, which was praised by Louis Sullivan, liberated the skyscraper from strict reliance on historical styles and pointed the way towards a modernistic abstraction that adapted and combined a variety of decorative motifs. In 1923 Saarinen traveled to the United States to accept his prize, and decided to remain. Beginning in 1926, he designed the buildings and other facilities for Cranbrook Academy near Detroit and went on to produce some of American Art Deco's finest furniture and household accessories.

A good deal of credit for popularizing the skyscraper style must go to Hugh Ferriss, whose romantically abstracted and visionary renderings of Art Deco buildings were persuasive in selling new design concepts to clients, as well as in generally influencing public acceptance of modern architectural trends. Though trained as an architect, Ferriss never had any actual buildings constructed to his design.

In 1923 construction began on New York's first zigzag-style building, the New York Telephone Building, also known as the Barclay-Vesey Building, designed by Ralph T Walker. Work did not begin on the city's second such structure until 1926. This, the Insurance Center Building, was designed by Ely Jacques Kahn. One of the most talented and productive of Manhattan's Art Deco architects, Kahn designed over 30 such commercial structures before 1931, including such outstanding examples as the Park Avenue Building, the Film Center Building, the Squibb Building and the Casino Building. Because two real estate developers commissioned most of his buildings, Kahn was able to develop a recognizably individual interpretation of Art Deco.

The first true skyscraper in the zigzag style was Sloan & Robertson's luxurious Chanin Building, started in 1927. The archetypal Art Deco skyscraper was William Van Alen's flamboyant Chrysler Building, with an ornamental frieze of automobile hub caps and mudguards, and accents of winged radiator caps at the base of its fantastic soaring spire. And the Empire State Building, topped with a machine-age mooring mast for dirigibles, provided a fitting end to the heroic era of the Art Deco skyscraper.

Raymond Hood was of great importance to Art Deco despite his relatively small architectural output, which included the American Radiator Building and its counterpart in London, the *Daily News*

LEFT: *Fellheimer & Wagner's Cincinnati Union Station (1929-33) is among the many Art Deco monuments unfortunately demolished during the postwar decades.*

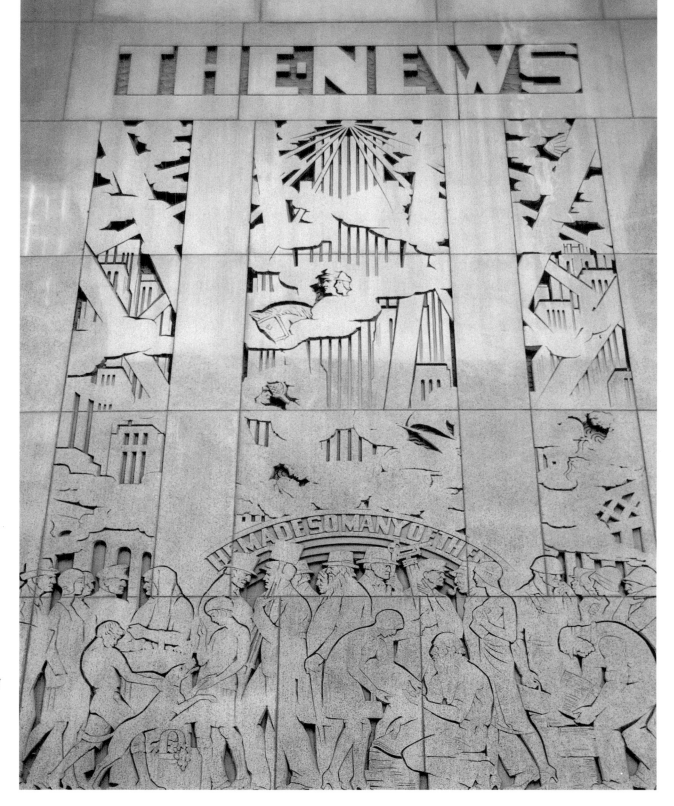

RIGHT: *While the asymmetrically setback tower of Raymond Hood's* Daily News *Building (1929-31) in New York suggested the International Style, at street level the building was pure Art Deco. This incised granite relief depicting the skyscraper city surmounted the entrance, while in the jazzy black glass-walled lobby, a colossal recessed revolving globe dramatically illuminated from beneath attracted hordes of tourists.*

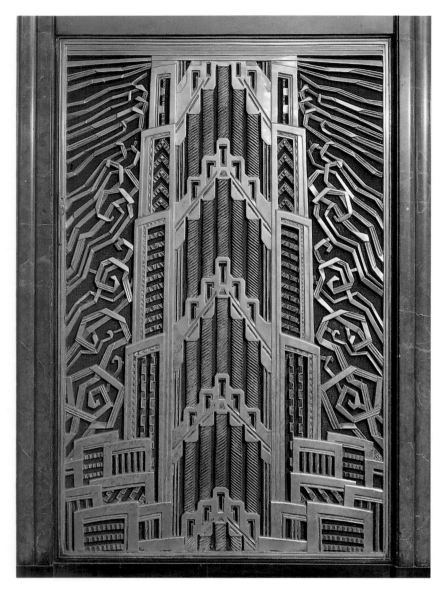

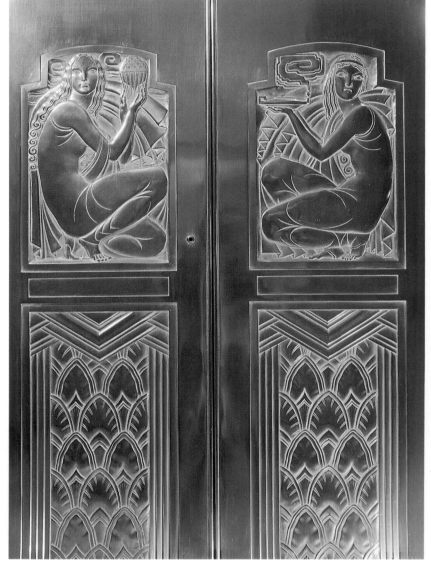

Building with its theatrical black glass lobby surrounding a colossal globe, and the McGraw Hill Building. He collaborated with a large group of architects on the design of Rockefeller Center, now considered as one of the greatest achievements of American Art Deco. The accessible complex of office buildings, theaters, restaurants, shops and an outdoor pedestrian mall was not so important for its monolithic towers as for its success as a planning concept. Its Art Deco highlights include exterior sculptural ornament by leading sculptors, as well as modernistic interiors by top Art Deco designers and artists in a variety of media.

ABOVE LEFT: *These grilles in Sloan & Robertson's 1926-29 Chanin Building typify the taste of the flamboyant zig-zag era. The lobby design was by Jacques Delamarre and the architectural sculpture by René Chambellan.*

ABOVE: *Elevator doors of the Farmer's Trust Building in New York City.*

BELOW LEFT: *Ventilator grilles in Radio City Music Hall at Rockefeller Center in New York.*

BELOW: *Spectacular lobbies, as seen in New York's 275 Madison Avenue, were an Art Deco speciality.*

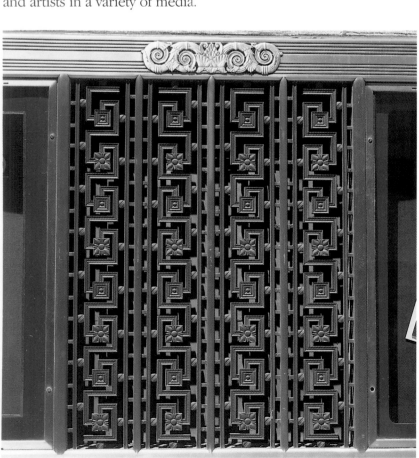

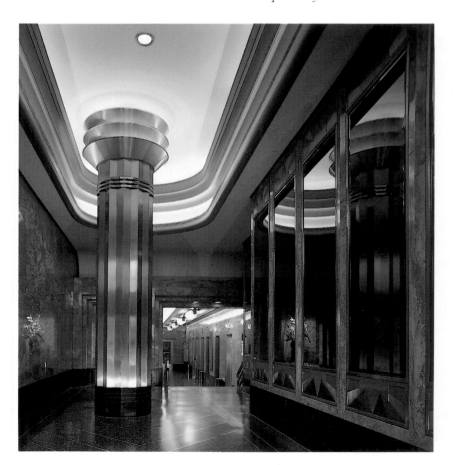

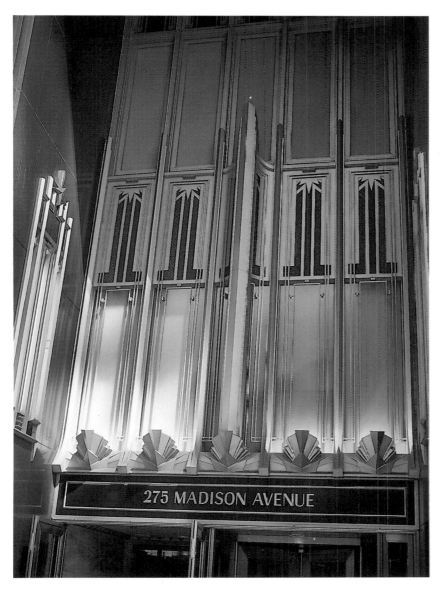

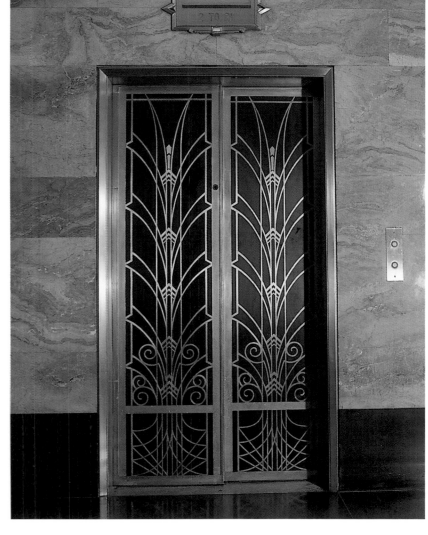

ABOVE: *Theatrical lighting effects were frequently exploited by Art Deco designers.*

ABOVE RIGHT: *The elevator doors at 275 Madison Avenue were part of the integrated lobby design.*

BELOW AND BELOW RIGHT: *Symbolic and cosmic imagery was a typical feature of Art Deco. The star motif on the lobby floor of 275 Madison Avenue is echoed on the entrance lobby mail box.*

One of the most recognizable characteristics of the Art Deco style was a wealth of surface ornament on the exteriors of the buildings, echoed in their interior fittings. The crisply patterned motifs included zigzags, triangles, stripes, segmented circles and spirals, while among the stylized naturalistic motifs were flowers, trees, fronds, fountains, gazelles, birds, clouds and sunrises. Astrological imagery, along with idealized personifications of natural and technological forces, was also popular. Expressive of the machine age and its dynamism were lightning bolts, airplanes, locomotives, ocean liners, automobiles, skyscrapers and bridges. The machine-age

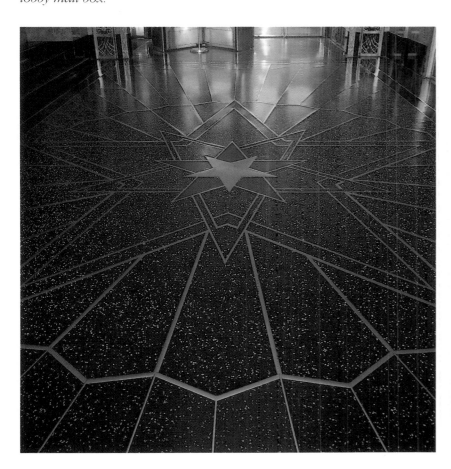

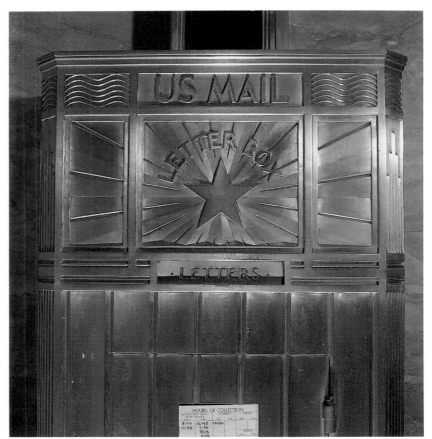

imagery also extended to the building summits, which were frequently surmounted by futuristic masts or finned parapets. Full of aspiration and optimism, the Art Deco imagery depicted man's place in the cosmos and his confident control of the machine, which was to usher in the dawn of a new era.

Often striking in its color, the Art Deco ornament was executed in a rich variety of media, including marble, terracotta, cast plaster, tile, mosaic, metal, etched or stained glass, stencil, paint and contrasting wood veneers. The use of metal and glass became more widespread in the 1930s. Theatrically illuminated, the exquisitely crafted tapestry-like wall ornamentation was part of a total co-ordinated design – which extended from the entrance doors through the vestibules, lobbies and elevators to the carpets, furniture and even the mail boxes – frequently realized through the collaboration of designers, artists, and craftspeople commissioned by the architects. Among the architects who designed their own ornament were Ely Jacques Kahn, Stiles Clements, Ralph Walker and Frank Lloyd Wright.

Zigzag deco was not just a Manhattan phenomenon; buildings in the style were soon erected nationwide. Art Deco, in all its variants, was a frequent choice for the technological and commercial firms that came of age in the 1920s and 1930s: radio broadcasting facilities, telephone companies, newspapers, cinemas, nightclubs, resorts, restaurants, hotels, department stores and especially the transport-related industries such as aviation, bus travel and the automobile. It

was the style for clients who wanted to project an updated, progressive image. Some of the more ambitious buildings were commissioned by utility companies. A picturesque example was Niagara Mohawk's building in Syracuse, New York. Conceived as a temple of electricity, the building's façade displayed bands of glass panels covering helium tubes and incandescent bulbs in a dramatic nighttime illumination system. A colossal stainless steel sculpture of the winged *Spirit of Light* was mounted above the entrance. Theatrical lighting effects were soon recognized as a useful form of self-promotion by utility companies such as Tulsa's Public Service Company and Kansas City's Power & Light, whose building was topped with a flame-red beacon.

Indeed, theatrical architectural illumination – by floodlighting, from within through translucent glass or structural glass blocks, or with colored neon tubing as on cinema marquees – became a quintessential Art Deco feature. Effects such as coloring, silhouetting, contrasting of light and shadow to emphasize masses and highlight compositional features, and toplighting of building summits were explored at the expositions of the period, and soon became characteristic adjuncts to zigzag-style skyscrapers.

Important groups of zigzag and other Art Deco buildings were erected in Washington, Baltimore, Pittsburgh, Kansas City, Seattle and elsewhere. In San Francisco, James Miller and Timothy Pflueger were the leading Art Deco architects; Holabird & Roche also

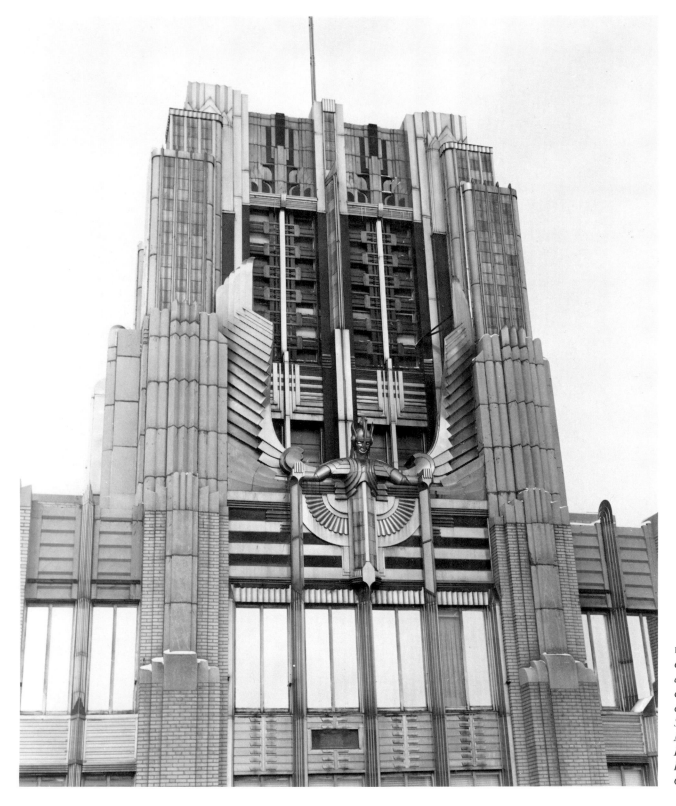

LEFT: *Among the more picturesque examples of American Art Deco architecture were the buildings commissioned by public utility companies. A prime example in Syracuse, New York, was the 1932 Niagara Hudson Building by Bley & Lyman, consultants to King &King, with sculpture by Clayton Frye.*

RIGHT: *As seen in this nighttime view of George Winkler's Public Service Company Building (1917-23) in Tulsa, Oklahoma, utility companies often made dramatic aesthetic and promotional use of one of their chief products – electric power.*

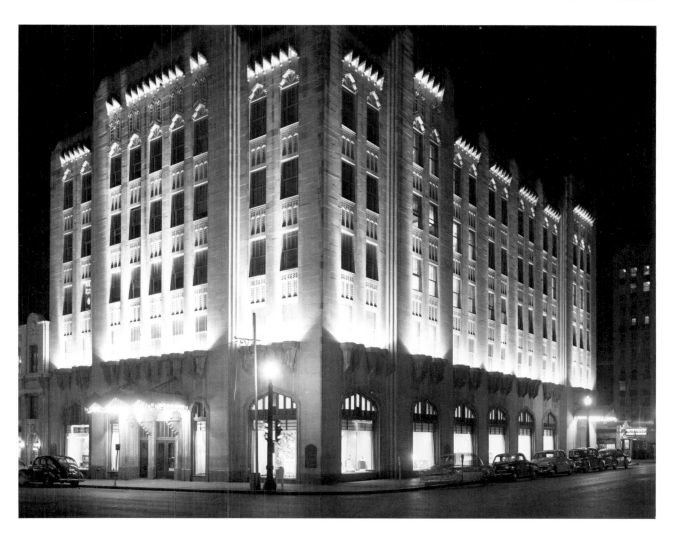

produced a number of important buildings in Chicago. Detroit, in addition to Albert Kahn's works, boasted the richly ornamented Union Trust Building by Wirt Rowland.

One of the most remarkable enclaves of Art Deco architecture was assembled in the oil boom town of Tulsa, Oklahoma, during the 1920s and 1930s. Outstanding here were the buildings of Bruce Goff. Like Barry Byrne and Frank Lloyd Wright, who also designed Tulsa buildings in those years, the individualistic, informally-trained Goff defied categorization. Among his inventive designs were the Tulsa Club, the Page Warehouse, the Guaranty Laundry and the Midwest Equitable Meter Company (which owed a debt to German Expressionism). But it was Goff's dynamic Boston Avenue Methodist Church that earned widest recognition with its stylized sculpture, geometric

ornament and Cubist-inspired stained glass, suggested by ideas in Claude Bragdon's *Projective Ornament* and *Architecture and Democracy*. As a means for spreading the latest architectural trends to the Midwest and other culturally isolated areas, architectural publications were essential to Goff and others.

Goff's Tulsa church exemplified a stylized gothic variant of zigzag Art Deco that can be seen in other religious structures of the era. It was used by Adrian Gilbert Scott for the St James Church in Vancouver, and by Barry Byrne in American churches as well as his Church of Christ the King in Cork, Ireland (1928). The sole ornament of the diamond-plan Cork church was a stylized relief of Christ between the portals by John Storrs. Medievalist Art Deco was also seen as appropriate for Detroit's Masonic Temple (1928).

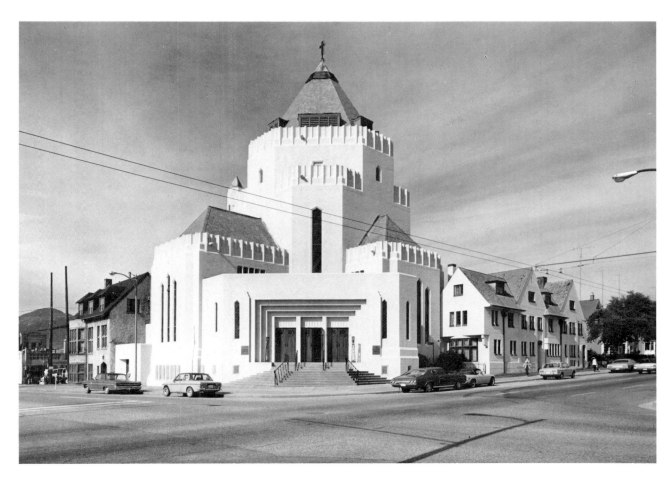

RIGHT: *A gothic variant of Art Deco is seen in Vancouver's St James Church (1935-37) by Adrian Gilbert Scott.*

During the 1920s Frank Lloyd Wright completed a number of in-
novative commissions allied to zigzag Art Deco. They were executed
in poured concrete and geometrically patterned textile block, a tech-
nique pioneered in the Unity Temple and the A D German Ware-
house (1915). Unfortunately, like his Larkin Building, Wright's Mid-
way Gardens pleasure palace (1913), which was adorned with
Alfonso Iannelli's modernistic sculpture, was later demolished. Still
extant, however, are a group of Mayan- or Aztec-style California resi-
dences. They are the Barnsdall (Hollyhock) house, with its recurrent
plant motifs, the Millard residence, the Storer residence, the Free-
man residence and the monumental Ennis residence.

Wright's oldest son, Lloyd Wright, supervised the construction of
these houses, and went on himself to design other California edifices
inspired by pre-Columbian forms, notably the John Sowden house
(1926), a futuristic Mayan Hollywood-style fantasy, with appropriate
furniture by Lloyd Wright. Lloyd Wright also designed the first angu-
lar Hollywood Bowl, as well as the second elliptical version, moder-
nistically more stylish but acoustically less effective.

The Mayan revival style, based on Meso-American architecture and
the decorative arts of pre-Columbian times, centered in southern
California. There the ebullient Robert Stacey-Judd, designer of the
Monrovia Aztec Hotel, was its ardent publicist. Stacey-Judd went on to
produce the Ventura First Baptist Church (1928-1930), an unusual
amalgam of gothic deco and Mayan, and the Masonic Temple in
North Hollywood (1951). The Mayan style's primitivistic stepped-
back massive forms also inspired Prairie School architect Walter Bur-
ley Griffin, who left in 1914 to design Canberra, the new Australian
capital. There he later designed a Mayan-style municipal incinerator

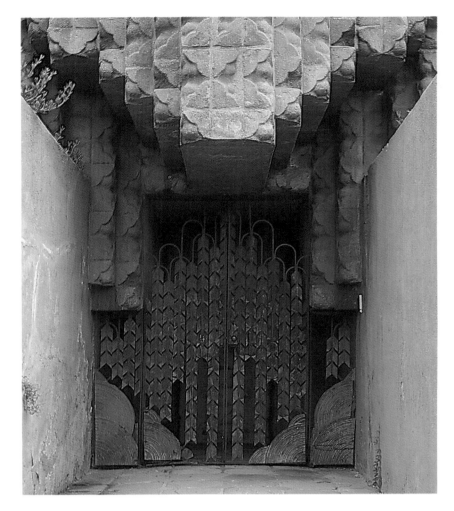

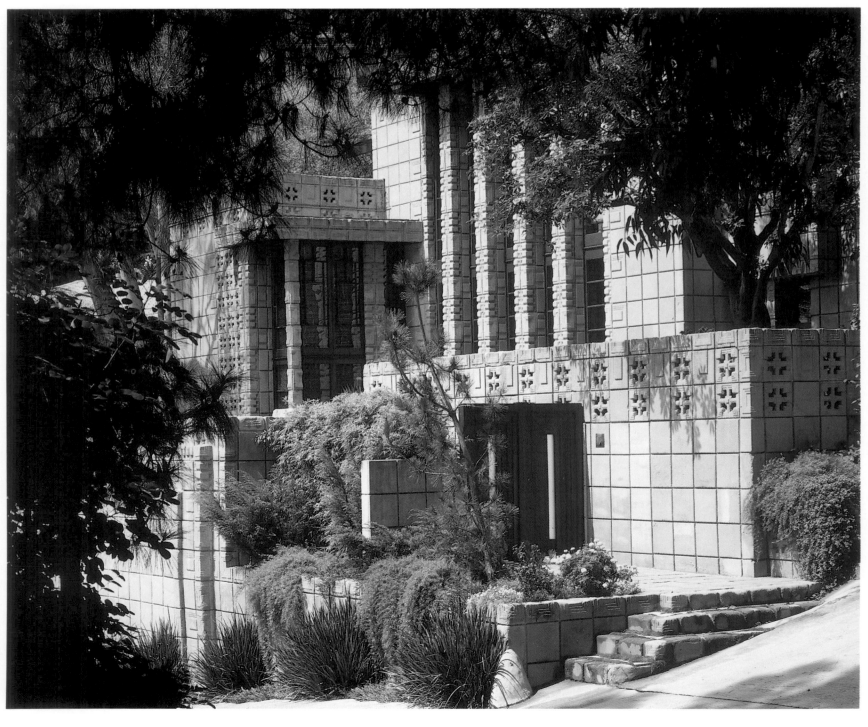

LEFT AND RIGHT: *After supervising the construction of his father's California textile block houses, Lloyd Wright designed the exotic John Sowden house (1926) in Los Angeles.*

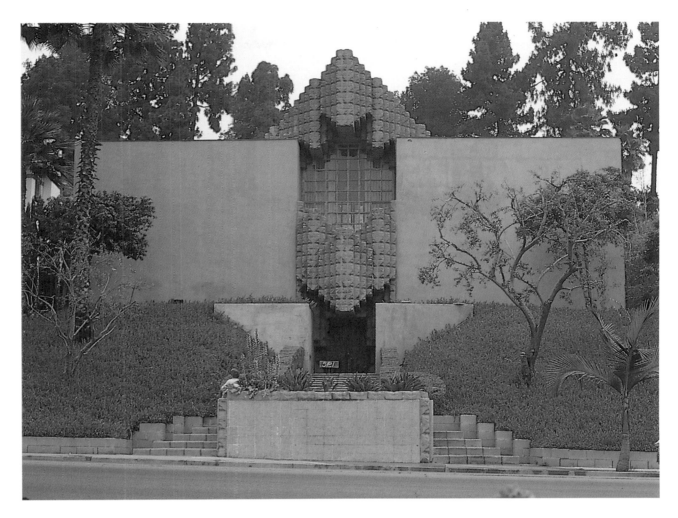

BELOW LEFT: *The 1923 Storer house was the second of Frank Lloyd Wright's innovative textile block houses in the Los Angeles area.*

BELOW RIGHT: *The Ennis house was the last of Wright's residential designs reflecting the Mayan style.*

for Sydney. The University of New Mexico commissioned a Mayan-style Chemistry Building, now the Art Annex. by Barry Byrne. The 1915 Aztec Theater in Eagle Pass, Texas, unique for its time, was followed by one in San Antonio, now home to the city symphony, and others in Los Angeles, Denver, Detroit and New York. In New York, Mayan style was also seen in the Bloomingdales store, the Kress building and the designs of Ely Jacques Kahn.

Southern California, which underwent a period of remarkable growth and prosperity during the 1920s, was the site of a number of exotic variations on zigzag deco, as well as of related revival styles. Bertram Goodhue adapted Egyptian ornament for his Los Angeles Public Library and Assyrian motifs were adapted for the Samson Tyre and Rubber Company, later the Uniroyal Tire Factory, by Morgan, Walls, and Clements. These architects also produced such other western zigzag Art Deco treasures as the black and gold Atlantic Richfield Building, the Dominiguez-Wilshire Building, the Security Pacific Bank Building, the Warner Brothers Western Theater/Pellissier Building, the Leimert Theater and the garish, flamboyant Mayan Theater in Los Angeles.

New heights of ostentatious luxury, probably reflecting the Hollywood ambience, were achieved by Claude Beelman's Eastern Columbia Building, which was clad entirely in glazed aquamarine and gold terracotta tile, and by the Bullocks Wilshire department store (1928), with consummate French-style interior detailing by René Lalique and other collaborating artists.

Another regional Art Deco variant, Pueblo deco – based on a fusion of Pueblo Indian, Spanish colonial and California mission revival architecture – arose in the Southwest (west Texas, New Mexico and Arizona). It was an architecture of massive forms, flat-topped arches, and primitivistic columns primarily derived from vernacular white-walled adobe buildings. The ornament was based on symbolic and ceremonial Navaho, Hopi and Pueblo Indian motifs from pottery, basketwork, jewelry and textiles. Related motifs were cacti, cowboys and sun symbols. The characteristic abstraction, angularity and repetitiveness of the Indian artwork were closely allied to Art Deco stylization. A number of Pueblo deco courthouses and theaters were erected, as well as at least one hospital and a railroad station. Quintessential was Albuquerque's Ki Mo Theater (1926-27) with its terracotta buffalo-skull light fixtures, stylized Kachina masks, Navaho rugs, Pueblo pottery and its mural on the theme of 'Seven Cities of Cibola.' Growing tourism made the style attractive for hotels, including those

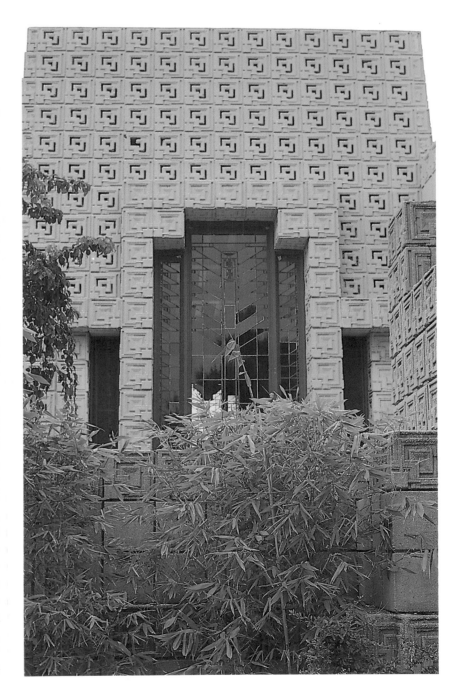

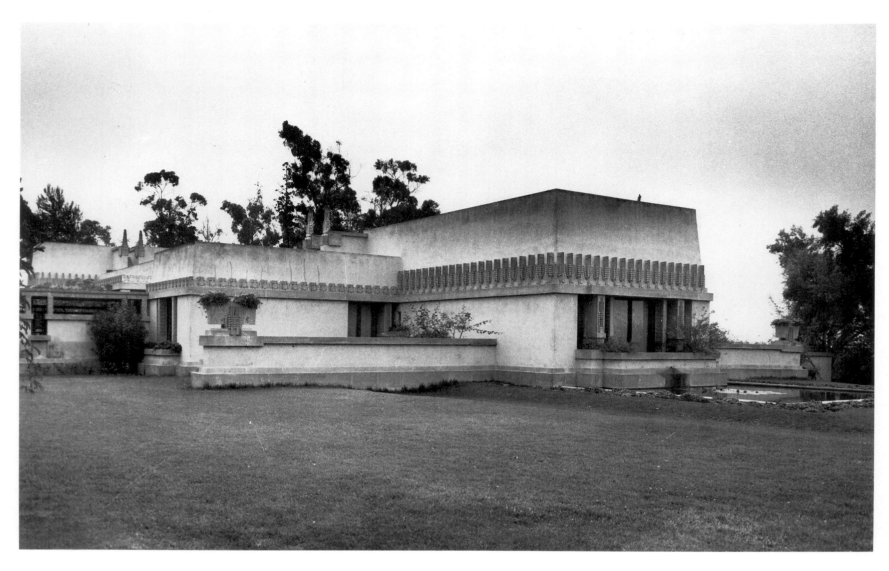

of the Harvey chain. Frank Lloyd Wright's ideas were included in the Arizona Biltmore, while the prolific Henry Trost produced Albuquerque's remarkable Franciscan Hotel (1923), a colossal Pueblo pile with a stepped-back silhouette, and with interior ornament of abstracted Indian motifs and wall plaques by noted Pueblo potter Nampeyo. Trost's Caverna Hotel in Carlsbad (1928) was a variation on this theme. Unfortunately demolished in 1972, the Franciscan was widely published in the 1920s and attracted international interest. Trost also produced skyscraper deco buildings for El Paso and Phoenix. Edward Sibbert, chief architect for the Kress stores chain, produced Pueblo deco designs for stores in El Paso and Phoenix. The

University of New Mexico's active encouragement of indigenous architecture influenced the development and production of Pueblo deco buildings for civic and commercial as well as domestic purposes throughout the Southwest.

The 1929 stock market crash abruptly ended the era of the ostentatious, ultra-expensive zigzag-style architecture. Most of the surplus profits parked in grandiose speculative real estate by the commercially-minded capitalists of the roaring twenties had now vanished. Indeed a number of buildings which began construction before the crash were not finished until after it, remaining alarmingly empty for years. From now on, the key was to be austerity.

ABOVE: *Frank Lloyd Wright's earliest textile block house in California was the Barnsdall (Hollyhock) house of Los Angeles (1917-20).*

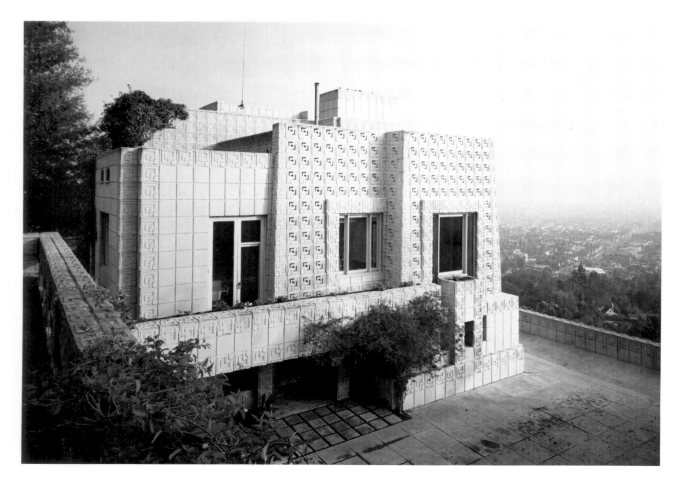

LEFT: *Wright's monumental Ennis residence offered a spectacular view of the Los Angeles metropolitan area.*

The third distinctive manifestation of Art Deco was known as the streamline style, or streamlined moderne. A horizontally oriented style of aerodynamic curves, flat roofs, glass brick, banded windows, tubular steel railings, speed stripes, mechanistically smooth wall surfaces and implications of mass production, the streamline style in architecture paralleled that used by the industrial designers of airplanes, locomotives, automobiles and household appliances. It was a romantic adaptation of the white, flat-roofed cubes of European functionalist architects like Adolf Loos, Le Corbusier and others. In France, *le style paquebot* or steamship style was based on the glamorous ocean liners of the era. With its horizontally banded tubular railings, elegant curves, porthole windows and modernistic decorative detailing, the style was frequently used for resorts or for the villas of the rich, avant-garde, or intellectual. Streamlining's futuristic resonances of machine-like efficiency and decisive forward movement continued the optimistic symbolism of the zigzag era.

The first suggestions of the streamline style appeared in Eric Mendelsohn's Einstein Observatory (1919-24) and the designs of other German Expressionists. The Futurist drawings of Italian visionary architect Antonio Sant'Elia also prefigured the streamlined style, which first appeared on the American scene in two transitional skyscrapers. Raymond Hood's zigzag style McGraw Hill building (1931) was placed on a colorful horizontally banded base curving in to enclose a streamlined lobby. And the design by William Lescaze and George Howe for the Philadelphia Savings Fund Society building (1932) mounted a functionalist International Style office tower on a streamlined base with a curved façade of glass and polished charcoal granite. The streamline style was never widely favored for domestic housing in the United States, although there were a limited number of such curvilinear, flat-roofed, horizontal, white stucco residences commissioned by consciously avant-garde and financially well off clients, particularly on the west coast.

Now widely acknowledged as a masterpiece of the streamline style, the Johnson Wax complex in Racine, Wisconsin was Frank Lloyd Wright's largest corporate commission. Here the disciplined curves of the exterior were echoed in the luminous banded ceiling of the reception area and the monumental columns of the clerical hall. Wright's decorative use of glass tubing for innovative lighting effects, his co-ordinating curvilinear office furniture and sleekly finished exterior walls expressed the machine aesthetic and modern corporate efficiency. Wright's investigation of curved forms culminated in his 1943 design for the Guggenheim Museum, which was finally erected in the late 1950s.

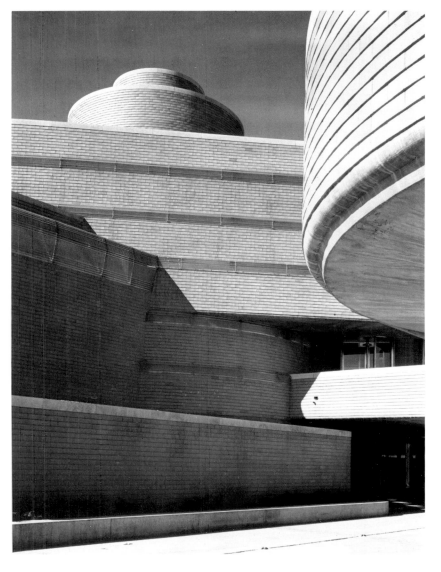

In its more picturesque form, the streamline style became a popular choice for numerous commercial clients across the United States. California boasted many notable examples, including the Winnie and Sutch Company building in Huntington Park and the Los Angeles Coca Cola Bottling Plant, both by Robert Derrah. In the remodeling of an older building, Derrah carried the steamship style to an extreme by including promenade decks, a ship's bridge, portholes and other nautical details. The streamline style, with its futuristic implications, climaxed at the end of the decade in the 1939 New York World's Fair.

ABOVE RIGHT: *Frank Lloyd Wright's 1936-39 Johnson Wax building in Racine, Wisconsin, was a streamline-style masterpiece.*

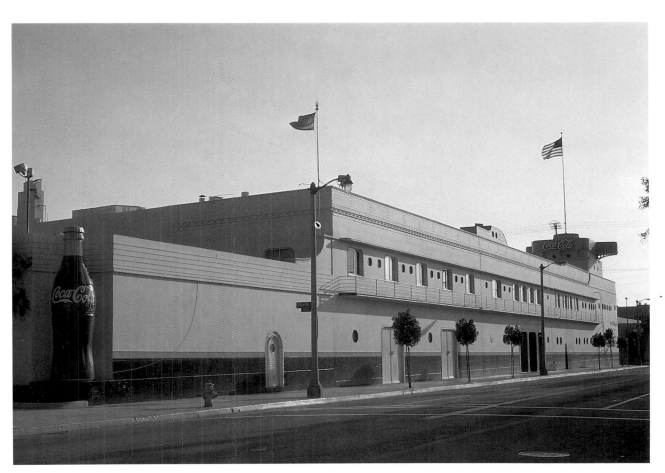

RIGHT: *By remodeling and adding to several older buildings, Robert Derrah concocted a nautically streamlined Coca Cola Bottling Plant for Los Angeles.*

The streamline style was also deemed appropriate by smaller commercial clients. Not only was it used for a whole range of new, modest, sometimes prefabricated roadside structures such as gas stations, diners, bus terminals and stores but, from 1936, it was heavily utilized in the context of the 'modernize Main Street' movement. This resulted in the renovation of countless traditionally styled commercial structures, which were given modernistic façades using such machine-age materials as vitrolite, black glass, backed enamel panels, aluminum and plastic, along with neon tube lighting. Not only the streamline, but also the zigzag style were used in such relatively inexpensive image transformations in the attempt to attract new customers. Eventually the streamline style became accepted as a well established commercial style favored by many business outlets throughout the 1940s and 1950s.

Tropical deco, a regional offshoot of the streamline style, was evidence of the breadth of influences at work on Art Deco. Tropical deco took its name from its Florida locale, although similar buildings were frequently erected in resort areas in California and elsewhere. As a rule, tropical deco buildings were constructed inexpensively of stuccoed concrete. They tempered the aerodynamic efficiency of the streamline style with zigzag-style setbacks, polychromy and stylized organic and abstract ornament. The functionalist white of streamline-style wall surfaces was often painted over with such sensuous pastel hues as flamingo pink, sea green and yellow. And when the curved walls of streamlining were supplanted by the Cubist boxiness of the International Style, their austere linearity was softened by the curves of the applied ornament. Frequently the horizontal structures were topped with the futuristic machine-age masts previously seen on New York's zigzag style skyscrapers. Sometimes these masts were finned, or displayed jazzy neon signs.

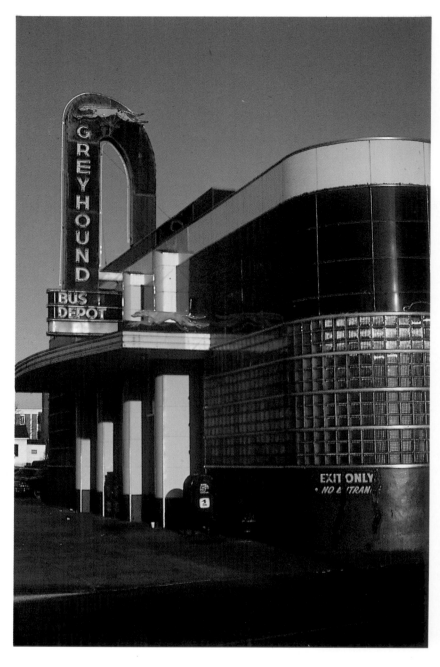

RIGHT AND BELOW: *Streamlining became a popular commercial style for such roadside structures as bus stations and diners.*

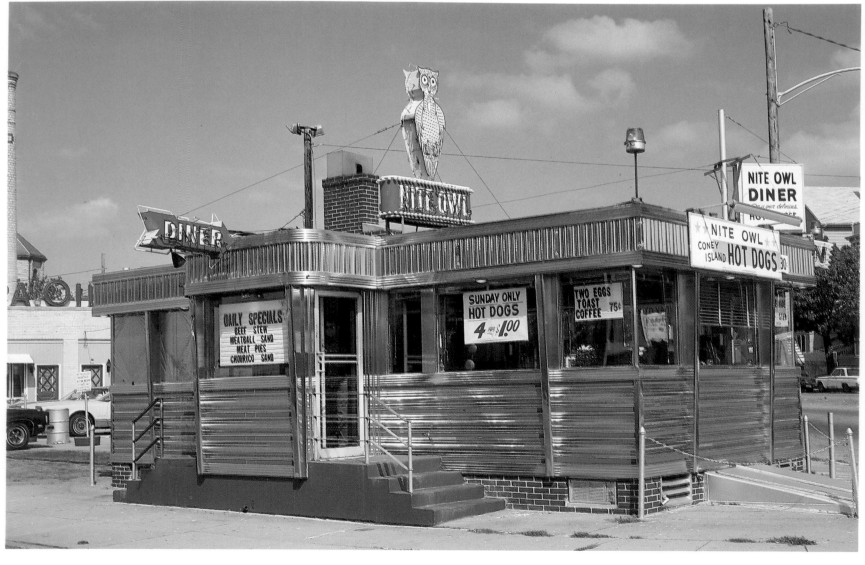

The concentration of tropical deco architecture – some 400 buildings in all – in the square mile of the historical district now known as Old Miami Beach was the result of an intense southern Florida building boom that ran from the late 1920s through the 1930s. Miami's tropical deco hotels, apartment buildings and houses confirm the essentially vernacular nature of art deco architecture – not only in the frequent anonymity of its designers, but also in its idiosyncratic combination of decorative motifs and architectural devices from the zigzag, classical moderne and streamline styles, as well as from the International Style.

The distinctive features of tropical deco included cantilevered sunshades over windows, octagonal and porthole windows, flagstaff parapets and deck-like balconies. These features were part of the regional marine imagery of tropical deco, as were such motifs as dolphins, herons, mermaids, sea shells, alligators, flamingos, palm trees and stylized waves and clouds. The Art Deco sunrise and fountain motifs had special meaning here – after all Florida, the sun worshipper's mecca, was the site of Ponce de Leon's fabled fountain of youth. The opulent, seductive quality of the interior and exterior ornament of tropical deco reiterated the theme of a glamorous vacation paradise, a welcome escape into fantasy.

Art Deco also gained a foothold elsewhere on the North American continent. In Mexico, during the height of the post-revolutionary artistic renaissance of the 1920s and 1930s, a series of splendid schools, hospitals, offices and apartment buildings were designed by Juan O'Gorman, Jose Villagran Garcia, Enrico de la Mora, Luis Ruiz, Antonio Munoz Garcia and others. Farther south, Bogota's Biblioteca Nacional by Alberto Wills Ferro (1938) was representative of Art Deco architecture in other South American cities.

BELOW: *This diner in St Paul, Minnesota, was one among many across the USA to sport the new streamline style.*

RIGHT: *The tropical deco style that developed in Florida's Miami Beach was to spread to other resort areas as well.*

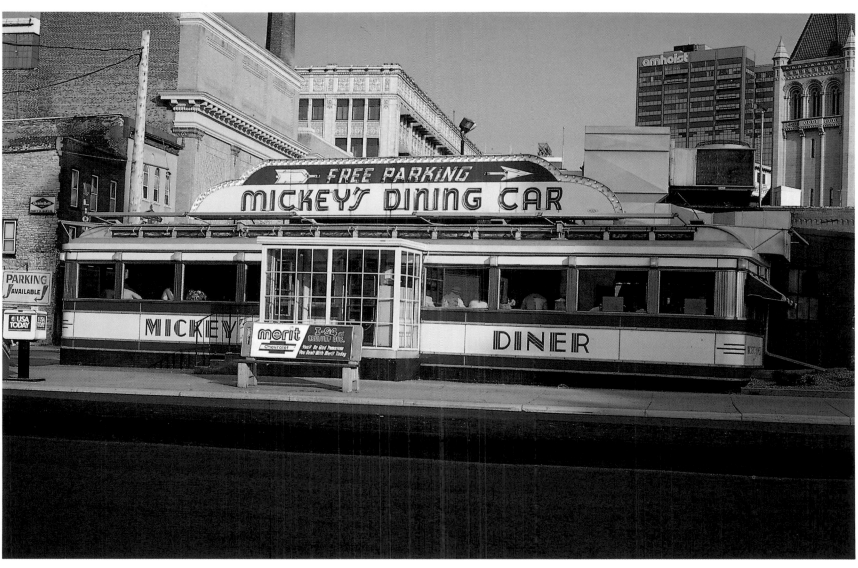

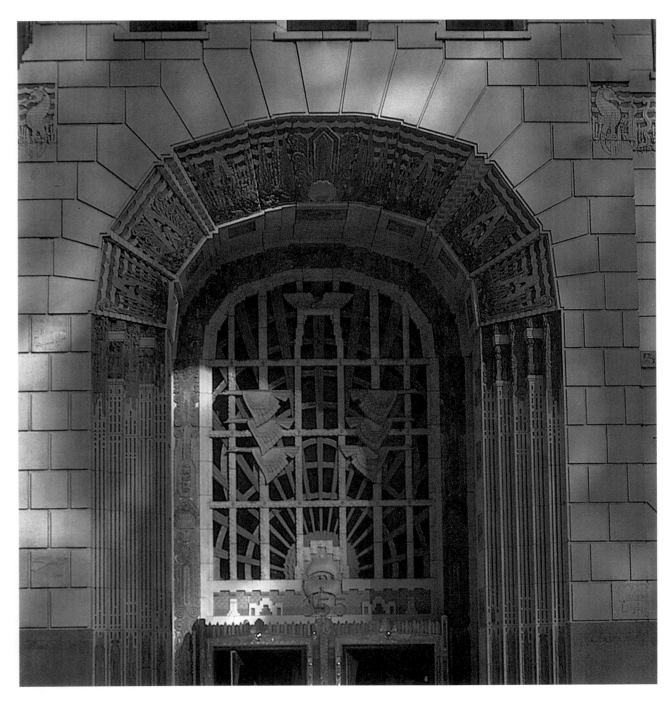

LEFT AND BELOW: *Canada's economy flourished after World War I and produced a large body of Art Deco architecture, including Vancouver's crown jewel, the Marine Building (1929-30) by McCarter & Nairne. The West Coast's tallest structure for many years, the zigzag-style office building was richly embellished with modernistic ornament on nationalistic themes, as well as with panoramas of the history of transportation.*

To the north, Canada also built an impressive number of Art Deco structures in the form of civic, office and apartment buildings, as well as department stores and movie theaters. Although many were, unfortunately, demolished in the years after World War II, others survive as splendid reminders of the Art Deco era. Among the monuments erected were Vancouver City Hall; Toronto's skyscraper-style Permanent Trust Company building, Maple Leaf Gardens and Eglinton Theatre, still in continuous use; and in Montreal, the *Maison Cormier* and the University of Montreal designed by the Québecois architect Ernest Cormier.

In an era of unprecedented prosperity and intense nationalism, Canada's determination to forge a unique identity was reflected in the architectural ornament of such buildings as Vancouver's magnificent zigzag-style Marine Building with its terracotta panels illustrating the discovery of the Pacific coast, and Toronto's Concourse Building, with its stylized decoration of Indian and nature motifs by J E H McDonald of the avant-garde Group of Seven. Classical moderne was a frequent choice for the expanding banking industry in Canada as elsewhere, and regional and national motifs played a prominent role in their buildings. This development was exemplified by the Ottawa headquarters of the Bank of Montreal by Ernest Barott, and particularly by the buildings of John Lyle. Working mainly for the Bank of Nova Scotia, Lyle designed numerous banks in Toronto and in the provinces. The Calgary office was appropriately ornamented with imagery depicting the regional oil, grain and cattle industries, along with its characteristic cowboys and buffalo; while the truly opulent headquarters in Halifax featured some 86 different motifs based on the flora, fauna, industry and history of the maritime provinces and of the nation as a whole. Lyle, who also designed metalwork and furniture, deliberately set out to create a distinctively Canadian style.

RIGHT: *The Expressionists were not only a source of ideas for Art Deco architecture, but they shared as well an interest in cosmic imagery, as seen here in Taut's vista from* Alpine Architektur *(1919).*

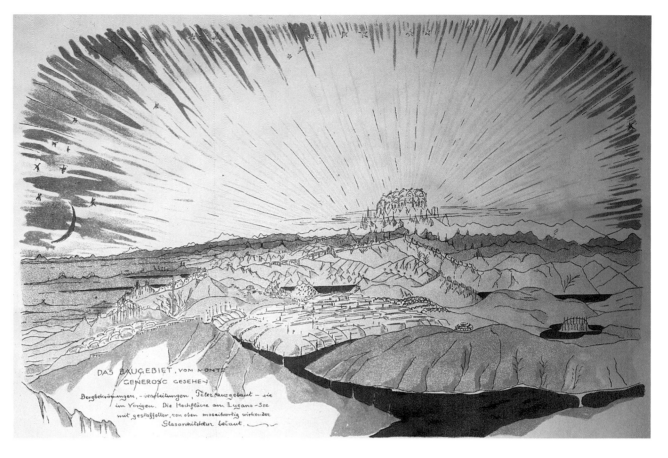

BELOW RIGHT: *In Paris, Auguste Perret's* Théâtre des Champs Elysées *(1911-14) is an Art Deco monument, as are Bourdelle's influential sculptural relief panels.*

Continental Europe produced little to compare with the glamorous jazz-age architecture of the prosperous Americas. Germany, in the throes of an economic collapse in the aftermath of World War I, found that the austere designs of the functionalist Bauhaus designers provided a low-cost solution to the country's acute housing and industrial needs. The modernistically decorated cinemas of Otto Kaufmann, Fritz Wilms, Hugo Pal, Friedrich Lipp and others were a rare exception to the prevailing austerity. Isolated examples of Art Deco could also be seen in Berlin in Philip Schaefer's Karstadt department store (1929) with its twin setback towers and in Hans Scharoun's streamlined wing, complete with porthole windows, for his Breslau hostel (1929). Classical moderne was still a choice for civic structures such as Wilhelm Kreis's art gallery and planetarium in Dusseldorf and Paul Bonatz's Stuttgart railroad station. A more ornate classical moderne railroad station was designed for Basel, Switzerland, by Karl Moser.

By the early 1920s, the sculptural and picturesque Expressionist architecture of Hans Poelzig, Bruno Taut and Peter Behrens had run its course. It remained a source of ideas for Art Deco architects, however, and to the exponents of Czechoslovakian Rondo-Cubism, a modernistic, sculptural and folkloric style pioneered by Josef Chocol and Josef Gocar. Jiri Kroha's interior for Prague's Montmartre Club (1918) might, in its extravagant modernist decor, be considered almost Art Deco. Also related to Expressionism were the unusual buildings of the Amsterdam School, adorned with stylized sculpture and decorative brickwork. Cross influences with Art Deco could be seen in the interior of the Tuschinski Theater (1920-21) where, in the midst of the characteristic jagged and organic Expressionist motifs was a leaping gazelle. American Art Deco was suggested in G W Van Henkelholm's 1920-22 Utrecht office block with skyscraper-style setbacks. Classical moderne was still a popular style for Dutch public projects such as H G J Schelling's Bussum railway station and Willem Dudok's series of buildings in Hilversum. Dudok's austere reworking of classical forms is exemplified by his 1928-31 clock-towered town hall, an asymmetrical grouping of cubic forms abstracted from classicism. Dudok's town hall proved influential both on the continent and in England, appealing to architects who sought a conservative modernism.

In France too, despite the exotic pavilions at the Paris expositions, classical moderne remained the primary expression of Art Deco. The first important design of Auguste Perret, noted for his pioneering innovations in reinforced concrete, was his transitional Paris Rue Franklin apartment building (1902), which was clad in stylized floral tiles between rectilinear structural members. Subsequent Perret pro-

jects included the *Théâtre des Champs Elysées* (1911-14), with sculptural ornament and interior murals by Emile-Antoine Bourdelle; his 1925 Paris exposition theater; his revolutionary Le Raincy church of Notre Dame (1922-24) with its geometric concrete grillework; and his monumental Paris Museum of Public Works (1937).

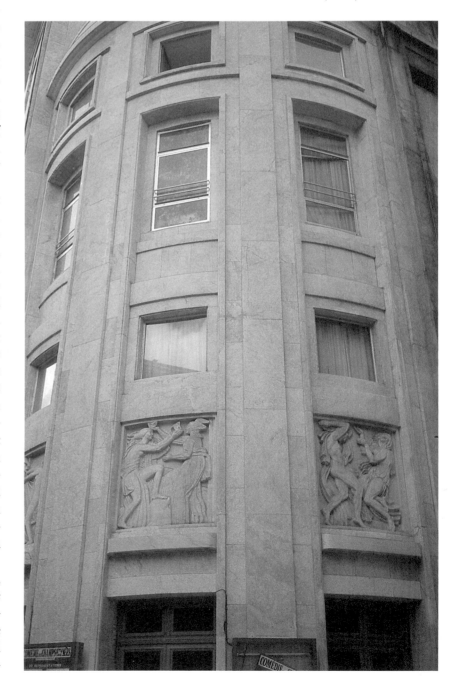

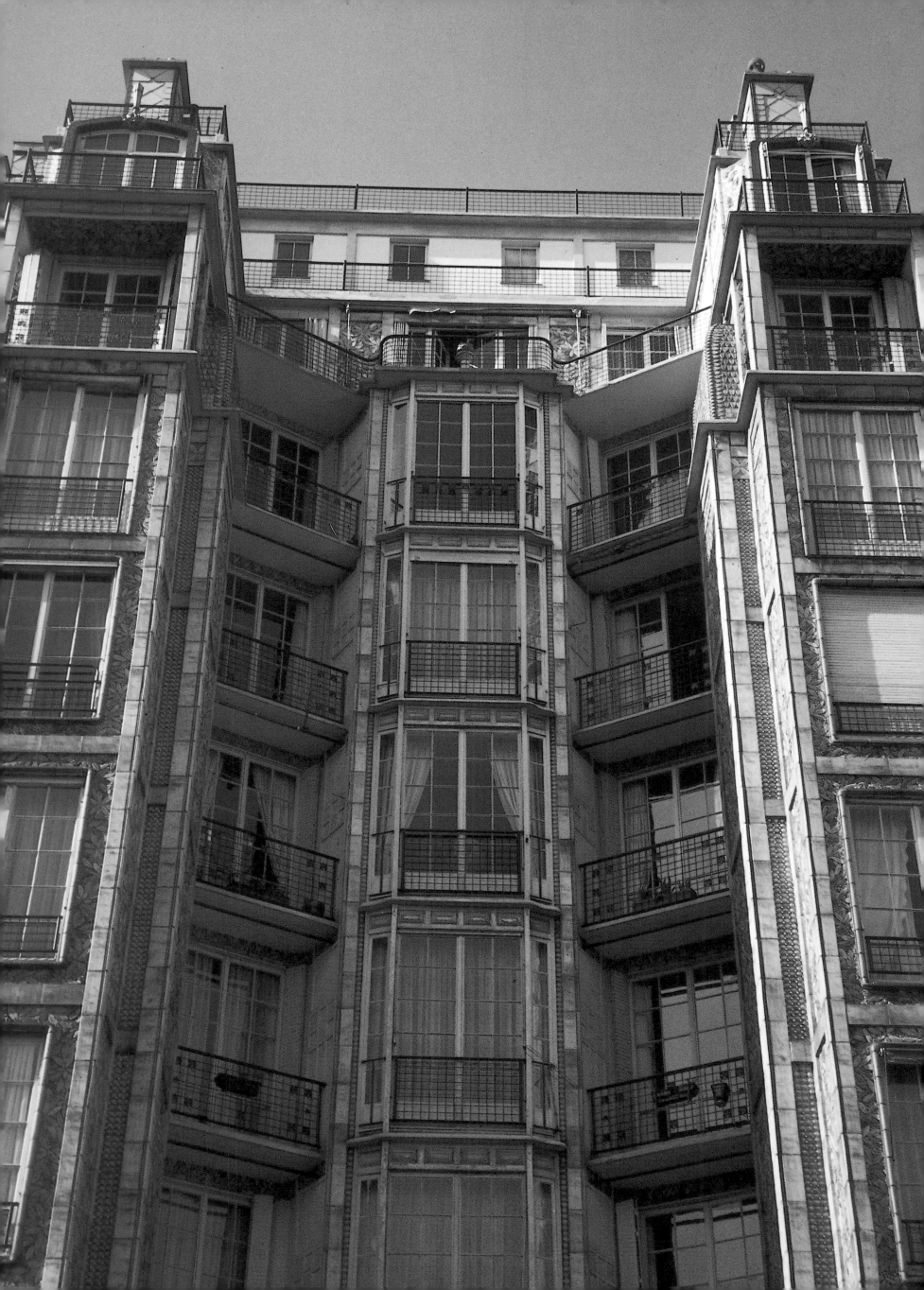

LEFT: *Auguste Perret's Rue Franklin apartment building of 1902 was a departure from his earlier Art Nouveau designs.*

RIGHT AND BELOW RIGHT: *Robert Mallet-Stevens created elegant designs reminiscent of Hoffmann's* Palais Stoclet *for a school and church in his* Une Cité Moderne.

The 1937 Paris exposition also saw the erection of the classical moderne and sculpturally ornamented Museum of Modern Art and the *Palais de Chaillot,* both by Dandel, Aubert, Viard and Dastuque. Among the other important classical moderne civic structures of the era was one of the most important European concert halls of the 1920s. The *Salle Pleyel* (1925-27) in Paris by André Granet sought acoustic excellence by means of a fan-shaped interior. Tony Garnier, author of the utopian *Une Cité Industrielle,* produced monumental structures of stripped classicism, including his municipal slaughter house at La Mouche (1908-09) and his Lyon Olympic Stadium (1913). A departure from classicism was attempted by Henri Sauvage, a collaborator on the 1925 Paris exhibition *Primavera* pavilion. In 1912, after working in the Art Nouveau style, Sauvage produced a remarkable pyramidal stepped-back Paris apartment building, a prototype for the zigzag style.

The white functionalist Cubist boxes of Adolf Loos and Le Corbusier were a major influence in the Art Deco era. They were interpreted in the spirit of Art Deco: romantically in *le style paquebot;* with discreet geometric or floral motifs in sculptural ornament, metalwork or glass in the apartment houses of Michel Roux-Spitz; or in the elegant amalgam of classical abstraction and austere functionalism typefied by the designs of Pierre Patout. Other French architects working in the mode of reinterpreted functionalism were André Lurçat, Gabriel Guevrékian, Jean Ginsberg, Djo Bourgeois and Georges Henri Pingusson.

Robert Mallet-Stevens was undoubtedly the most successful of these rationalists, as they were called. Prolific and eclectic, he produced a series of sophisticated designs for private homes, apartments, offices, public buildings, shops, factories and exhibition pavilions, as well as for film sets and furniture. He enjoyed collaborative design work and often commissioned leading artists and Art Deco craftspeople to create metalwork, glass, murals and furniture for his buildings. Probably the most radical French experiment in domestic architecture was the *Maison de Verre* in Paris (1928-31) by Pierre Chareau and Bernard Bijvoet. Inserted into an existing building, the combination of three-storey glass façades and exposed metal structure was a *tour de force* of machine-age design.

The Scandinavian countries possessed a strong tradition of abstracted classicism and, during the early decades of the twentieth century, restrained modernistic stylization and ornament brought their buildings into the realm of classical moderne. Typical, in Finland, was the work of Armas Lindgren, who left the partnership with Eliel Saarinen before 1907. Saarinen's Helsinki station was, of course, a proto-Art Deco monument. Representative of classical moderne in

Sweden was the elegantly ornate Stockholm concert hall (1926), along with earlier buildings, by Ivar Tengbom. Ragnar Ostberg's Stockholm Town Hall (1909-23), was in an abstracted medieval style, although it possessed ornamental interior detail reflecting the latest modernist trends. In a similar spirit in Norway was Oslo city hall, designed in 1920 and under construction from 1931 to 1950. Erik Gunnar Asplund, Sweden's major architect of the era, started out in the

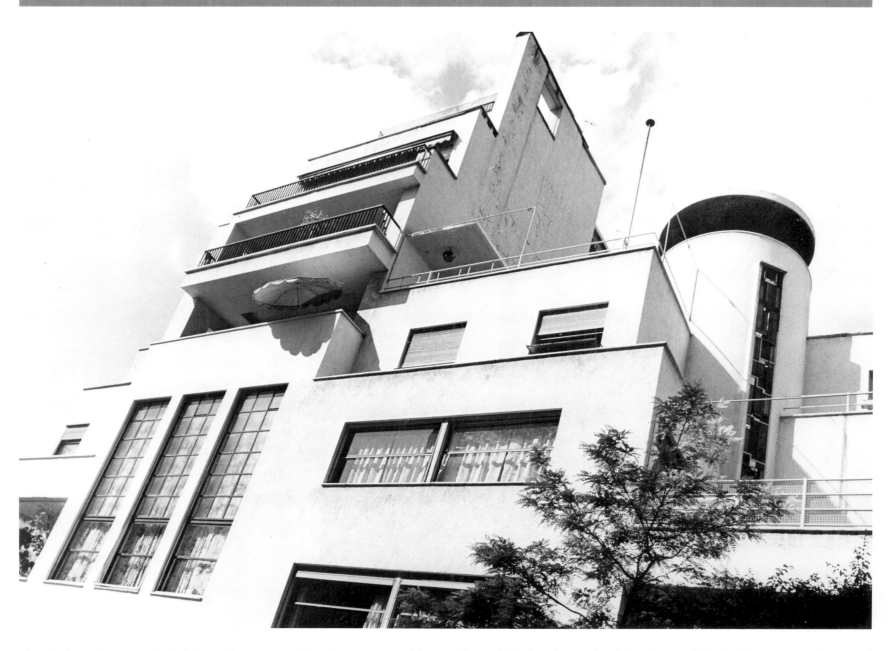

classical moderne mode. His Skandia cinema (1922-23) was notable, but his primary achievement was the Stockholm city library (1924-27), which took the form of a monumental cylinder atop a cube. Along with Dudok's Hilversum designs, this conservative Scandinavian modernist interpretation of classical forms was particularly attractive to British architects of the era.

In the British Isles during the last decades of the nineteenth century an innovative group of architects developed new interpretations of traditional forms and produced designs widely admired abroad. Under the aegis of the Arts and Crafts Movement, abstracted variations on medieval, vernacular and classical forms led to such remarkable proto-modernist designs as Arthur Mackmurdo's classical moderne house in Enfield, Middlesex (1883-88); Charles Voysey's Perrycroft house (1893-94); C H Townsend's Horniman Museum (1896) and Whitechapel Art Gallery (1901); Charles Rennie Mackintosh's work on the Glasgow Art School, beginning in 1896; and Edgar Wood's stylized Lindley Tower (1900-02), later followed by his Royd House in Manchester (1916), which is now cited as a pioneering Art

ABOVE: *While active in a wide range of areas, Robert Mallet-Stevens completed various commissions for imposing residences. A Paris street, on which a number of his houses stand, is named after him.*

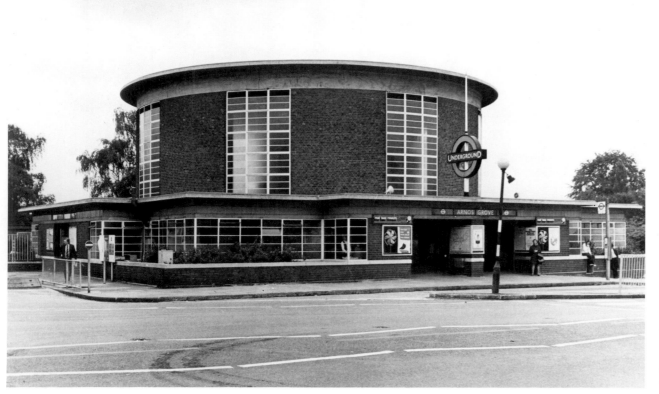

LEFT: *Charles Holden designed many buildings for London Transport, including Arnos Grove station on the Piccadilly Line.*

RIGHT: *The London Transport headquarters building by Holden was completed in 1929.*

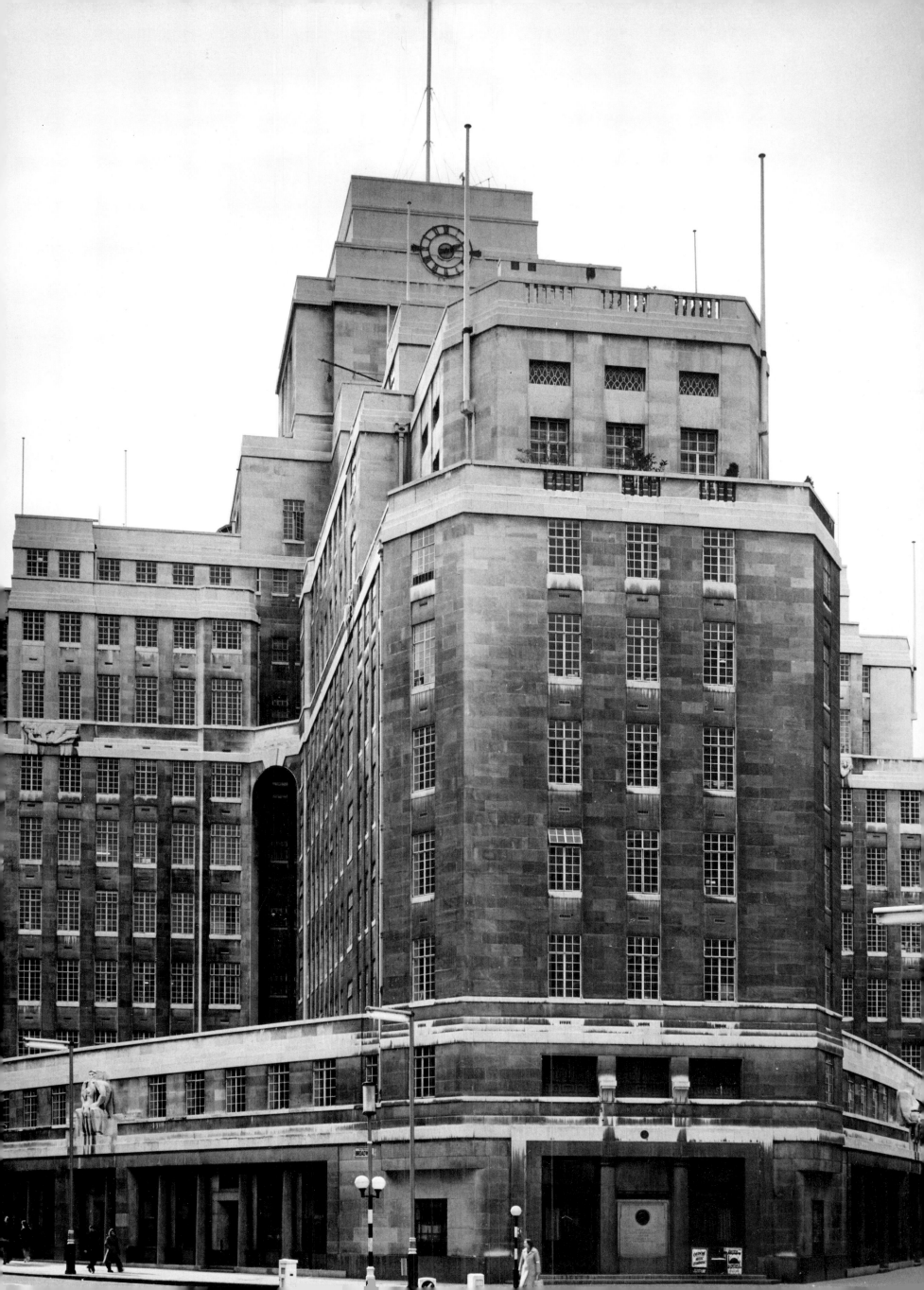

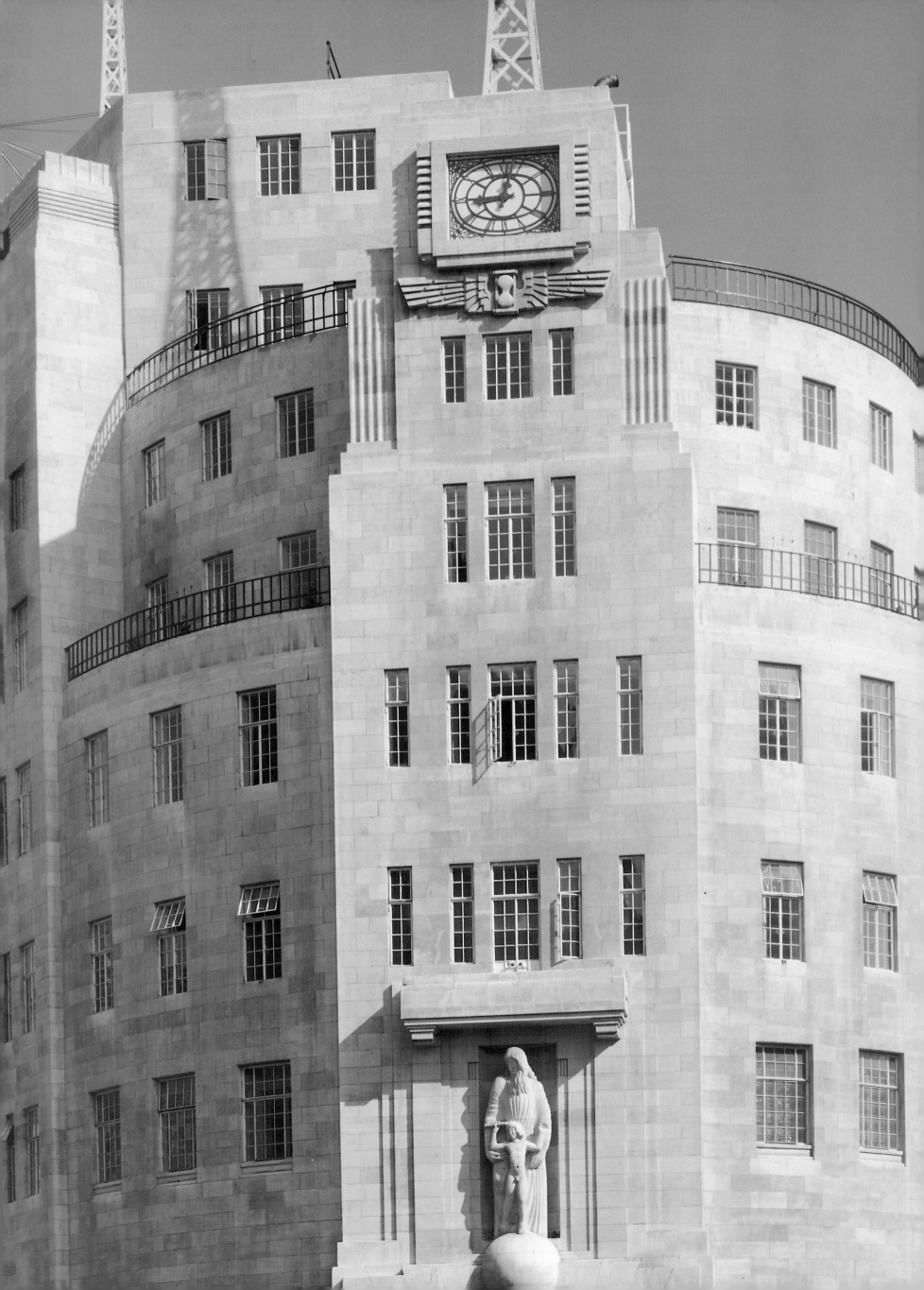

Deco design. A prolific country house builder to the nouveau riche, Sir Edwin Lutyens came to classicism late. Moderne or not, his essays in abstracted classicism include the final monuments of the British Empire. His inventive designs included several World War I memorials, the finest of which was the Memorial to the Missing in Thiepval, France (1923-25); the uncompleted Liverpool Cathedral; and foremost, New Delhi's Viceroy's House (1912-30), a palatial amalgam of Mughal and classical. Influenced by Lutyens in India was the truly extraordinary St Martin's Garrison Church (1928-30), a stepped-back Cubist monolith by Lutyens' assistant, A G Shoosmith.

One of the most active architects of the 1920s and 1930s, Charles Holden also started with the Arts and Crafts Movement. His inventive early works – the Soane medallion market hall design (1896), the Danvers Tower design (1897), the Bristol Library designs (1905-06), the British Medical Association building (1907) with sculpture by Jacob Epstein and, again with Epstein, the 1911-12 Oscar Wilde tomb in Paris – led to his mature classical moderne period. Holden's major work included, for London Transport, the stations on the Northern line, completed in 1927 and the 1932-34 Piccadilly Line stations, including the one at Arnos Grove so reminiscent of Asplund's Stockholm Library. A unique design was his London Transport headquarters (1927-29), a massive stepped, cruciform building enlived with the stylized sculptural reliefs of Epstein, Eric Gill and Henry Moore. In his projects, Holden tried to incorporate sculpture whenever possible. Another major classical moderne commission was Holden's Senate House for London University (1933-37).

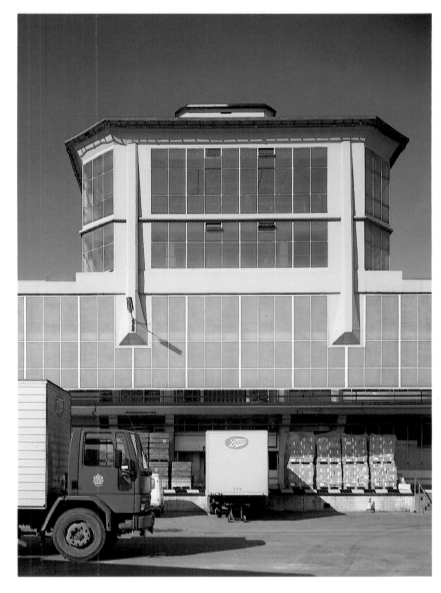

LEFT: *Val Myer's 1932 Broadcasting House for the BBC, with sculpture by Eric and Vernon Gill, is another monument of classical moderne architecture in London.*

RIGHT AND BELOW: *The Boots factory (1932) in West London, by Owen Williams, drew on the new ideas coming from the Bauhaus.*

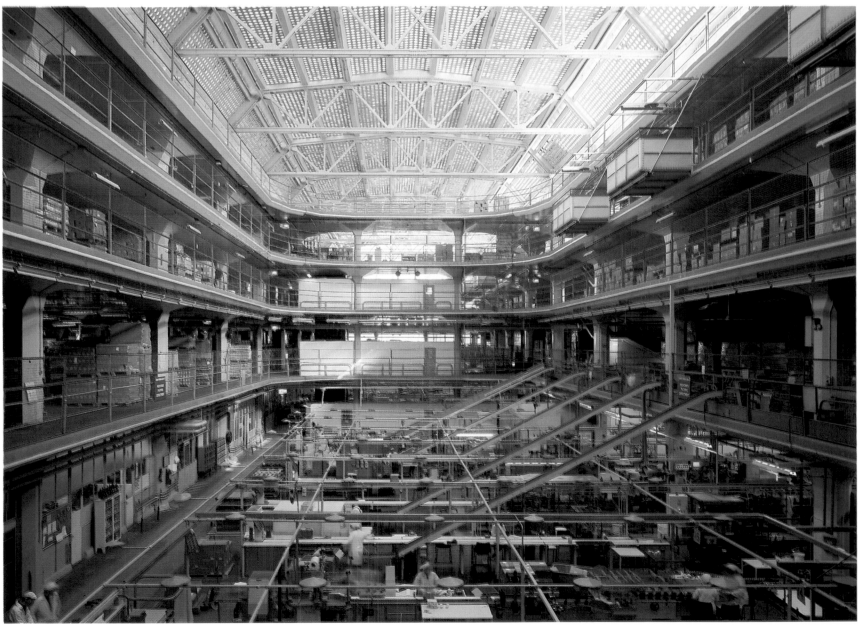

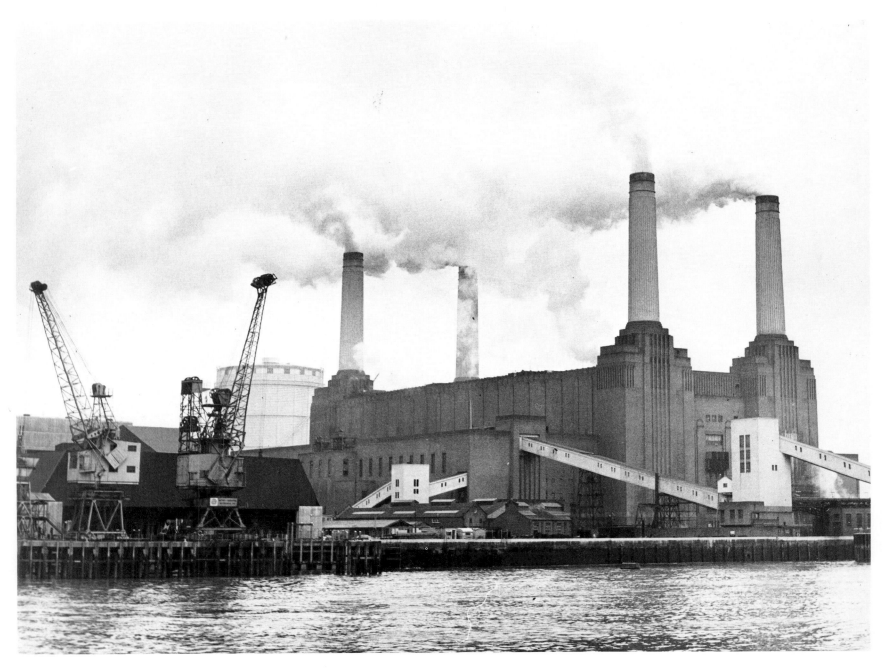

Monumental classical moderne also informed the 1929-1931 river-front remodeling of the gigantic Shell Mex building, as well as Val Myer's BBC Broadcasting House (1932), with sculptures by Eric Gill and Vernon Gill. Called a leviathan or a battleship of a building, Broadcasting House, like the London Transport headquarters, had to occupy a cramped site, which resulted in a similar adaptation of classical moderne with unusual angles and curves.

The other leading architect of the Art Deco years was Sir Giles Gilbert Scott, who came from Gothic Revival to combine modernist ideas with the high quality techniques and materials of traditionalism. Scott's major commissions in the classical moderne style included the library for Cambridge University, the New Bodleian Library for Oxford University, the new Waterloo Bridge and London's Battersea Power Station. Scott was hired on the basis of his previous work to allay initial protests at the intrusive siting of the power station on the River Thames. His successful aesthetic solution to this industrial problem – a design of elaborate parapets, decoratively fluted columns for smokestacks and bold symmetry – established the ideal for power stations over the next decades. Shortly after its completion, Battersea Power Station was judged in a newspaper survey as one of the most beautiful buildings in London.

Important buildings also were designed by the firm of Burnet, Tait & Lorne. Glaswegian Sir John Burnet, who had practiced simplification and abstraction in inventive buildings during the Edwardian era, produced with his partners an elegant, modernistic, classically massed, sculpturally adorned design for the Royal Masonic Hospital (1930-32). Thomas Tait, a fellow Scot who had studied under Mackintosh, later explored functionalist ideas and had also acted as a consultant on the jazzy *Daily Telegraph* building in London's Fleet Street (1928). But in the staider Edinburgh government building St Andrews House, Tait opted for the traditional grandeur of the classical moderne style.

Classical moderne was the preferred style for civic buildings outside London: in Scotland in Glasgow's Scottish Legal Building and in Edinburgh's Lothian House by Stewart Kaye, with sculpture by Pilkington Jackson; in Wales in Cardiff's Hall of Nations and Swansea's city hall by Sir Percy Thomas; in Liverpool's Royal Philharmonic Hall and the Mersey Tunnel ventilating station (with a touch of skyscraper deco) by Herbert Rowse. One of the most ambitious projects of the era was Stratford's Shakespeare Memorial Theatre by Elizabeth Scott, Chesterton & Shepherd. The simplified massing of the exterior recalled Swedish modernism while the ornament, including Eric Kennington's sculpture, was stylishly Art Deco.

A major architectural controversy centered on the competition for the new building for the Royal Institute of British Architects. Chosen from 284 entries, the winning classical moderne design by Grey Wornum was criticized by traditionalists as too modern and by modernists as too traditional, and by both as too influenced by Swedish neoclassicism. But with the passage of time, the RIBA building has come to be accepted as appropriate in its fusion of old and new, and as eminently suitable for its site. The lavish interior design included ornate metalwork, glasswork, wall paneling and floors of unusual and opulent materials, as well as extensive mural and sculptural programs by Raymond McGrath, Eric Gill, Eric Kennington and others.

The glitter and flash of the American-type zigzag style was seen far less but was not entirely unheard of. It was not only present in the hotel and restaurant interiors by Oliver Bernard and others, but also in building exteriors. An early model was Ideal House, later Palladium House, in London. With its sheer black granite and rich gilded floral motifs, it was a smaller version of architect Raymond Hood's New York American Radiator building for the same company. One architectural critic nicknamed Ideal House the 'Moor of Argyle Street.' Another design receiving much publicity was that by Ellis & Clark for the flagship of Lord Beaverbrook's press empire, the *Daily*

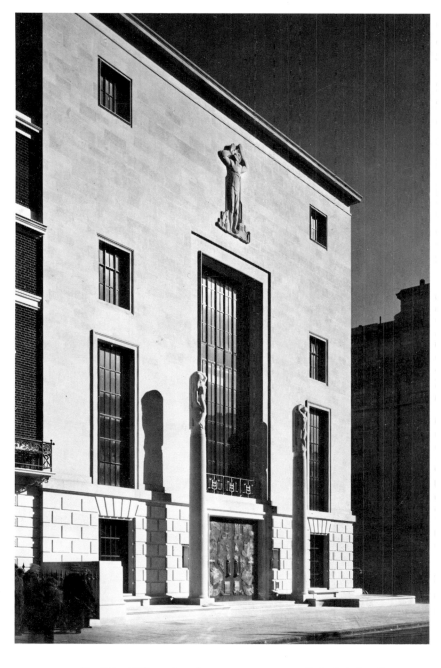

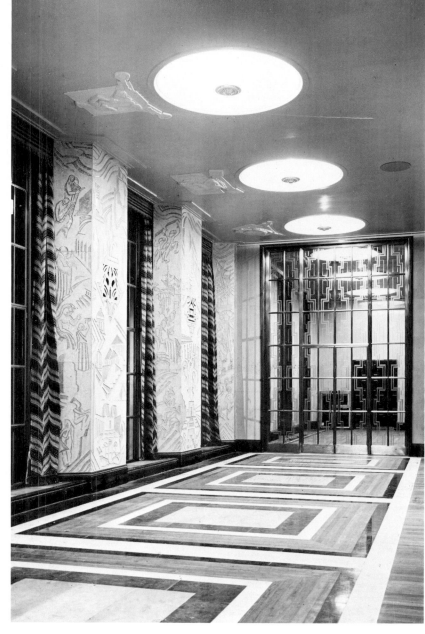

ABOVE LEFT: *Sir Giles Gilbert Scott's design for Battersea Power Station (1929-34) was declared one of London's most beautiful buildings.*

ABOVE: *Grey Wornum's dignified classical moderne design for the new RIBA building was selected from 284 competition entries.*

ABOVE RIGHT: *Britain's leading artists and designers of the Art Deco era collaborated on the interior of the RIBA building.*

RIGHT: *London's* Daily Express *Building owed its jazzy black glass façade and pyramidal profile to Owen Williams.*

Express Building. Owen Williams, brought in as a consultant, was credited in large part for the bold (and 'unneighborly') design of ascending setbacks with streamlined corners sheathed in horizontal bands of windows alternating with polished black glass. Robert Atkinson was responsible for the striking interior design. A similar effect was evoked by the new buildings for sister papers in Manchester and Glasgow. Williams, an engineer rather than an architect, was also the author of other important structures of the era, including the Boots factory (1932) and the Empire Swimming Pool at Wembley (1934), at the time the largest covered pool in the world.

'American style' was a title also applied to the Hoover factory and others along London's Great West Road and Western Avenue. By Wallis, Gilbert & Partners, the Hoover complex was an unusual and colorful combination of streamlined and zigzag deco. Besides the Firestone factory and the Pyrene factory, Wallis, Gilbert & Partners were also responsible for other new deco style buildings such as London's Daimler Car Hire Garage (now American Express), Victoria Coach Station and the Green Line Coach Station in Windsor.

The growth of aviation required new structures too. Art Deco provided an appropriate stylistic vocabulary for buildings such as the Imperial Airways Building in London (1939) by A Lakeman, and David Pleydell-Bouverie's streamline-style design for Ramsgate Airport which, with its swept-back wings, echoed an airplane in appearance.

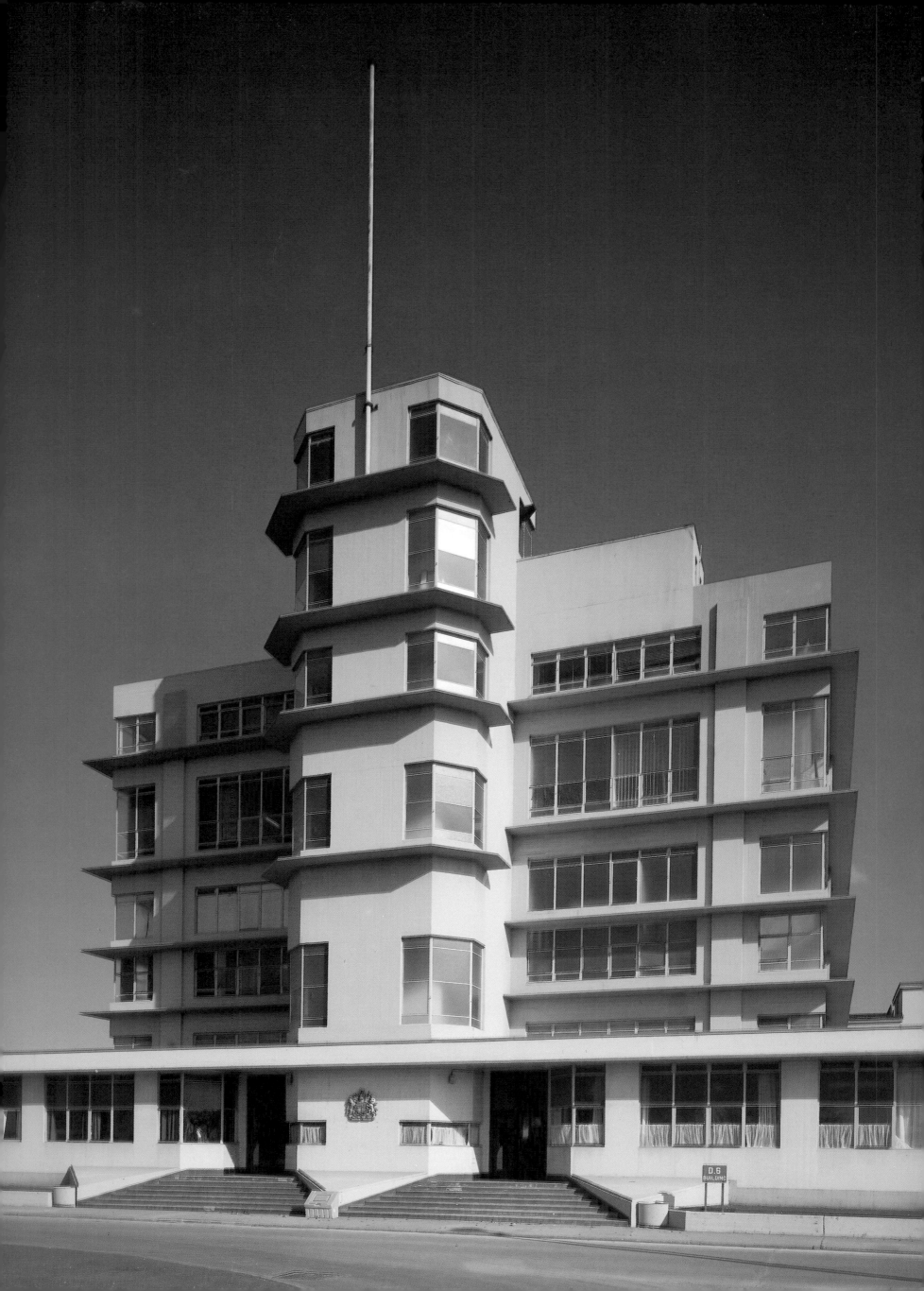

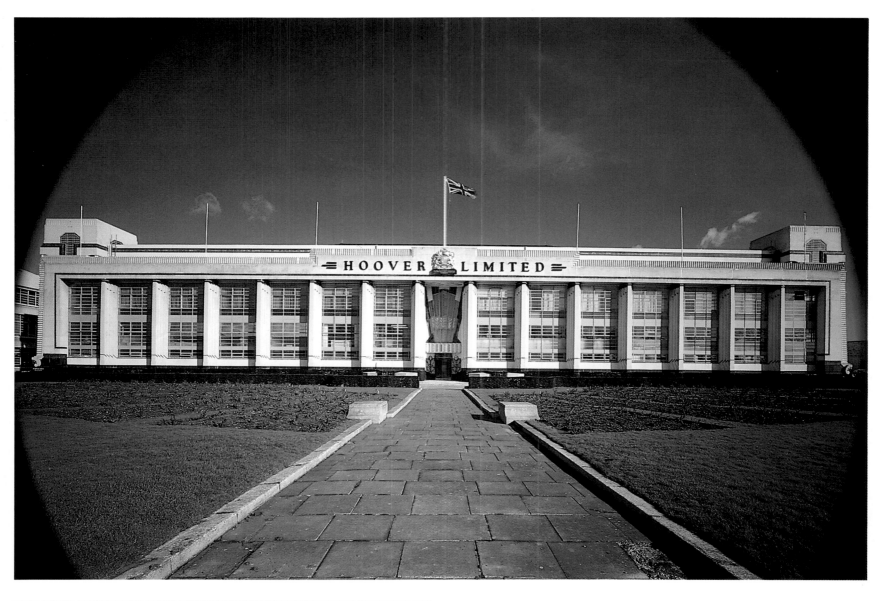

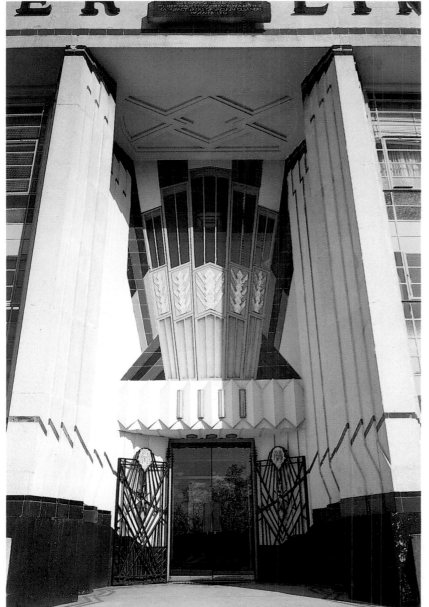

FAR LEFT: *Façade of the Boots factory by Owen Williams.*

LEFT: *The colorful Hoover factory was considered 'American style' by conservative British.*

ABOVE: *The Hoover factory (1932-35) in West London, by Wallis, Gilbert & Partners.*

BELOW: *Wallis, Gilbert & Partners designed the Firestone factory.*

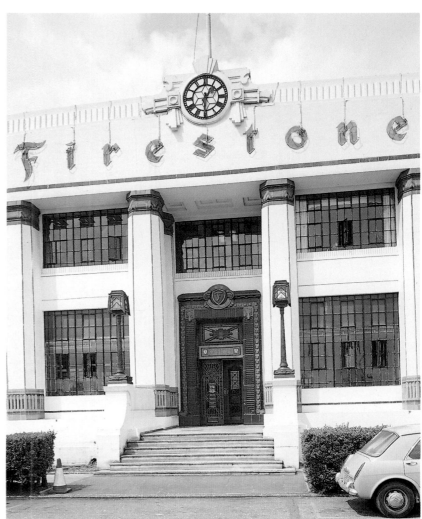

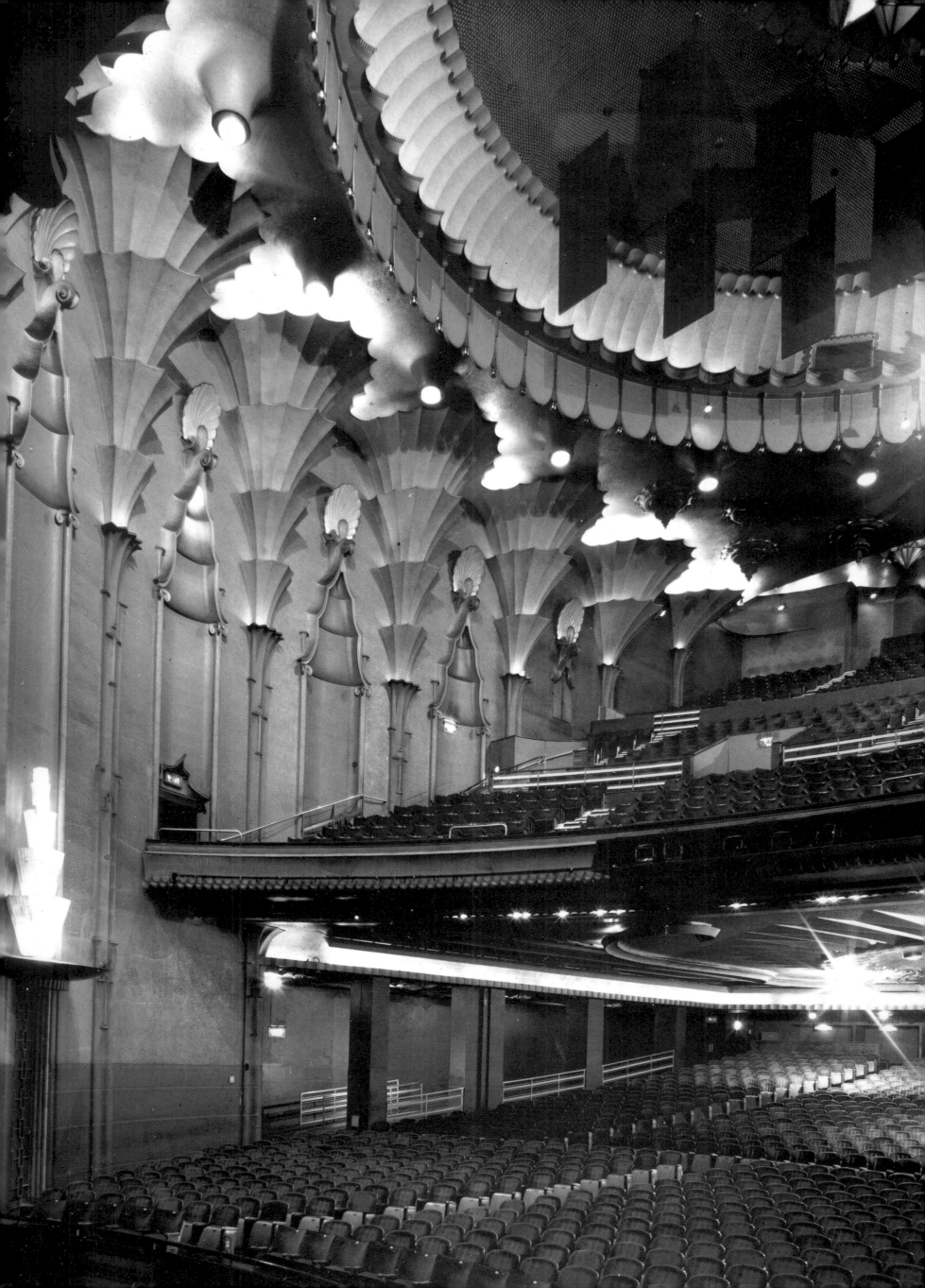

LEFT: *The New Victoria (1929-30) by E Wamsley Lewis was one of London's most spectacular Art Deco theaters.*

RIGHT: *The Dreamland cinema (1935) in Margate, Kent, by Iles, Leathart & Grainger epitomized the streamline style.*

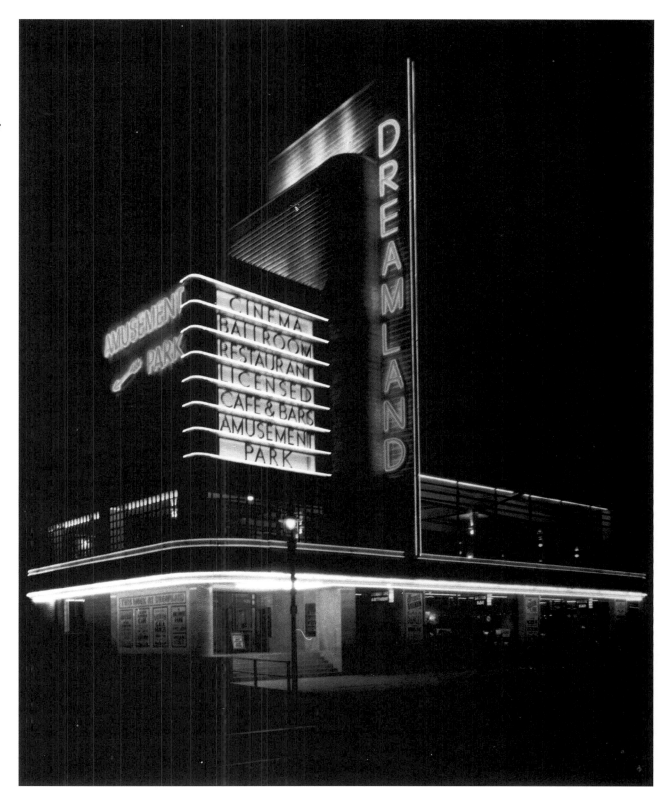

The streamline style came to have many applications. Not only was it used in religious contexts such as the Manchester church of St Nicholas by Welch, Cachemaille-Day & Lander, but it also became increasingly popular for the growing body of roadside architecture that developed for the automobile culture. Streamlining even brought a modernist flair to the traditional British institution of the pub – a prime example was E B Musman's Hatfield 'Comet' road house with an interior design of aviation motifs and sculpture by Kennington – as well as to a new generation of resort architecture. With its pastel hues and nautical flavor, the Showboat Lido in Maidenhead was an adaptation of American tropical deco.

During the 1930s, shop and restaurant owners looking to update their outmoded shop fronts provided a sizeable business for modernist architects and designers. Leading architects such as Burnet, Tait & Lorne designed an elegant streamlined façade for a Glasgow men's shop; Walter Gropius and Maxwell Fry produced a curved façade of glass block and vitrolite for a London electric shop; Joseph Emberton transformed a Regent Street tobacco shop; Frederick Etchells did Jaeger's in Oxford Street; Raymond McGrath designed for the Polyfoto shops; and Oliver Bernard created an exciting deco exterior and interior for the Lyons Corner Houses. A similar transformation occurred abroad where in Paris, for example, Robert Mallet-Stevens consulted on the design of two shop fronts and Pierre Patout designed others. Hotels and department stores were also important

clients for new buildings. London's leading deco style hotels included the Savoy, Claridge's, the Cumberland and the Dorchester; and among the department stores were Derry & Toms, Simpsons and Peter Jones, while Selfridges commissioned Edgar Brandt to design lift interiors in the early 1920s.

The burgeoning film industry gave rise to a large body of Art Deco cinema architecture, one of the finest examples of which was London's New Victoria cinema by Wamsley Lewis. Certain architects concentrated exclusively on cinemas; R Cromie, for example, who designed the Ritz in Southend, Essex (1934), was a leader in the field of independent cinema design, producing over 50 theaters from 1928 to 1930. With the advent of the talkies in the late 1920s, good soundproofing and effective acoustics became a priority. Another new development, neon lighting, came to be widely employed for attention attracting cinema marquees. The streamlined cinema façades of the 1930s were frequently at odds with the palaces of escapist fantasy within, where Moorish, baroque and other themes rubbed shoulders with Art Deco in a riot of splendid illusions achieved through the use of plaster, paint and colored lighting effects. One of the most consistent exterior and interior programs was that developed for the Odeon circuit under Harry Weedon. The low-key modernist streamlining was both elegant and cost efficient, and the standardization of fixtures, furniture and design created a recognizable identity for the Odeon chain of theaters.

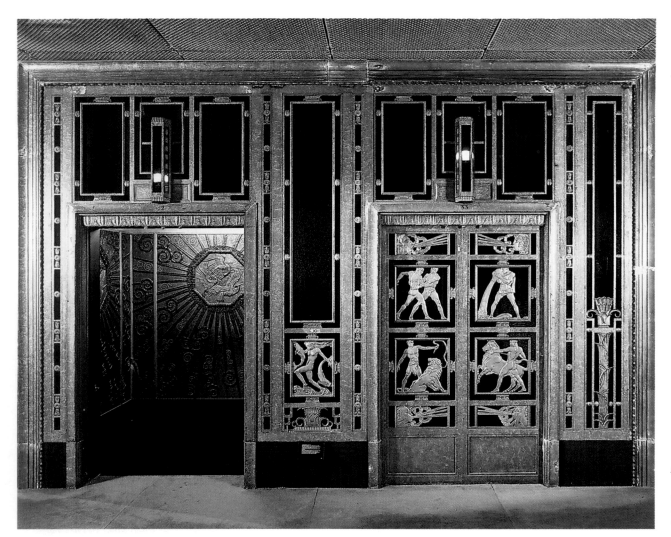

LEFT: *Edgar Brandt's splendid lift doors (1922-23) for Selfridges department store adapted motifs from classical mythology.*

BELOW: *The preliminary design proposed for the façade of the New Victoria Theatre by Lewis was an austere contrast to the elaborate sculptural decor later created within.*

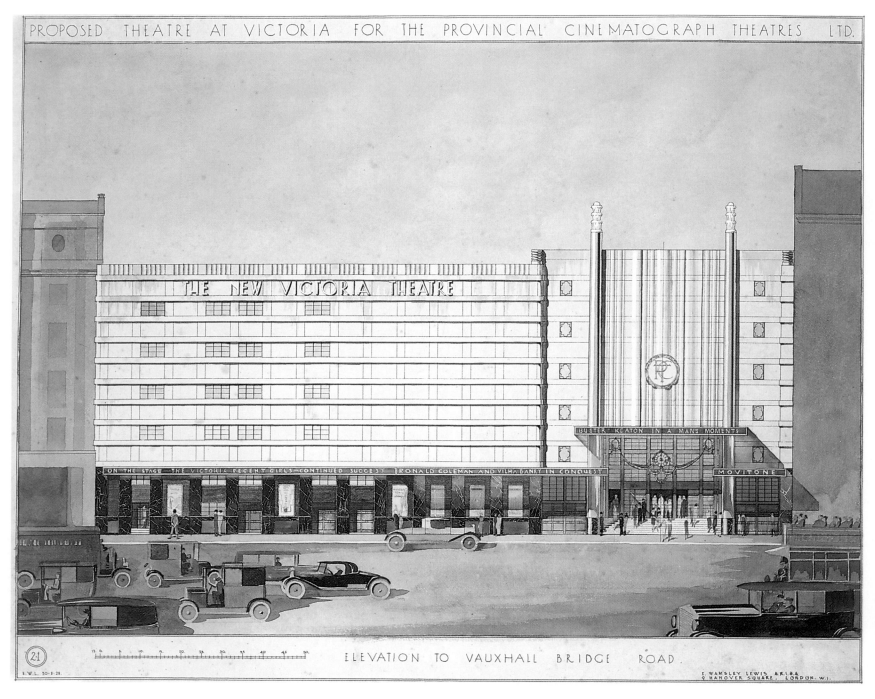

LEFT: *In Joldwyns (1930-32), Oliver Hill tempered the austerity of functionalism with curves and discreetly elegant ornament.*

BELOW: *Highpoint One (1936-38) in London was a landmark of the functionalism promoted by Berthold Lubetkin and others.*

Modernism, in the form of white Cubist boxes, had a limited success in England with its rainy climate. The decks provided little opportunity for sunbathing, the flat roofs often leaked, the concrete walls frequently cracked and the metal window frames soon stained the white walls beneath. In fact architects had to commission photographs of these buildings for their portfolios immediately after completion before the inevitable decay began to set in. To alleviate the blandness of the designs, architects and photographers soon became expert at devising dramatic lighting effects and using oblique angles.

Some architects came to modernism from classical moderne, as did Joseph Emberton when he pioneered the use of the steamship style in England with his yacht club of 1930-31. He had previously collaborated on London's Summit House, produced a new façade for the Olympia exhibition hall, and later went on to design Simpson's department store. A leading adapter of functionalism was the eclectic and fashionable Oliver Hill. Discreet deco ornament and detailing enhanced such private villas as Joldwyns (1930-32) and the more nautically flavored Holthanger (1933). Hill's Midland Hotel in Morecambe (1932-34), with decorative mosaics and sculpture by Eric Gill,

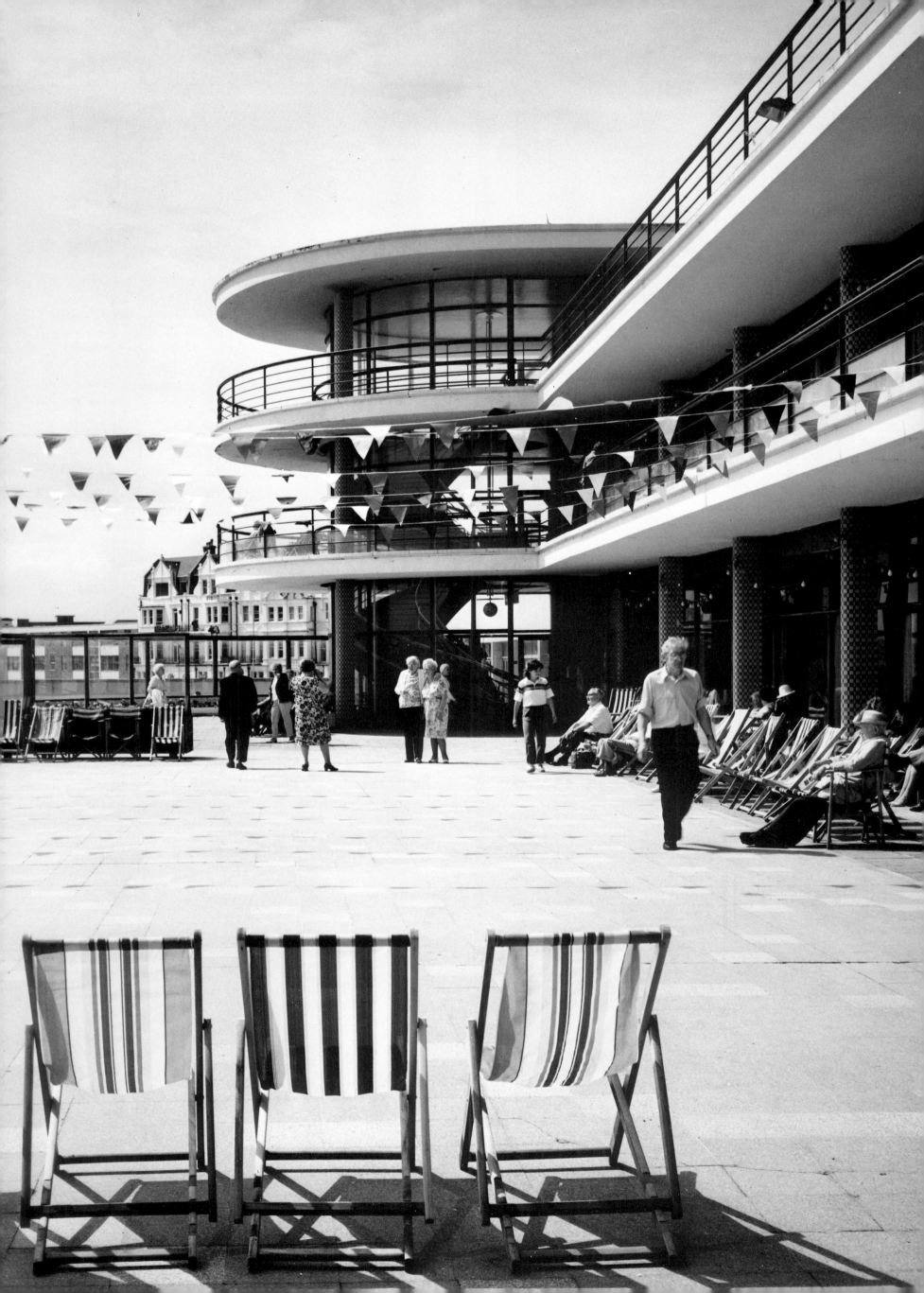

LEFT: *Serge Chermayeff collaborated with Eric Mendelsohn on the De La Warr Pavilion at Bexhill (1934-35).*

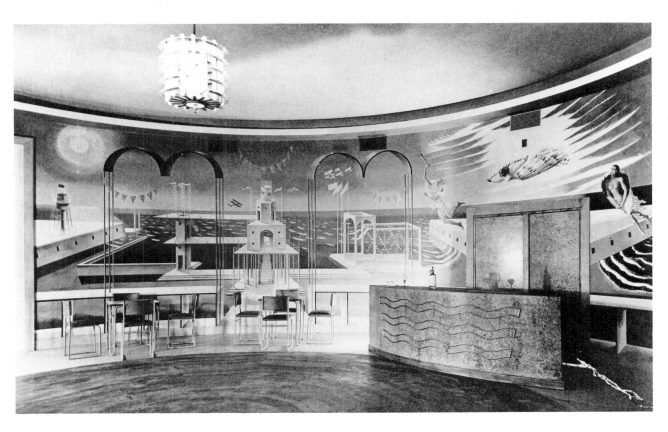

RIGHT AND BELOW: *In his design for the Midland Hotel in Morecambe, Lancashire, (1932-34), Oliver Hill emphasized luxury.*

was the first British hotel in the modern style. A later resort complex in a purer functionalist mode was Serge Chermayeff and Eric Mendelsohn's socialist pleasure palace, the De La Warr Pavilion at Bexhill, which became a source of some controversy because its designers were foreigners. Many functionalists were motivated by the socialist principles that informed Maxwell Fry, Walter Gropius, Erno Goldfinger and Berthold Lubetkin's public housing projects, although others were content to produce functionalist villas for the fashion conscious, as did Christopher Nicholson and Amyas Connell & Basil Ward. One of the first functionalist apartment buildings was the Lawn Road flats commissioned by Isokon from Wells Coates. Of monolithic reinforced concrete, these service flats for the well-heeled but foot-loose were completed just as the political emigrés from Germany began to arrive. The tenants came at various times to include Walter Gropius, Marcel Breuer, Moholy-Nagy, Siegfried Giedion and E H Gombrich, as well as Le Corbusier and Agatha Christie. Although many leading functionalists soon moved on to America, a more stringent functionalism, shorn of any remnants of ornament, developed and became an ideological expression of socialism. With its implications of low cost and efficiency, it supplanted Art Deco entirely in the years following World War II, not only in England but also in most of the rest of the world.

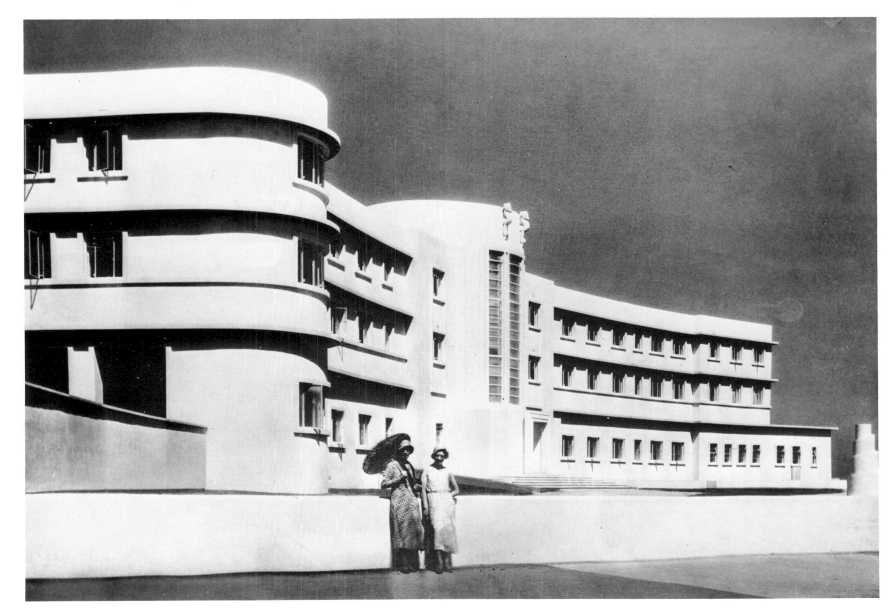

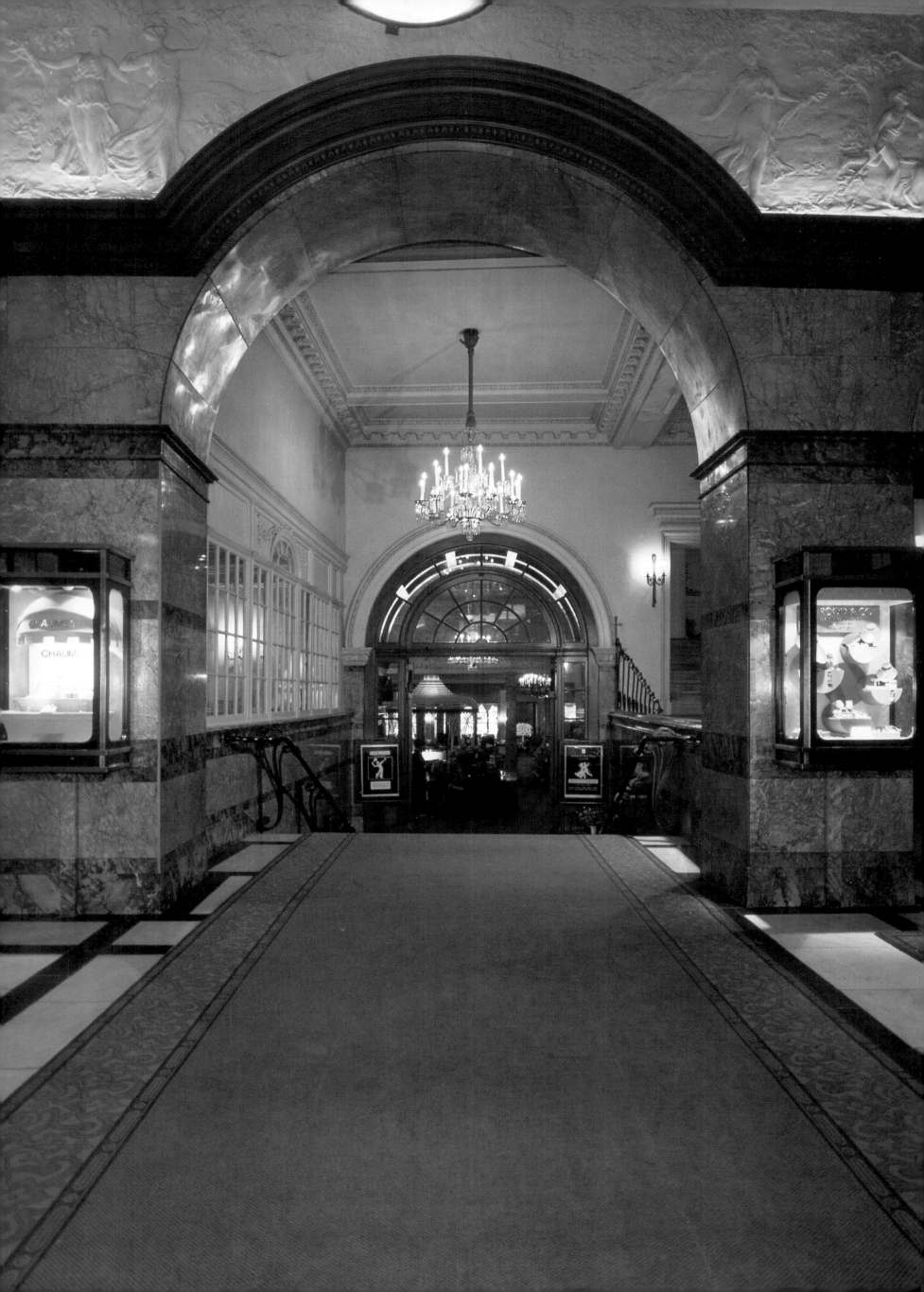

Furniture and Interior Design

LEFT: *London's Savoy Hotel
commissioned the era's leading
interior designers, including Basil
Ionides and Betty Joel, to create a
sumptuous aura.*

It is widely acknowledged that the greatest masterpieces of Art Deco furniture were those produced by the French. France had a tradition of furniture-making virtually unmatched in artistic inventiveness and almost overwhelming opulence. Though the patrons of furniture in the styles of Louis XIV, Louis V, Louis XVI and Louis-Philippe were inevitably aristocratic and necessarily wealthy, the names of makers, or *ebénistes* and *menuisiers,* such as André-Charles Boulle, Charles Cressent and Jean-François Oeben became household words throughout Europe.

The stylistic roots of Art Deco can be found in the linear, geometric purity of neoclassicism. This rebellion against the gilded and curvilinear excesses of the baroque and rococo began, paradoxically, as the style of Madame du Barry and the late Marie Antoinette, and enjoyed a relatively brief success in France. In its moralistic and intellectual rigor, neoclassicism predicted the Revolution in which many of the paragons of conspicuous consumption were beheaded. The austere Roman classicism of the directoire style that followed was soon subsumed in the late neoclassical self-conscious grandeur of Napoleon's ponderous empire style, which incorporated Egyptianate motifs commemorating his military adventures in the land of the pyramids. As orchestrated by Percier and Fontaine, with furniture by Jacob-Desmalter, the empire style was highly symbolic, responsive to contemporary events and developments, and a vehicle of collaborative total design in a way that foretold the concerns of Art Deco.

At the end of the nineteenth century, winds of change – this time artistic rather than political – swept Europe once again. Art Nouveau was a deliberate attempt to forge an entirely new style, free of all historicist motifs and associations with the past. As the decorative equivalent of the Symbolist movement in the arts and literature, French Art Nouveau was marked by the use of sinuous, elongated stylized plant and other forms derived from nature. The work of such French masters as Emile Gallé and Louis Majorelle owed much to rococo in its emphasis on the voluptuously decorative and the inventively fanciful; indeed Majorelle also made rococo reproductions. As its direct predecessor, Art Nouveau lent Art Deco its floral and faunal imagery, which arose from attitudes of asymmetrical languor and reassembled in syncopated ranks of kaleidoscopic geometry.

While the masterpieces of French Art Nouveau looked essentially toward the past, a more progressive form of the style evolved elsewhere – the culmination of decades of debate, led by the British Arts and Crafts movement, about standards of decorative design and about the impact of industrialization on the arts. The Art Nouveau furniture of the Austrian *Sezessionstil,* as practiced by Vienna modernist Josef Hoffmann and others, began to undergo an elegant linear styl-

ization while retaining an old-world opulence. Hoffmann's masterpiece was the *Palais Stoclet* in Brussels (1905-11). He not only acted as the architect of the building but also designed the luxurious unified furniture and accessories. By 1910 Hoffmann was making stepped, or ziggurat-shaped case furniture that was, perhaps, more Art Deco than anything else.

To the north, the secessionists of Munich – center of the German *Jugendstil* – began to design simplified veneered pieces recalling the furniture of the Biedermeier period. Although German furniture making had been through a neoclassical phase of its own with the work of David Roentgen, purveyor of classicist cabinetry to Marie Antoinette, Louis XVI and other crowned heads of Europe, the legitimate Germanic parent of Art Deco was the Biedermeier style. Pioneered by the Berlin architect Karl Friedrich Schinkel and the Vienna furniture factory owner Joseph Danhauser, Biedermeier flourished between the 1820s and the 1840s. Compared to the highly embellished aristocratic styles, Biedermeier – which was produced for the middle classes – was characterized by very restrained ornament, clean lines based on geometrically simplified forms, and light toned woods. To modern eyes, it looks a lot like Art Deco.

To the French critics who saw the new neoclassicist works of Munich Secessionists such as Bruno Paul at the 1909 Munich *Werkbund* exhibition or at the 1910 Paris *Salon d'Automne,* this furniture seemed clumsy and garish. They did admit, though, that they were impressed by the German concern with total design, or *Gesamtkunstwerk* and, in a climate where Art Nouveau was coming to be seen as increasingly decadent, the new German ideas did not take long to sink in. In 1911, after visiting Hoffmann in Vienna and German crafts schools during a grand European tour, Paris couturier and trend-setter Paul Poiret established the interior design studio Atelier Martine and, according to Erté's autobiography, 'launched the "Munich" style, as it was called at the time.'

The quintessential French furniture maker of the Art Deco era was Jacques-Emile Ruhlmann. Regarded as a 'magnificent anachronism' for the remarkable quality of his work in the long tradition of opulent French furniture, he established his own decorating firm in 1910. Ruhlmann's furniture, constructed of the finest materials by means of the most exquisite craftsmanship, fetched astoundingly high prices from wealthy sophisticates. His simple, elegant pieces, a modernistic variant of neoclassicism, were characterized by the use of rare veneers, exotic woods, discreet inlay of ivory or other materials, restrained ornament, a historicist vocabulary, and slender tapering legs often capped by silver 'shoes.' Ruhlmann's workshop artisans – masters of *ebénisterie* (cabinet making), *menuiserie* (joinery and

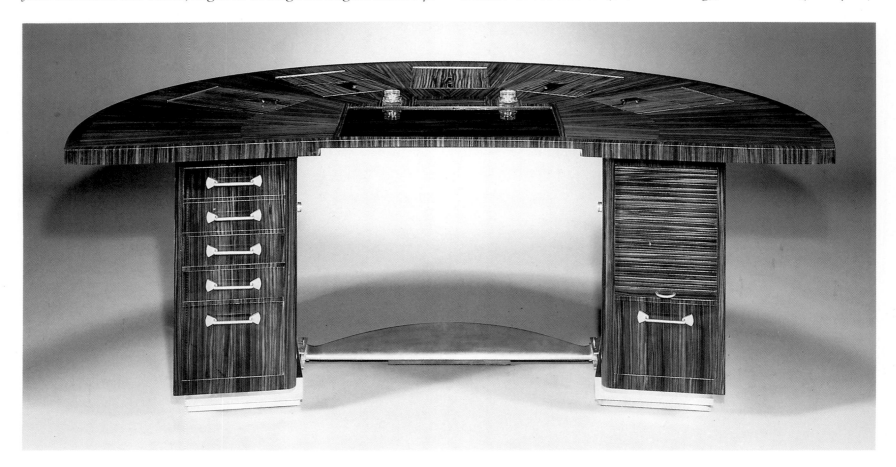

carved pieces), lacquer and upholstery – executed his designs with a degree of perfection that made Ruhlmann's *Pavillon d'un Collectionneur* at the 1925 Paris exposition a sensation. Despite the fact that Ruhlmann acknowledged the rise of functionalism around 1930 by using metals and plastic and by designing sectional pieces, his peerless furniture remained conservative, classic and essentially timeless.

An initial conservatism also typified the work of Jules Leleu, Clement Mere, Süe et Mare, and André Groult. The designs of many of those who made the transition from Art Nouveau to Art Deco – among them Paul Iribe, Leon Jallot, Paul Follot, Maurice Dufrêne, René Lalique, Louis Majorelle and Clement Mere – frequently used floral motifs. Paul Iribe helped to popularize the flower as a motif when his stylized rose came to symbolize the spirit of France during World War I. Jules Leleu, who opened a studio in 1922, often used the Iribe rose together with blond shagreen (sharkskin). Unusual materials such as shagreen, ivory, mother of pearl, galuchat, eggshell, ormulu, tortoiseshell, leather, painted parchment, snakeskin, exotic animal hides and silver and gold leaf often were featured in the French Art Deco furniture of the 1920s and earlier. Clement Rous-

seau, who began making furniture in 1910, used finishes such as lacquer, stamped and patinated leather and inlaid ivory – used previously in the making of snuff boxes – for the unique pieces he created for Baron de Rothschild and others.

In order to cater to a less exclusive clientele, Louis Süe and André Mare as Süe et Mare established in 1919 the *Compagnie des Arts Français*, an association of workshops and artisans like those found in Austria and Germany. Süe et Mare were known for well designed curvilinear furniture inspired by the Louis-Philippe period and available at affordable prices. In the years of transition from Art Nouveau around 1910, Majorelle and Léon Jallot also called on the Louis-Philippe period to help achieve a modernist simplification.

The large department stores played a major role in popularizing the Art Deco style by hiring Paul Follot, Maurice Dufrêne and others to head their newly organized modern design ateliers. Follot and Dufrêne had been among the pioneering designers showcased by the annual salons of the *Société des Artistes Decorateurs,* established in 1901. They began to move away from Art Nouveau around 1903, seeking out new design ideas in the neoclassical furniture of the late

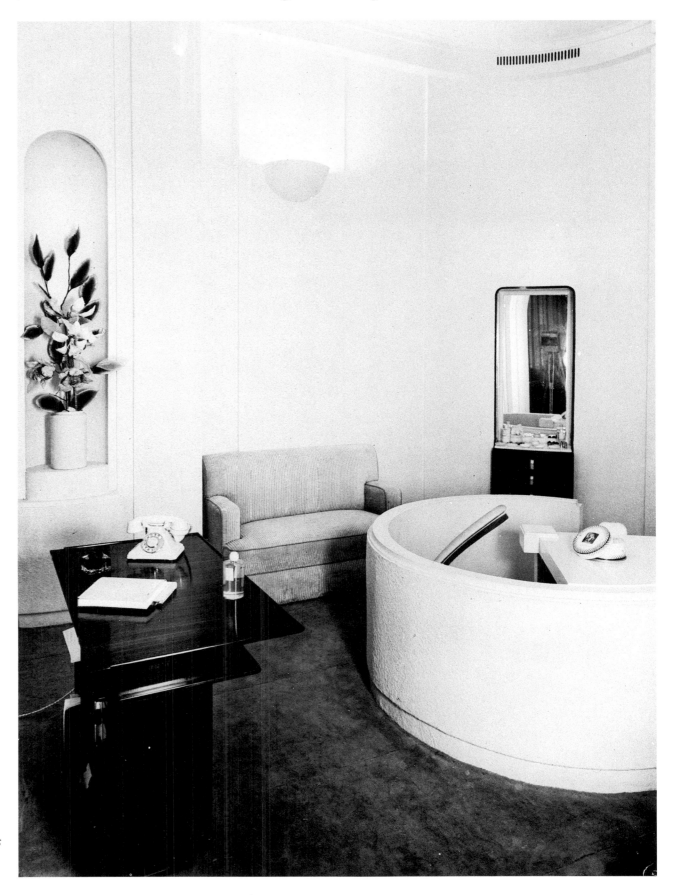

LEFT: *France's leading Art Deco furniture designer Emile-Jacques Ruhlmann created this ebony and gilt bronze desk in 1929.*

RIGHT: *Yardleys, under design director Reco Capey, refurbished its London showroom with furniture by Ruhlmann.*

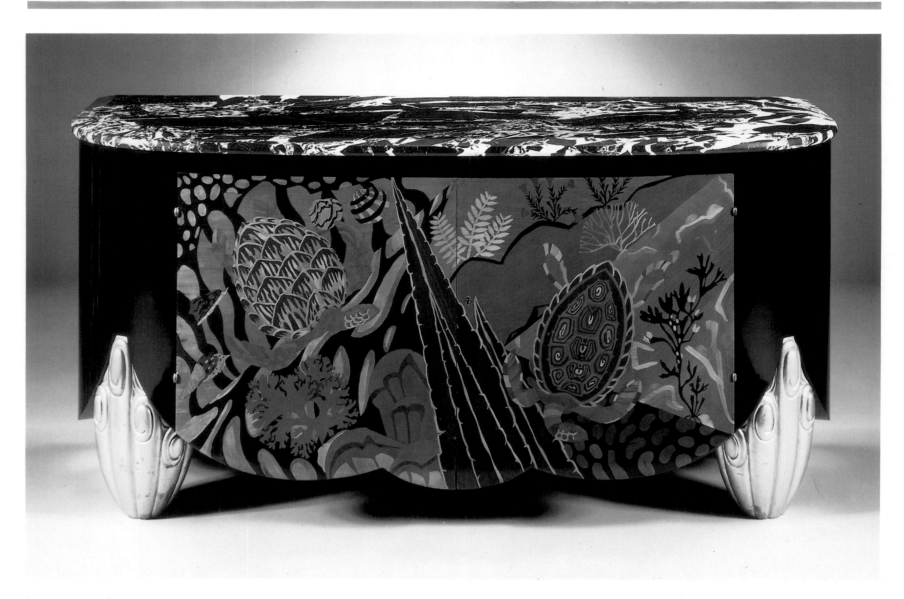

eighteenth century. In 1910 the salon exhibited the furniture of Ruhl-
mann for the first time. The years preceding the First World War gave
rise to traditionalist and floral versions of Art Deco. Follot, for
example, was known for his use of the fruit basket motif. Of the
department stores, the Magasin du Printemps was the first to found its
design workshop, Atelier Primavera, in 1919. Three years later, the
Galeries Lafayette followed by asking Maurice Dufrêne to head its La
Maîtrise, and Bon Marché hired Paul Follot to supervise Atelier
Pomone. The Louvre store set up Studium in 1923. These design
workshops produced not only furniture but also a whole range of
modernistic interior accessories in a unified style, and offered their
design services as well. They catered mainly to the middle-class
customer, but offered to take on exclusive commissions too.

André Groult, Poiret's brother-in-law, who earlier had explored
neoclassical variants of Art Deco, produced in 1925 some rather
unique pieces with swollen bombé forms covered in sharkskin and
detailed in ivory. The visual vitality of Groult's designs and of Art
Deco furniture in general owed something to the fact that many of
the leading Paris designers such as Ruhlmann, Louis Süe, Eileen
Gray, André Mare and Francis Jourdain had started out as painters,
while others such as Clement Mere and Jean Dunand had begun their
careers as sculptors.

Dunand came to the Art Deco style after World War I. His technical
virtuosity in lacquer work was recognized by Ruhlmann and Pierre
Legrain, who used his services. Besides his magnificent lacquered
folding screens (discussed in the chapter on sculpture and painting),
Dunand's workshops produced a whole range of luxury items in-
cluding jewelry, *dinanderie* – vases decorated with nonprecious
metals and lacquer – and furniture. His specialties included carved
lacquer and *coquille d'oeuf*, a technique of setting crushed eggshell
into lacquer.

Some of the more experimental French Art Deco furniture was
produced by designers influenced by the avant-garde art move-
ments. In the 1920s Pierre Chareau's angular and volumetric arm-
chairs clearly reflected Cubism, as did the geometrically stylized
pieces of Jean Michel Frank. And primitivism obviously was the root
of the sculptural exotic furniture, which was at times deliberately

*ABOVE: An ebony, marquetry, gilt-
wood and marble commode by
Süe et Mare, with doors decorated
after a design by Mathurin Meheut.*

*LEFT: A combination standing lamp
and display stand by Ruhlmann.*

*ABOVE RIGHT: A lacquered cocktail
cabinet by Paul Follot.*

*RIGHT: A 1925 dining room by Süe
et Mare.*

made in a crude manner in order to suggest tribal carvings, by Pierre
Legrain and Marcel Coard. Primitivistic furniture received a further
boost from the Paris 1931 international colonial exposition, and was
sometimes referred to as *le style coloniale*. The designs of Eileen
Gray, a British expatriate working in France, reflected various avant-
garde trends. Her 1930 *pirogue* (or canoe) sofa of lacquered wood

and silver leaf was a luxurious interpretation of a Polynesian dugout canoe, while through her Paris gallery Jean Désert, opened in 1922, Gray offered elegant screens, lighting fixtures, rugs and furniture. Some of her pieces reflected the influence of Cubism, others a more austere functionalist aesthetic.

The French focus on luxury Art Deco furniture was due in large part to the influential patronage of the leading Parisian couturiers Jacques Doucet, Paul Poiret, Jeanne Lanvin and Suzanne Talbot. The single greatest patron was Jacques Doucet who created a sensation in 1912 by suddenly selling off his collection of eighteenth-century art – including works by Houdon, Boucher, Fragonard and others – along with his antique furniture. Having decided to devote his attention to avant-garde art and to modernist designers, Doucet retained Paul Iribe to oversee the considerable project of redecorating and re-furnishing his Paris house, to be followed by a similar project at his villa in Neuilly. Over the following years, Doucet commissioned works by Iribe, Marcel Coard, Pierre Chareau, Rose Adler, Eileen Gray, Gustave Miklos, Clement Rousseau, Josef Czaky and Pierre Legrain. When Iribe departed in 1914 for the United States, Legrain took over the project.

Doucet was the first major sponsor of many of the leading Art Deco designers, encouraging some, like Legrain and Gray, to explore new directions. With Doucet's support during most of the 1920s, Legrain received the freedom to develop his ideas on primitivism in modernist furniture, while Gray was first hired in 1913 to make lacquered frames for Doucet's new art collection. She went on to create some very fine work for Doucet, including the lacquered screen, *Le Destin,* followed by other lacquered screens and tables such as the lotus motif table specifically requested by Doucet. Doucet, who had a special fondness for rare and exotic things, sometimes influenced designers to create some of their more unusual items for him. Between 1919 and 1922 Gray completed another important project in

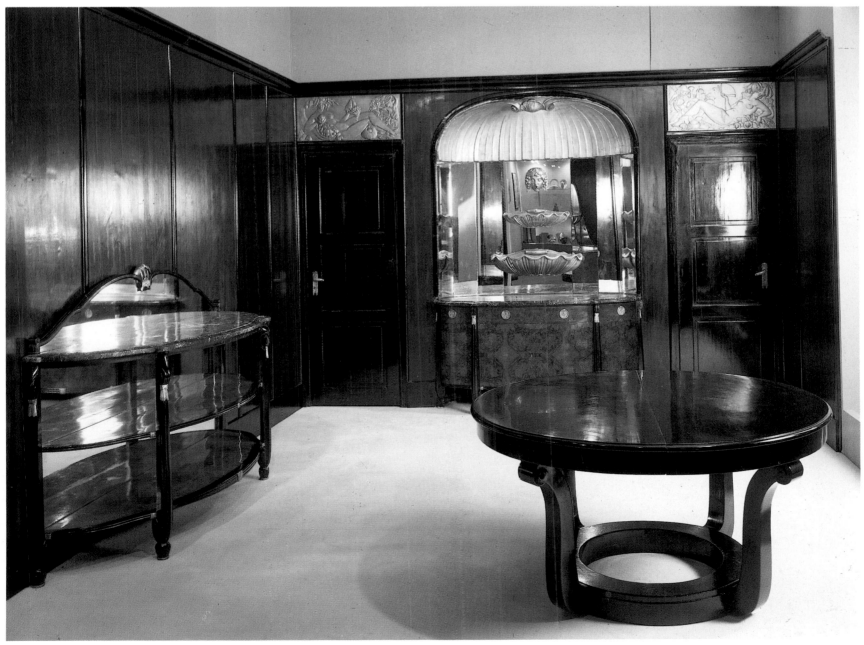

LEFT: *An ebony and rosewood commode attributed to Maurice Dufrêne.*

the design of the Suzanne Talbot's apartment, for which she created lacquer panels for the walls, carpets, lighting fixtures and plush furniture. In 1927 Gray turned to more austere furniture, influenced by the example of Le Corbusier, and to architecture as well.

Couturier Jeanne Lanvin commissioned interior decorator and furniture designer Armand-Albert Rateau to modernize her premises between 1920 and 1922. His stylish decor and furniture – notably in Lanvin's blue and floral bedroom, as well as her elegant new bathroom – became landmarks of Art Deco design. Some of the Lanvin furnishings are now in the Musée des Arts Decoratifs. Rateau was also interested in oriental and Pompeiian art and, as director of Lanvin-Décoration, went on to provide sumptuous settings for the Rothschilds, the Duchess of Alba, New York art collector George Blumenthal and many others.

Paul Poiret, who started out under Doucet, unquestionably reigned in the realm of style in women's fashion and interior design in Paris from 1915 to 1925. He hired Iribe, Georges Lepape, Erté, José Zamora, Raoul Dufy and others to execute and design illustrations, women's dresses, theater sets and costumes, textiles and domestic accessories for his fashion design house and for his interior design studio, Atelier Martine. Poiret was especially significant for setting the trend for such new modernist colors as tango orange, silver, black and the vibrant hues of the Russian Ballet.

With the 1930s came a rejection of ornament and a turn to ascetic metal furniture inspired by Le Corbusier and the Bauhaus, and a shift to mass production techniques. The *Union des Artistes Modernes*, founded in 1928, was in effect a secessionist group protesting against the ostentatious excesses of 1920s style French Art Deco design. René

LEFT: *Gustave Miklos was active, as were many other visual artists of the Art Deco era, in creating textile designs such as this wool carpet.*

RIGHT: *Pierre Legrain's cabinet dating from 1925 hints at his interest in primitivism.*

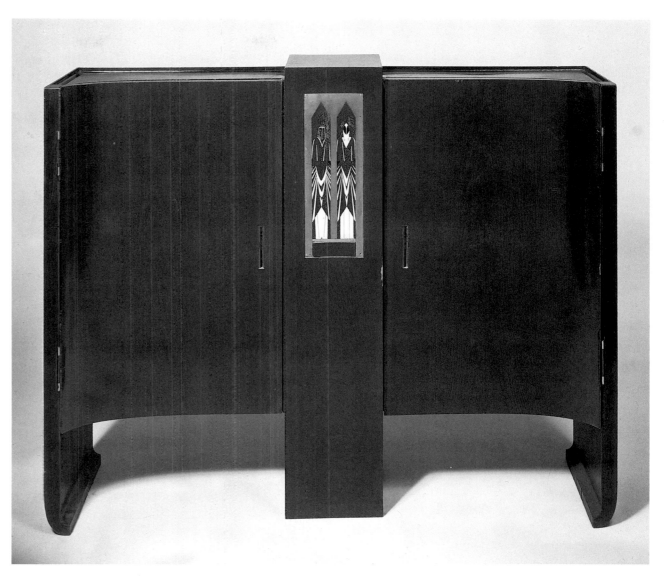

BELOW: *Eileen Gray's 1924 armchair looks ahead to the functionalism of the 1930s.*

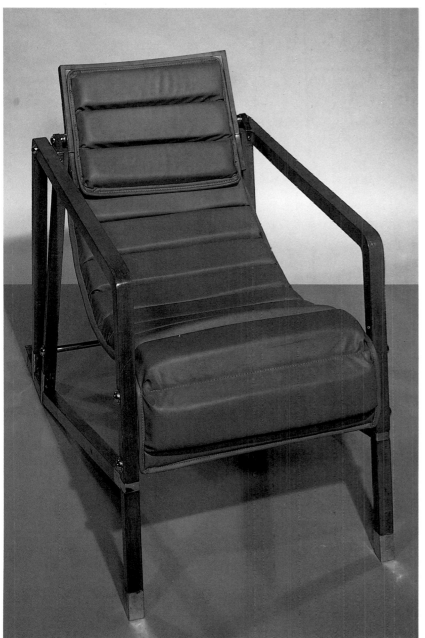

Herbst led the revolt; he was soon followed by Pierre Chareau, Eileen Gray, Robert Mallet-Stevens and others. The torch of aesthetic innovation had passed to the functionalists.

In the context of the totally designed Art Deco environment, textiles – not only in the form of upholstery, curtain fabrics and wall coverings, but also carpets and tapestries – played an integral role. Many of the design studios, including Poiret's Atelier Martine, Primavera and Pomone, produced lively textiles in stylized floral and other Art Deco motifs; Paul Iribe, Raoul Dufy, Robert Bonfils, Paul Rodier, Robert Mallet-Stevens, Marie Laurencin and Edouard Benedictus were also active in this field.

Some of the more abstract designs were produced by avant-garde artists such as Alexandra Exter, Jean Lurcat, Fernand Leger and, foremost, Sonia Delaunay. In 1912 she and her husband Robert had founded the school of abstract color painting known as simultaneism; she now adapted its geometric arcs, circles, discs and wedges, and its vibrant primary hues, to the field of textile design. Her first group of fifty textile designs for a Lyons company brought Delaunay fame in 1923, and led to collaboration with couturier Jacques Heim. Their designs at the *Boutique Simultanée* were a highlight of the 1925 Paris exposition. Some of her more memorable projects included the Citroën car she painted with a pattern matching a coat worn by its driver, and the coat of many colors she created for the Hollywood film actress Gloria Swanson.

The Art Deco years were a golden age for the ironsmith, or metalworker. Architects, designers, and shops provided a vast market for the elegant stylized gates, grilles, stair and balcony railings, elevator doors, radiator covers, lighting fixtures and other architectural adjuncts included in their unified design schemes. Among the French metalworkers were sculptors such as Jan and Joel Martel and noted *ferroniers* such as Raymond Subes.

The giant of this craft was Edgar Brandt, the creator of some of the finest metalwork of the modern age. Brandt, who founded his business in 1919, was known for his curvilinear designs of frozen fountains, stylized flowers and other nature imagery. These motifs appeared on the decorative panels, room dividers, screens, mirrors, lamps and console tables he designed in addition to architectural

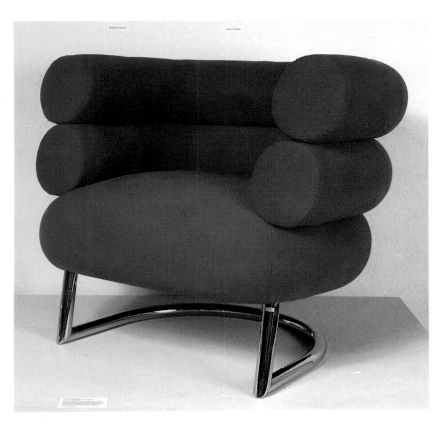

wrought iron, but also incorporated other metals such as bronze, steel and aluminum; the effects were widened further by gilding and patinating – the artificial induction of a film of green or brown oxide on the surface of the metal. In view of the relatively reticent, functionalist aspect of much of the French Art Deco architecture, Brandt's delicate metalwork was just the thing to give these buildings a tasteful touch of ornament or lend a commercial establishment that inimitable imprint of style. His entrance door to Poiret's Paris fashion house did just that.

Brandt also worked on many commissions abroad. An important one came from Selfridges store in London for wrought-iron and bronze decorative panels for the lift interiors (1922-23); after redecoration, these panels were given to British museums. His first New York project was for the Cheney Brothers textile store, where he designed not only the large doors of stylized florets and palm fronds surrounding frozen fountains, but also the wrought-iron 'trees' on which the silken fabrics were displayed. Ferrobrandt, his New York office, continued in business for some three years, bringing the essence of Parisian Art Deco to the New World. Another important New York building with French style ornamental metalwork was the Chanin building (1929); its opulent design was the work of Jacques Delamarre.

Brandt also produced lighting fixtures, some with glass shades by Lalique, Daum and others. His cobra lamp, which came in three sizes, was the most successful. The glass manufacturers also sold lighting fixtures with metalwork by Brandt and Majorelle, while many architects and interior designers created fixtures appropriate to specific environments, such as Armand Rateau's birds' heads lamp for Lanvin and Pierre Chareau's sliced alabaster lamps. Simonet Freres was an important source of Art Deco lighting, while Donald Desny and Jean Perzel came up with avant-garde models in the functionalist vein.

In French Art Deco, the concept of total design was perhaps best realized in the collaborative work by leading designers on those ostentatious anachronisms, the luxury ocean liners. Some of these palatial ships were planned during the 1920s but were not actually launched until the following decade. In contrast to the extravagant New York skyscrapers which came to completion after the Wall Street crash and hence lost many of the tenants they were intended to

items. His early studies as a jewelry maker as well as a smith certainly contributed to the exquisite quality of his work, which brought him major public commissions from the Louvre, the Banque de France, the Marseilles opera and for the eternal flame at the Tomb of the Unknown Soldier in Paris. The 1925 Paris exposition where Brandt's metalwork was seen everywhere, marked a turning point. His work there included the gates and doors for the Ruhlmann pavilion, the Porte d'Honneur and the *L'Oasis* screen of copper, brass and iron for the room he designed in the *Ambassade* pavilion. The acclaim and international exposure that Brandt achieved at this exhibition led to the opening of his own Paris gallery and of a New York branch which operated under the name Ferrobrandt.

Brandt executed both his own designs and those of others, and employed a large number of artisans to do so. He worked not only in

ABOVE LEFT: *Eileen Gray's 'Bibendum' steel and canvas chair (c 1929).*

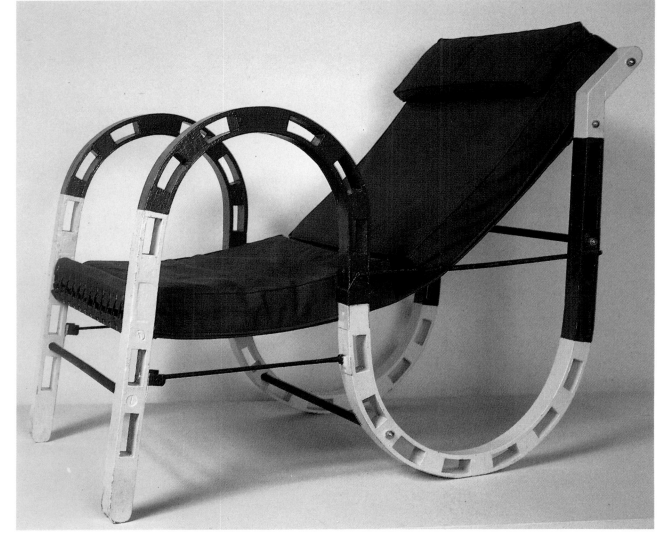

LEFT: *A wood and canvas armchair by Eileen Gray from the late 1930s.*

RIGHT: *A lamp with metalwork by Edgar Brandt.*

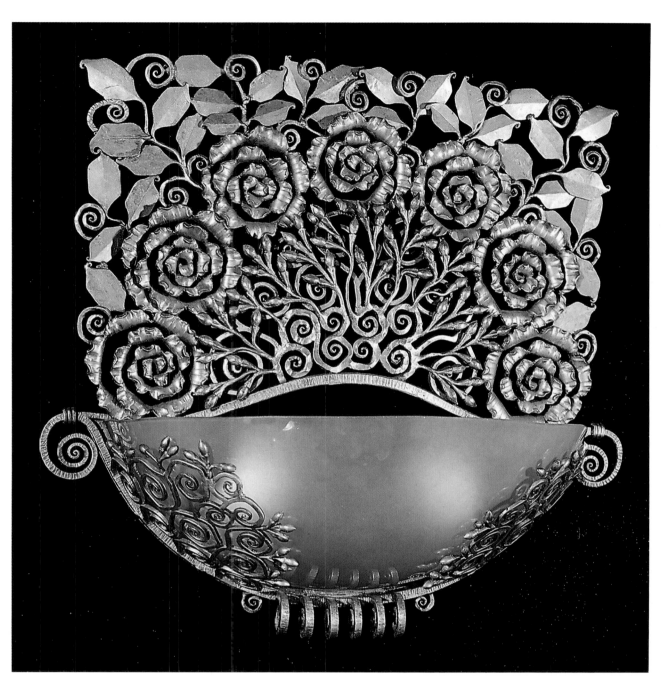

BELOW: *A detail from the set of ten murals designed by Jean Dupas for the French ocean liner* Normandie.

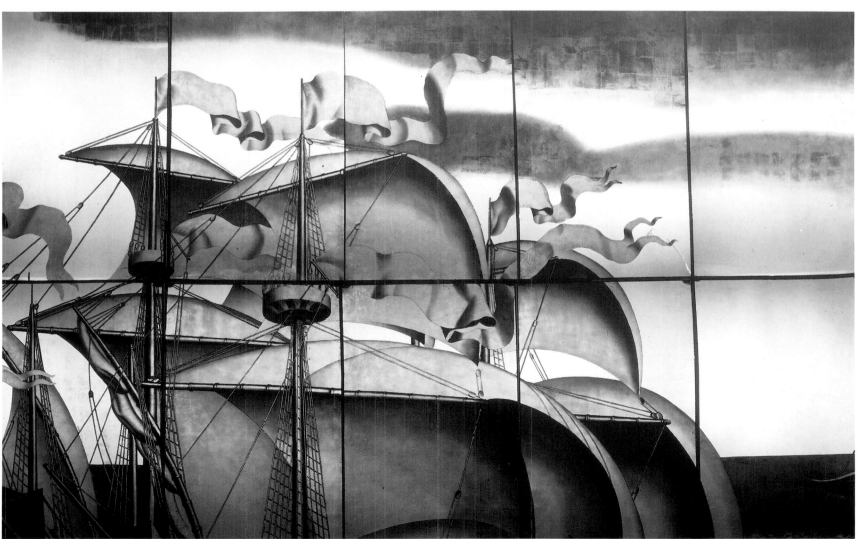

shops, children's playrooms, libraries, and even the brokerage offices through which capitalists on the high seas were able to track their vanishing fortunes in October 1929. The *Ile de France*, launched in 1926, was the first big liner built after World War I and it established the standard in modernist luxury. After intense competition, over 30 top interior designers were selected to collaborate in the decor and furnishing of such features as the 700-seat first class dining room by Pierre Patout, with molded glass light fixtures by Lalique and a dramatic entrance staircase with metalwork by Subes at one end; the main salon by Süe et Mare; the large Salon de Thé by Ruhlmann; the four-storey grand foyer with a concourse of tiered shops; and the deluxe bedroom suites, each of them the work of a different designer.

Even more than the *Ile de France*, the *Normandie*, which entered service in 1935, was intended as a floating showcase for the leading French designers, artists and artisans of the 1920s and 1930s. It was an opulent dream world, a fantasy enhanced by an etched and painted glass panel by Jean Dupas, colossal Lalique chandeliers, an enormous carved lacquer mural by Jean Dunand and Ruhlmann furniture in the more exclusive suites.

The atmosphere of gaiety and elegance on these ocean crossings – with celebrities, noblemen, Hollywood film stars, diplomats, musicians, vaudeville performers and members of high society on the passenger list – the shipboard revelry, entertainments, sports and romances, the festive embarkations and gala arrivals, were all part of a social ritual remote from the paltry comforts of contemporary first class air travel.

In the other European countries, Art Deco design never formed a broad based movement to the extent that it did in France. In avant-garde European circles, it was the functionalist aesthetic that soon came to dominate. This does not mean, however, that Art Deco furniture and related items were not made outside of France. That they were (though certainly to a rather limited extent) is documented by the design and architectural periodicals of the 1920s and early 1930s. From Germany, which published such important modernist journals as *Dekorative Kunst* and the Art Deco magazine *Styl*, came furniture and other Art Deco designs by Bruno Paul, Berlin cinema architect Oskar Kaufmann, *Werkbund* members Theodor Reimann and Waldemar Raemisch, designer Willy Lutz, and Darmstadt's prolific Josef Emanuel Margold, who produced a whole range of wares in the floral and Cubist styles, including chairs, lamps, metalware and ceramics. Italy's protean Gio Ponti, ever responsive to international design trends, created furniture, ceramics and interior designs, among them work for ocean liners.

Just before World War I, Czechoslovakia's Prague Art Workshop members Pavel Jonak, Josef Chochol and Josef Gocar sought to transmute Cubist ideas into architecture and furniture of crystalline forms and multiple planes, inspiring designer Vlastislav Hofman to proclaim that 'Form . . . is superior to function.' In the 1920s rather more conventional Art Deco designs were created by Prague architect Fritz Lehmann in glass, ceramics, metalware and interior decor. The Scandinavian giant of the decades between the wars was Finland's Alvar Aalto. His graceful, innovative blond-toned birchwood furniture of bent plywood was not precisely Art Deco, but it had much in common with the curves of streamlining.

Despite England's inherently conservative response to the excesses of decorative modernism, a surprising amount of activity revolved around the production and presentation of Art Deco furniture, particularly for hotels, restaurants, shops and style-conscious private clients. That very competent pieces of Art Deco (or jokingly, George V style) furniture were created in the late 1920s is testimony to British achievements in furniture design during earlier eras. The neoclassicism of Robert Adam was, perhaps, more influential on Art Deco furniture in its unity of design rather than its style. The designs of Hepplewhite and Sheraton, Thomas Hope's Egyptianate exoticism and the Regency style can all be seen as precursors of Art Deco, and the proto-modernist Anglo-Japanese designs produced in the 1860s by E W Godwin (whose work influenced Charles Rennie Mackintosh), followed by the elegant linear pieces of Ernest Gimson, had a distinctly 1920s look to them.

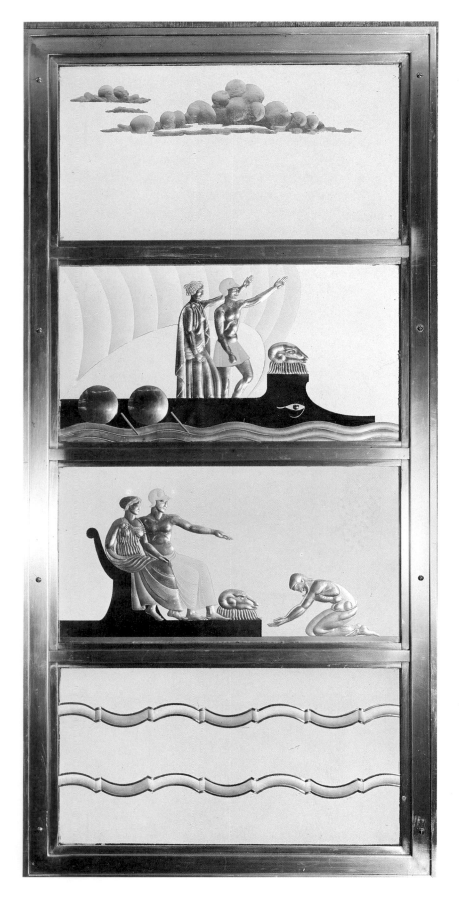

ABOVE: *Glass panels engraved with the legend of Jason and the Golden Fleece for the* Queen Mary *by Jacob Drew.*

house, the luxury liners had not yet been challenged by the airplane on the North Atlantic route and thus sped on through the waves, spectacular symbols of an already passing era. Although the names of such French ships as the *Ile de France* and *Normandie* evoke the essence of Art Deco, other nations produced somewhat more restrained variations on this theme, including such successful examples as Britain's *Queen Mary* and Holland's *Nieuwe Amsterdam*.

These ocean liners were not just a means of transportation; like the international expositions of the era, they were vehicles of chauvinistic pride that offered the best possible opportunity to publicize a nation's artistry and cultural authority. Nor were they simply floating luxury hotels either; they were more like floating cities of thousands of passengers and crew, who were serviced by restaurants, bars, theaters hospitals, chapels, barber shops, beauty salons, gymnasiums and other sports facilities, swimming pools, dry cleaning

RIGHT: Queen Mary's *tourist class swimming pool.*

BELOW: Queen Mary's *first class cocktail bar.*

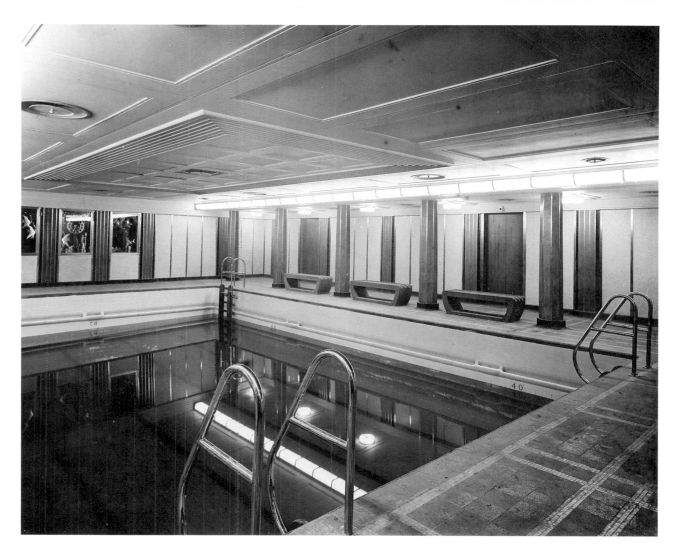

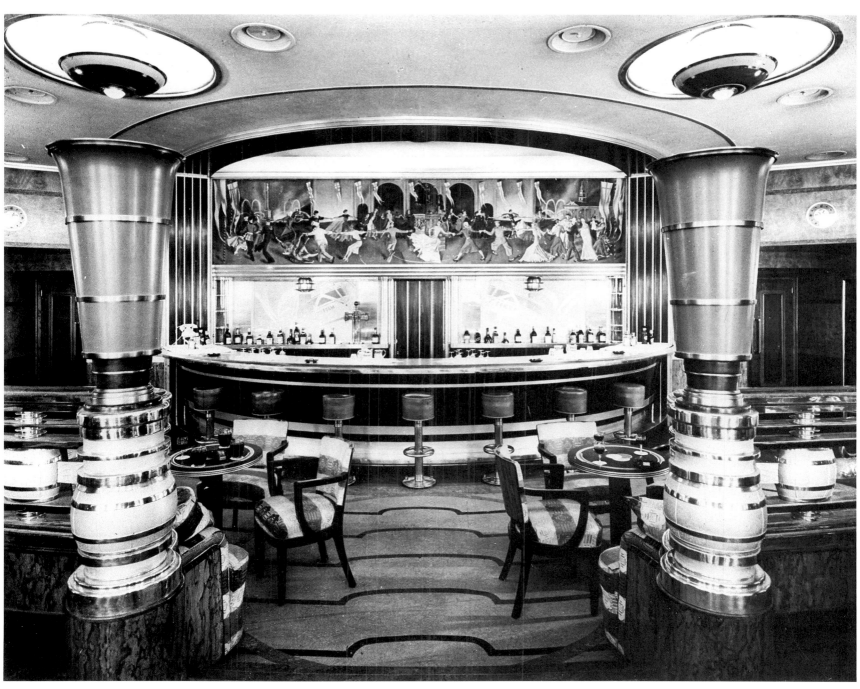

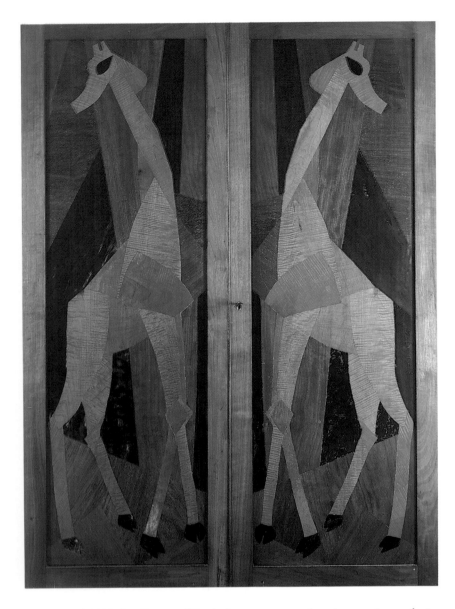

Waring & Gillow was certainly the most forward-looking in its commissioning of work by avant-garde designers; in 1929 the firm placed Serge Chermayeff, together with Paul Follot, in charge of its department of modern furniture. Chermayeff, who was later to embrace functionalism, designed a wide range of attractive Art Deco furniture. Some of his work featured French-style floral motifs, although most of his designs achieved their effect through the application of exotic veneers, paint or silver leaf to simplified basic forms, and were frequently upholstered with Cubistic textiles. Some of Chermayeff's more satisfying works were his built-in furniture, his tub shaped armchairs and his multipurpose jazz-age pieces, such as his combination end table/cocktail cabinet/bookshelf/room divider.

Among the more elegant English Art Deco pieces were the designs by Charles A Richter, usually for Bath Cabinet Makers. A few of Richter's more remarkable designs were heavy, abstracted classicist pieces on plinth-like bases. R W Symonds and Robert Lutyens produced some similar work, with light colored veneers, including a truly monumental piano. This furniture had much in common with the Biedermeier style, and today looks very like postmodernism half a century before its time.

Some of the best-made British modernist furniture was that produced by Betty Joel Ltd. Joel's simple and luxurious designs, characterized by rounded curves and discreetly ornamented with contrasting veneers, were executed by yacht fitters. These pieces, along with accessories such as light fixtures by Lalique, were sold to the exclusive clientele of her London gallery. Joel executed commissions for the Savoy Hotel group and for such private customers as Lord Mountbatten and Winston Churchill.

Betty Joel's success came in an era when the female interior designer first gained ascendancy in Britain in the years that followed World War I. Among the most gifted of these decorators was Syrie Maugham, who claimed credit for being the originator, in 1927, of the 'all-white' room. This idiosyncratic concept established her reputation and was later adapted by Hollywood set designers to create scenes of ultimate glamor. Maugham's social connections, as well as her talents, played no small part in attracting such celebrity clients as Tallulah Bankhead, Noel Coward, Gertrude Lawrence, Wallis Simpson and the Prince of Wales.

Modernist architects played a significant role as well in bringing French Art Deco ideas to British interiors. A key event was the redesign of Finella, the 'mouldy Victorian villa' of Cambridge University Master Mansfield Forbes by young Australian architect Raymond McGrath. Following this well publicized success, McGrath went on to other commissions for shops and restaurants, eventually becoming

Around 1913 the Omega Workshops assumed a pioneering role in the development of modernist furniture. Though the furniture itself was not very innovative, the decorative marquetry designs by Roger Fry, Henri Gaudier-Brzeska and Duncan Grant, as well as some of Fry's painted panels on case furniture, were a brave attempt to apply the principles of Cubism to the decorative arts.

In line with the development of the new style on the continent, such traditional furniture companies as Ambrose Heal, Gordon Russell and even Liberty began to include some modernist pieces among their generally Arts and Crafts style lines. The venerable company of

ABOVE LEFT AND LEFT: From the Omega Workshops came such decorative furniture as Roger Fry's cupboard with 'Giraffe' marquetry doors, and his painted circular dining table.

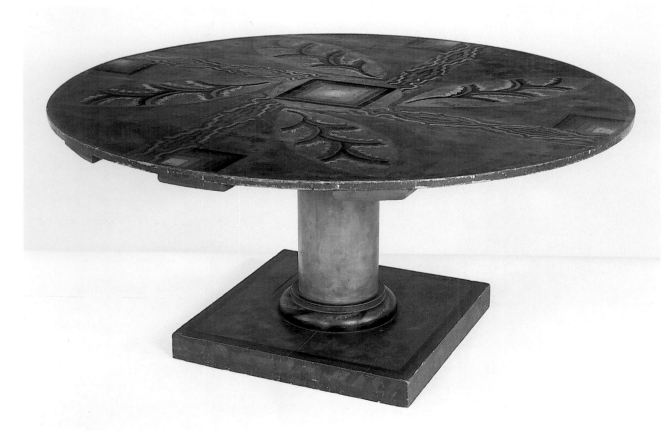

RIGHT: Oswald Milne supervised the 1929 redesign of Claridge's ballroom and its anteroom, seen here. The carpets were designed by Marian Dorn.

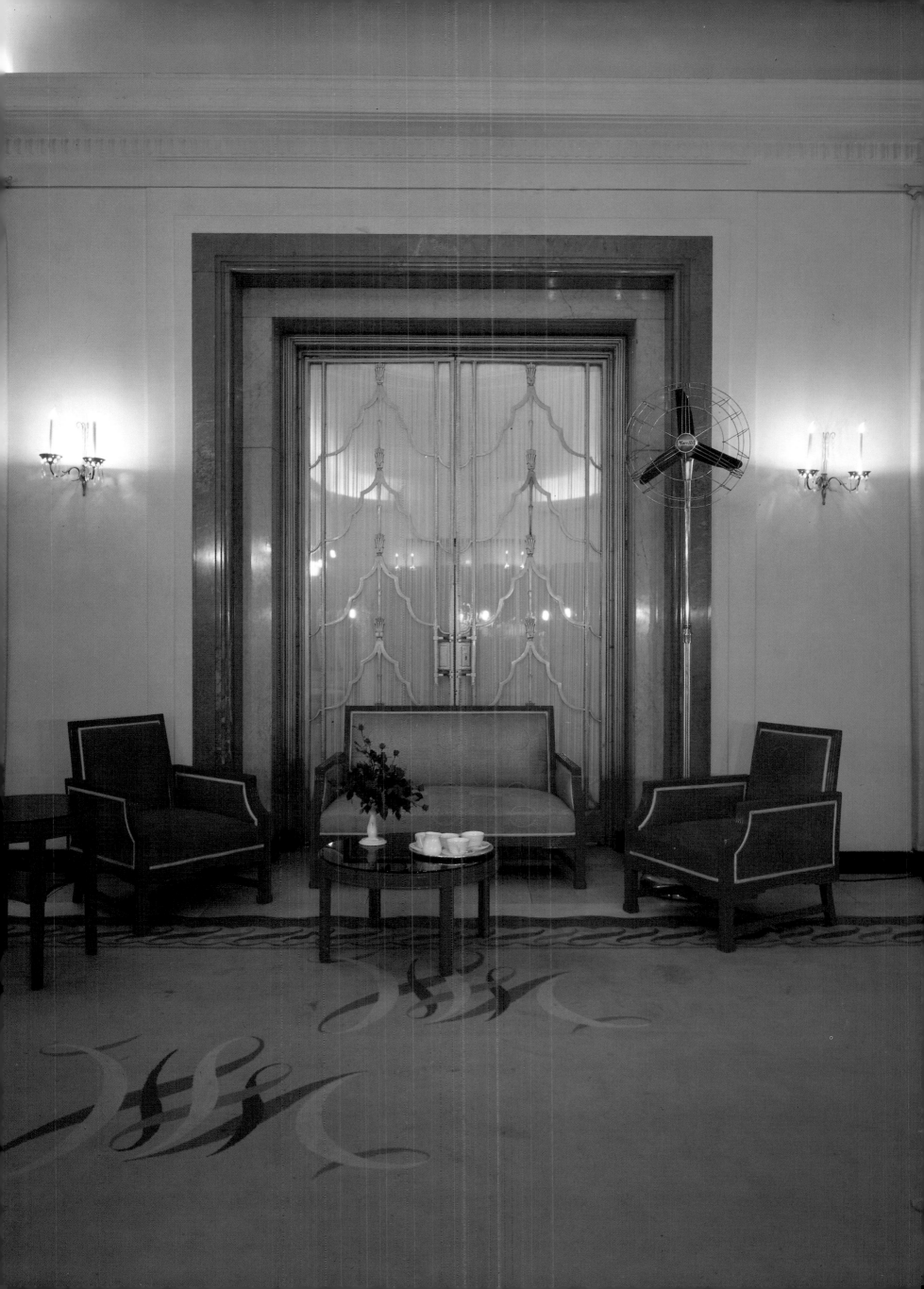

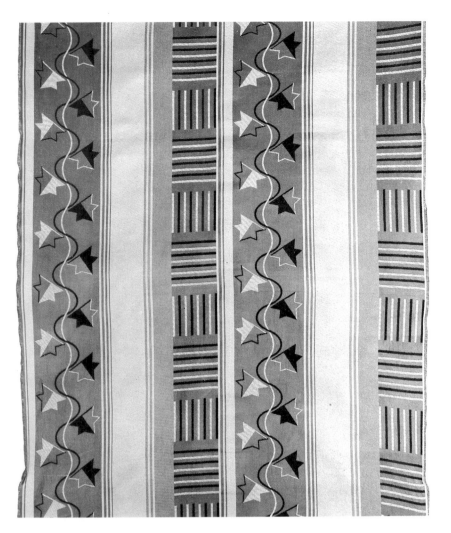

panels are now disassembled and in storage at the Victoria and Albert Museum.) Bernard's use of Cubist glass effects reflected a British taste for vitreous design. Raymond McGrath decorated the Embassy Club with panels of cut and polished glass, while architect Oliver Hill created a stylish bathroom with ceiling, walls and fittings all faced with gray mirror glass. During the 1930s there was a vogue for tables, cocktail cabinets and other furniture faced with white or tinted mirror glass; peach was a particularly popular color.

Neoclassicism inspired some of the many schemes of Basil Ionides, notably his transformation of the Savoy Theatre (1929). Ionides was also kept busy with commissions for the Savoy Hotel and the Swan and Edgar department store. A major project, under his supervision, was the complete modernistic refurbishing of Claridges in 1929. This transformed the hotel – even down to the bathrooms – into a showcase for the work of top British designers. Oswald Milne's plan for the new ballroom with decorative panels by George Sheringham, and Marion Dorn's carpets, were particularly noteworthy.

Other private and commercial clients also sought modernistic decorative design schemes by Ionides, Guy Elwes, Edward Maufe, Symonds Lutyens, Serge Chermayeff, Lord Gerald Wellesley and others. Reco Capey, working together with Ruhlmann who provided the furniture, created a completely new image for Yardleys. And the new Simpson's store by Joseph Emberton drew on the services of Moholy Nagy to work out the interior displays and of Ashley Havinden to create a unified range of graphics, as well as suitably modernistic carpets.

That a wide range of modernistic textiles and carpets was made available to the British public was largely due to the fact that many leading artists and designers created textile designs; among them were Raymond McGrath, Serge Chermayeff, Betty Joel, Evelyn Wyld, Paul Nash, Francis Bacon and McKnight Kauffer. The leading figure in the British textile design of the Art Deco era was American expatriate Marion Dorn, who became instrumental in raising the craft of textile design to new heights of artistry. She began collaborating with McKnight Kauffer in 1927 on carpet designs for Wilton Royal and by the 1930s was signing her name to the rugs that came to function as the decorative equivalents of paintings. Dorn's characteristically stylized abstract designs in subdued hues harmonized well with modernistic interiors by Oliver Hill, Wells Coates and others, and earned her the title 'Architect of Floors.'

design consultant to the British Broadcasting Corporation. Other deco transformations of the dwellings of the fashion conscious included that of New Ways, a Northampton house, by Peter Behrens, and Joseph Emberton's 1927 decoration of Stratford Lodge and of a Portman Square flat.

Oliver Bernard, a former theatrical set designer, created some of the most dramatic Art Deco interiors in England for such restaurant and hotel settings as London's Oxford Street Corner House, the Empire Room of the Trocadero Restaurant, the Cumberland Hotel and, surely his masterpiece, the Strand Palace Hotel. (The entrance

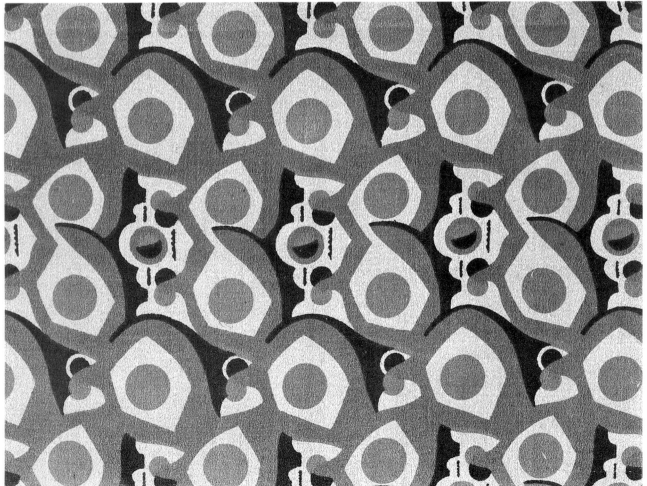

ABOVE LEFT: *Textile design by Marian Dorn.*

LEFT: *Paul Nash's textile pattern 'Fugue,' screenprinted on linen.*

ABOVE RIGHT AND FAR RIGHT: *More views of the 1929 Claridge's redesign featuring carpets by Marian Dorn.*

RIGHT: *In this 1928 dining room by Serge Chermayeff for Waring & Gillow the black and yellow furniture veneers were echoed by the rugs and curtains.*

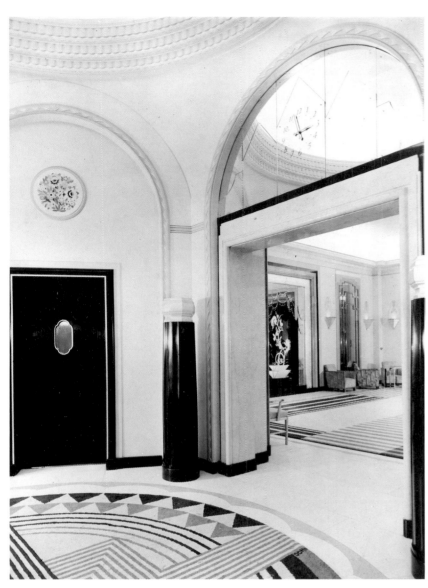

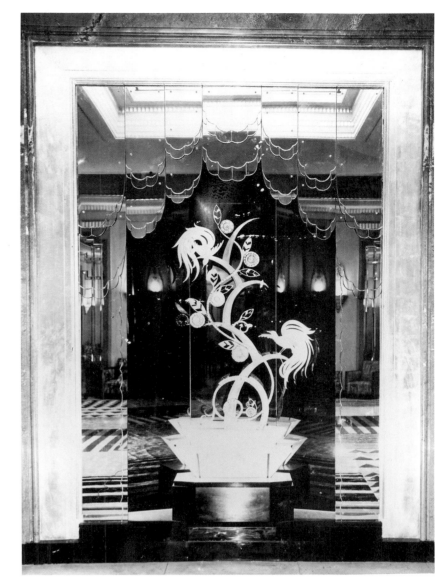

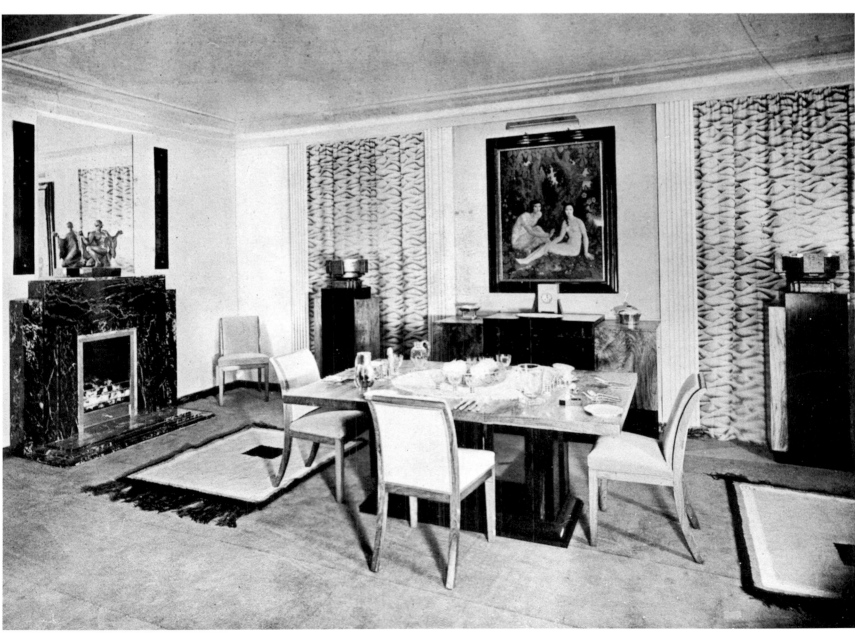

The United States produced some remarkable Art Deco furniture, which drew upon the resources of a strong furniture-making tradition that had developed over the previous centuries. Some of the masterpieces produced by eighteenth- and nineteenth-century makers were equal and, in some cases, superior to the works of their European counterparts. The elegantly veneered and geometrically linear furniture of the federal period – the era of neoclassicism – in the decades following the American Revolution was a direct stylistic antecedent of Art Deco; among the products of this period were some quite exceptional pieces by the likes of Thomas Seymour, Samuel McIntire and Duncan Phyfe.

Some of the first truly modern pieces of furniture, certainly akin to Art Deco, were those designed by Frank Lloyd Wright. Wright was as much a virtuoso in interior and furniture design as he was in architecture. Some of his decorative items, such as lighting fixtures and leaded windows, began to fetch extremely high prices at auction in the 1980s, creating a powerful economic motivation for the unscrupulous to dismantle some of his classic houses which in some cases were worth less than single decorative pieces. This is particularly distressing because Wright was the most insistent proponent of the environment unified by design, a concept central to Art Deco. From the time of his pioneering prairie houses, Wright had designed unique freestanding and built-in furniture to complement the architectural surroundings. While his earlier furniture designs resembled the works of the Arts and Crafts movement, those of the 1920s and 1930s reflected Art Deco ideas. Wright also designed lamps, rugs and stained glass for his interiors. As he disliked curtains, he came up with the idea of using exquisite geometrically stylized leaded glass as screens in projects such as his prairie houses, Midway Gardens and Barnsdall House.

The chairs Wright made for the exotic Tokyo Imperial Hotel were allied in their lively geometric lines to the zigzag style. A later analogy to the zigzag style was seen in the 1937 office interior Wright designed for Edgar Kauffman's department store. Here the geometrically patterned wall paneling harmonized with the Cubistic furniture; both were of a matching, light-toned natural finish. Wright's major commercial projects also provided him with furniture design opportunities. For the Larkin building (1903) he designed some of the earliest metal office furniture, introduced vertical steel filing cabinets and attached legless steel chairs to the desks to make office cleaning easier. Wright returned to the problem of office furniture with the Johnson Wax company in the 1930s, designing desks and chairs in curved and streamlined forms that echoed the architecture.

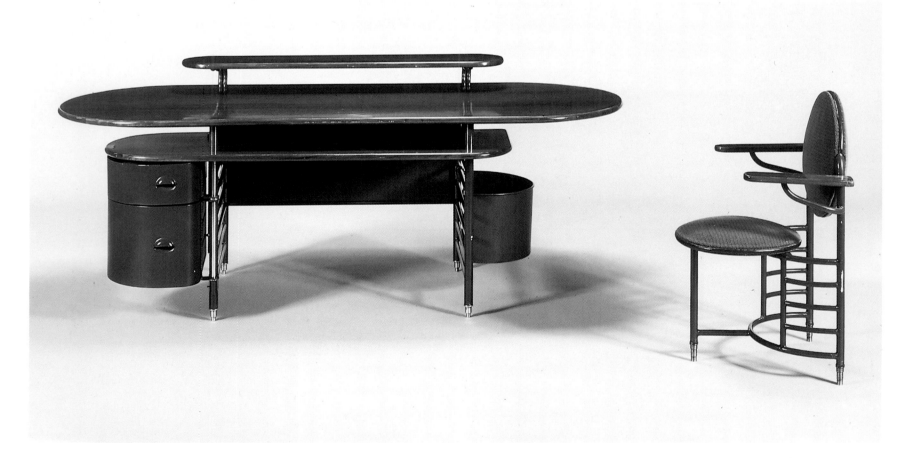

Although visually sophisticated and artistically inventive, Wright's chair designs generally ignored the needs of their users and were notoriously uncomfortable. One critic compared them to a 'fiendish instrument of torture,' and Wright himself once admitted that he had become black and blue from sitting on one of his own chairs; a case of form taking precedence over function. Though some avant-garde furniture-makers consistently ignored the idea of comfort, most of the later American Art Deco designers, particularly those producing for a mass middle-class market, were fairly sensitive to such utilitarian considerations.

Although the 1925 Paris exposition served to popularize the Art Deco style, prophets of decorative modernism had reached American shores over a decade earlier. In this first wave, from the Germanic regions, arrived designers who were to take a leading role in the conversion to Art Deco. From the Vienna *Sezession* and the Wiener *Werkstätte* came Joseph Urban in 1911 and Paul Frankl in 1914. And the new German ideas came with Winold Reiss in 1913 and in 1914 with Kem Weber, who had studied under Bruno Paul.

Thus the primary impetus for American Art Deco furniture design came from Europe. This wave of European designers, which in-

ABOVE LEFT: *Oak side chair by Frank Lloyd Wright for Tokyo's Imperial Hotel (1916-22).*

BELOW LEFT: *Office desk and chair by Frank Lloyd Wright for the Johnson Wax building (1936-39).*

BELOW: *A recent view of the Storer house including Frank Lloyd Wright's furniture in both original and reproduction form.*

cluded Eliel Saarinen, Wolfgang and Pola Hoffmann, William Lescaze, Ilonka Karasz and Walter von Nessen, provided the leaders of a movement that sought to transform the fashionable domestic and commercial interior environment, bringing it in line with the concepts of modernism and of the machine aesthetic. At the same time, many leading American-born designers – among them, Donald Deskey, Gilbert Rohde, Eugene Schoen, Ruth Reeves, Raymond Hood and Ely Jacques Kahn – had either studied or traveled in Europe, gaining firsthand knowledge of the latest developments in modern design. Travel, though, was not essential since many European modernists had participated in earlier international expositions. At the 1904 St Louis fair, the interior design and furniture by Bruno Paul and other Munich modernists excited interest in the American architectural establishment, not only for its innovative style but also for its emphasis on total design. It is significant that many of the American Art Deco furniture and interior designers were architects, or originally had studied architecture.

At the 1925 Paris exposition the luxury Art Deco furniture of leading French designers came as a revelation to the thousands of Americans who attended. A selection of works from the Paris exposition later traveled to New York's Metropolitan Museum and to eight other American museums, evoking widespread interest and creating a demand for such items. Specialized shops and galleries had already made French and Austrian designs available to the American customer. One of the earliest was the Austrian Workshop opened in New York in 1919 by Rena Rosenthal, the sister of Ely Jacques Kahn. After the Paris exposition major department stores began to host exhibitions of modern design. Toward the end of the 1920s, however, many French designers began to refuse to participate in American exhibitions because of the practice of some department stores of making unauthorized reproductions.

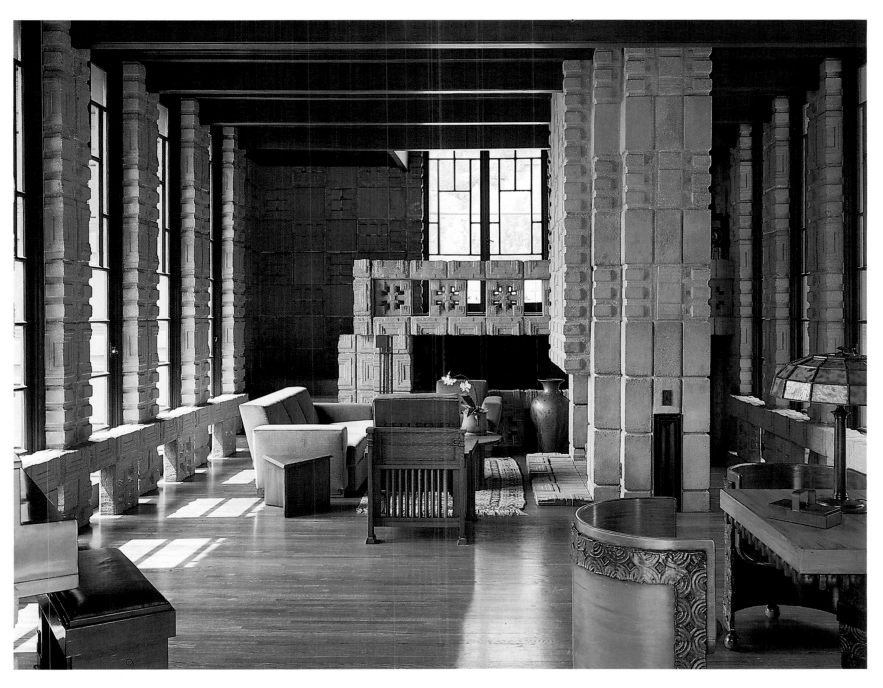

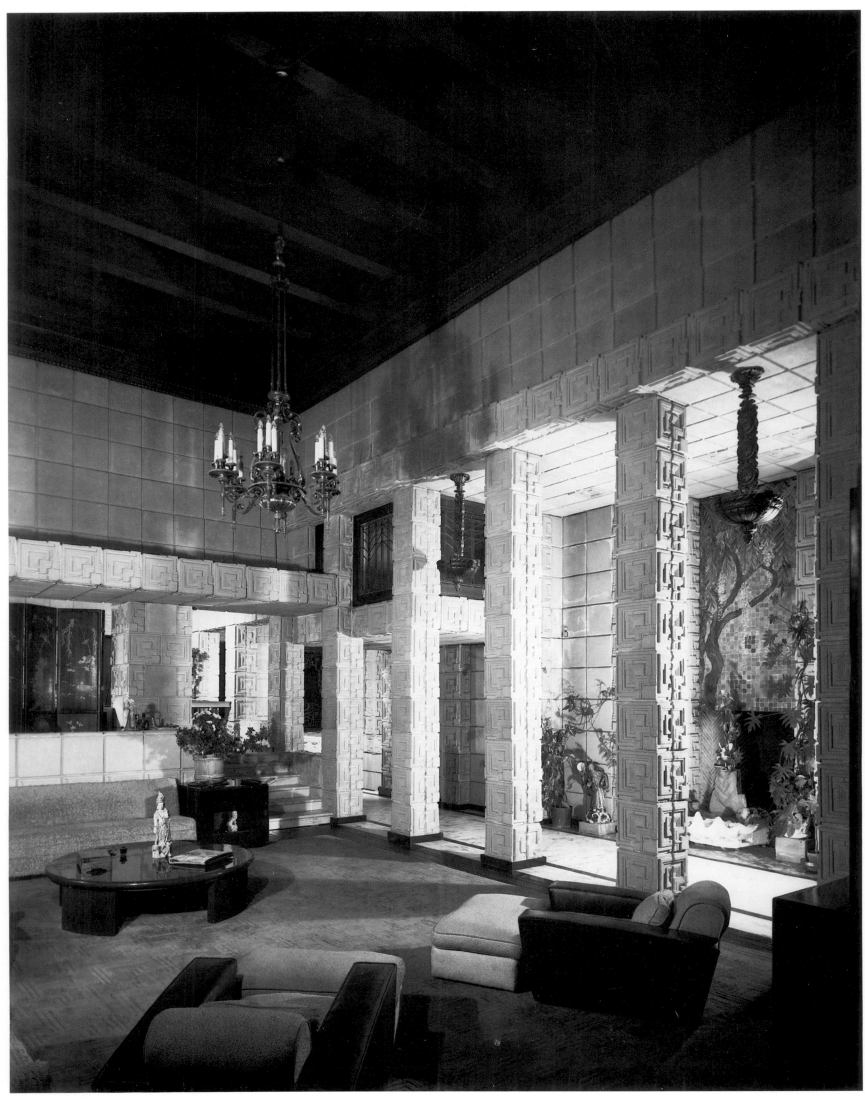

The first important exhibition of American contributions to Art Deco was that staged by the Metropolitan Museum in an effort to foster collaboration between designers and industry. The 1929 *Architect and the Industrial Arts* featured 13 room ensembles created by leading architects, among them Ely Jacques Kahn, Ralph Walker, Joseph Urban, Eugene Schoen, John Wellborn Root, Eliel Saarinen and Raymond Hood. This show was so popular that it had to be extended from six weeks to six months. The versatile architects designed not only the integrated modernistic furniture and accessories, but also the textiles and the decorative geometric wall treatments. As was typical of the 1920s style, most of the furniture consisted of expensive, one-of-a-kind pieces. Only Root later put his bedroom furni-

LEFT: *A recent interior view of Frank Lloyd Wright's textile block Ennis house.*

RIGHT: *This pair of 'Skyscraper' bookcases by Paul Frankl date from the late 1920s. They are of California redwood with nickle-plated steel trim.*

ture into production and had it sold through Montgomery Ward outlets. Some critics complained, justifiably, that the designs were inaccessible to all but the wealthy few.

The stylistic sources of the 1920s American Art Deco furniture were diverse. From the neoclassical and empire styles came the refined use of contrasting veneers, of fluting, of octagonal and oval forms, of sunburst- and fan-shaped motifs, and of pedestal bases; from Chinese furniture the low center of gravity and the use of black and lacquered finishes; from the machine aesthetic the use of industrial materials such as chromium, aluminum and bakelite; from Cubism the angular, sculptural shapes and the use of vibrant colors and stylized geometric ornament; and from primitivism, the use of exotic woods and other unusual natural materials.

The most distinctive motif of American Art Deco furniture in the 1920s was the skyscraper style so enthusiastically promoted by Paul Frankl in his articles and books on the modern design movement. Frankl designed desks, desk-bookcases and dressing tables in the stepped skyscraper style, often in exotic wood veneers or highly polished lighter toned woods enhanced with brightly hued lacquers or with gold and silver leaf. Frankl held that the furniture inside a modern urban apartment should harmonize with the metropolitan skyline seen through the windows. He also produced more con-

servative, neoclassically inspired pieces. As did many other designers, Frankl also designed smaller interior accessories such as a Telechron brass and bakelite mantel clock with a decorative sunburst of rays of silver and gray. The skyscraper style was adapted by other designers such as Abel Faidy.

Frankl's fellow Austrian Joseph Urban, whose most important architectural designs were New York's Ziegfeld Theater and the New School for Social Research, had worked as a theatrical designer for the Metropolitan Opera and the Ziegfeld Follies. He also designed lively, theatrical-looking furniture, usually characterized by contrasting veneers and mother-of-pearl ornament. Urban's designs were among those sold through the New York outlet of the Viennese workshop, of which he was the American director in the early 1920s. Urban worked on numerous interior design commissions for hotels, restaurants and stores in New York and the hinterlands, though not all of his usually exuberant floral mural designs were executed.

In the late 1920s Winold Reiss also developed a substantial career as an 'interior architect,' as he called himself. Some furniture commissions were included among his many projects for restaurants and hotels such as the Crillon, the Elysee, the Esplanade, Longchamps Restaurant, the Ritz-Carleton Hotel, the Hotel Almac's Congo Room and the South Sea Island Ballroom in Chicago's Sherman House.

stitution that trained under his directorship a generation of innovative designers, artists and artisans. Among the results of Saarinen's activity were some of the finest examples of Art Deco furniture created in America. Some of Saarinen's most elegant designs were the furniture for his own residence at Cranbrook. Restrained zigzag motifs in veneer embellished the surfaces of the living-room chairs, cabinets and tables, which were constructed in a combination of exotic woods. A neoclassical influence was seen in the dining-room chairs with their graceful linear fluting, and the circular table inlaid with a radiating geometric pattern. Originally the dining room's octagonal shape, the octagonally patterned rug, the custom designed light fixture, the textiles, the paneled walls and even the dishes (designed by Saarinen to match the chairs) harmonized with the furniture. Elements from the Saarinen residence – notably the tiled living room fireplace and the octagonally patterned rug – were displayed as part of Saarinen's dining-room ensemble at the 1929 Metropolitan Museum exhibition. There, though, the exhibited chairs were of a different design, and subtly reflected the skyscraper style.

The leading New York Art Deco architect Ely Jacques Kahn also executed many interior design commissions that required the creation of specialized furniture. An unusual example was his glass, marble and chromed metal luminaire/planter. The design of new types of combination furniture to meet modern needs was characteristic of the Art Deco era. The more cramped quarters of the fashionable skyscraper apartments called for furniture adaptable to many functions; and the social life of the jazz age also required new types of furniture such as bar consoles and cocktail tables with bakelite tops resistant to spilled alcohol and cigarette burns. Even such traditional furniture types as wicker armchairs were redesigned by Frankl, Deskey, Rohde and others in cubistically angular shapes with compartments for drinks or magazines. The incorporation of electric light fixtures into furniture was another Art Deco phenomenon. Kem Weber, for example, designed a skyscraper-style dressing table with vertical light tubes flanking the mirror.

One of the finest American furniture designers of the 1920s was Eugene Schoen, who established an interior design firm and a New York gallery selling his own and imported designs. In his various commissions for luxury apartments, bank interiors, theaters and department stores, Schoen exploited the decorative possibilities of contrasting wood veneers, of lacquered orientalism and of dignified classicistic proportions. Schoen's most important project was the interior design of the RKO Theater at Rockefeller Center. His later furniture pieces ranged from the conservatively moderne to the exploration of such machine-age materials as glass and metal.

Art Deco ideas also spread out from the urban centers, as seen in the unique modernist furniture hand made by Wharton Esherick, a painter, sculptor, graphic artist and woodworker who practised his craft in the relative seclusion of rural Pennsylvania. Through his work as an avant-garde stage designer in the 1920s, Esherick had become familiar with German Expressionist stage sets. As a result, his 1929 Victrola cabinet, designed as a sculptural and functional base for the carved wooden statue of a stylized dancer, reflected expressionist as well as Art Deco ideas in its attenuated triangles and oblique geometric surface articulation.

The Wall Street crash brought about radical changes to the design and production of Art Deco furniture, marked by a repudiation of the luxurious style of the 1920s and a turn to mass production. This move toward a functionalist aesthetic coincided with political events in Europe. In 1933 the Nazis closed the Bauhaus, bringing a second wave of top European designers to the United States. The move toward functionalism was given an added impetus by the attention given to Bauhaus ideas by American industrial design exhibits of the late 1920s, and especially by the new Museum of Modern Art's vigorous promotion of Bauhaus design concepts.

The hitherto symbolic and decorative use of modernistic and machine age materials such as plastics, industrial metals and new glass products gave way to a simplified, structural use of these materials. The functionalist Art Deco furniture was transformed by the streamline style promoted by the rising generation of American industrial designers.

Fellow immigrant Kem Weber became a pioneer of modern design on the west coast. His varied activities included interior design, Hollywood film set design, industrial design and the design of individually commissioned and mass-produced Art Deco furniture, ranging in style from the zigzag to the streamlined and from the ornately decorative to comfortably upholstered tubular metal chairs. Weber's avowed aim was 'to make the practical more beautiful and the beautiful more practical,' a philosophy he publicized through lectures and articles. One of Weber's most prestigious interior commissions was the opulent zigzag-style interior for the Mayfair Hotel in Los Angeles.

Shortly after his arrival in the United States from Finland, Eliel Saarinen became involved in the founding and construction of the Cranbrook Academy of Art outside Detroit. As chief architect, interior designer and furniture designer, Saarinen created a sophisticated integrated setting for the artistic community and educational in-

LEFT: *One of the most picturesque manifestations of the skyscraper style was Abel Faidy's 1927 armchair, part of a furniture suite created for a Chicago penthouse.*

RIGHT: *A desk with nested seat designed by Paul Frankl.*

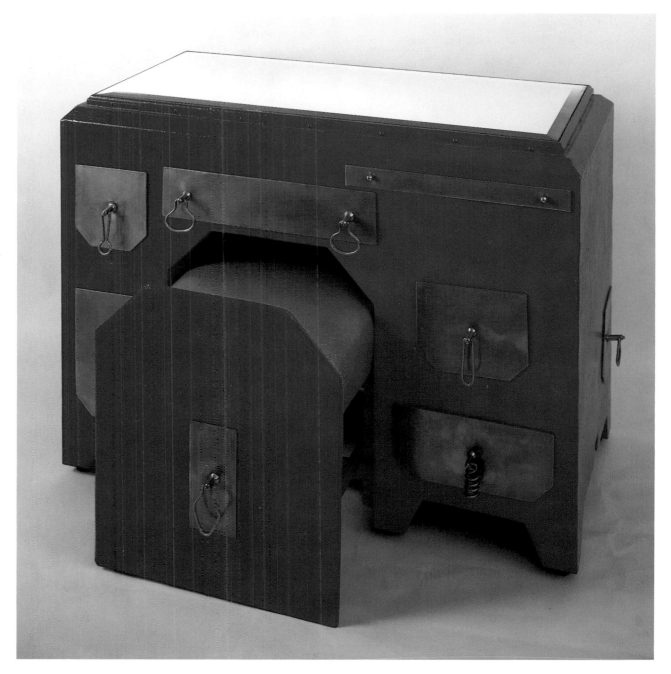

BELOW: *A tiered glass table (1928-29) by Kem Weber.*

Nowhere was the change more apparent than in the 1934 Metropolitan Museum exhibition, *Contemporary American Industrial Art,* where the architect-designed rooms embraced the new aesthetic. The chairs, tables and even a Steinway piano were mounted on metal legs and bases; glass-brick window walls were featured; and there was even a lady's room by Saarinen with blocky built-in furniture embellished with horizontal speed stripes.

During the Depression a number of furniture designers such as Donald Deskey, Gilbert Rohde and Kem Weber carved out successful careers by creating functionalist Art Deco designs for mass production by formerly traditional furniture companies. Often the manufacturers turned to modernist designs from sheer economic desperation and some, in particular the Herman Miller company, even thrived as a result.

Donald Deskey was one of the most successful designers of the 1930s. He had originally studied architecture and painting in the United States and Paris. While traveling in Europe he visited the Bauhaus, and was also impressed by Dutch *De Stijl* design. Deskey achieved an initial success with the Art Deco folding screens he painted for Paul Frankl's gallery and on commission for individual clients. In 1927 he established the design firm of Deskey-Vollmer together with Phillip Vollmer. Between 1930 and 1934, over 400 of Deskey's furniture designs were put into production. Though he admired Bauhaus ideas, Deskey maintained a sensible respect for comfort and ornament, as well as an eclectic regard for historicism. He would not have been so successful in the age of mass production without this pragmatic instinct.

Gilbert Rohde, whose modernist designs for the 1933 Chicago exposition's Design for Living house brought him widespread recognition, developed a successful career in the 1930s creating furniture designs that utilized new materials and new manufacturing

techniques. Among Rohde's notable mass-produced designs were laminated and bentwood chairs inspired by Finnish architect Alvar Aalto's designs, and sectional sofas. Stylistically, Rohde ranged from 1920s deco veneered furniture to functionalist pieces of plastic and tubular steel. His 1935 desk-bookcase for the Herman Miller company combined the exotic veneering of the opulent Paris style with a design that was typically inventive in its space-saving, multi-functional concept. For less traditional tastes he designed a bakelite topped, tubular metal-framed desk advertised as the ultimate in modern functionalism not only in its clean geometric lines, but also for its 'no mar,' 'no tarnish' surfaces. The desk's color combination of silvery metal and black bakelite was a popular one in Art Deco furniture design of the 1930s. Rohde also offered such typically Art Deco interior settings as walls decorated with alternating horizontal bands of brushed copper and cork; he was also one of the era's leading clock designers.

Some of the more unusual pieces were created by people not primarily concerned with furniture design. Photographer Edward Steichen, for example, designed two jazz-age pianos with mirrored panels above the keyboard to reflect the pianist's hands. These models were entitled 'Vers Libre' and 'Lunar Moth.' Lee Simonson, active in the theater, dreamed up 'Death of a Simile,' a piano of white holly accented with turquoise lacquer.

Architectural glass was an important feature of Art Deco interior design, and art glass manufacturers met the demand by producing stained glass for residential and commercial settings. These panels were made not only for windows but also for doors, screens and skylights. Among the more favored motifs were the inevitable geometric patterns, zodiacs and stylized elements from nature.

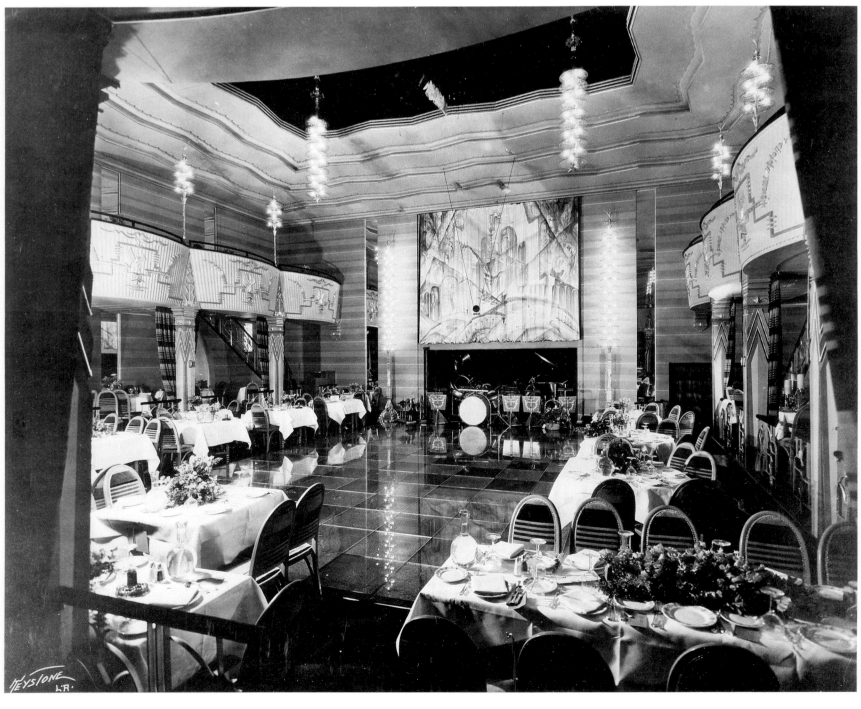

LEFT: *Joseph Urban's End Table of black lacquer with silver trim (c 1920).*

BELOW LEFT: *Kem Weber's design for the Mayfair Hotel, Los Angeles (1926-27).*

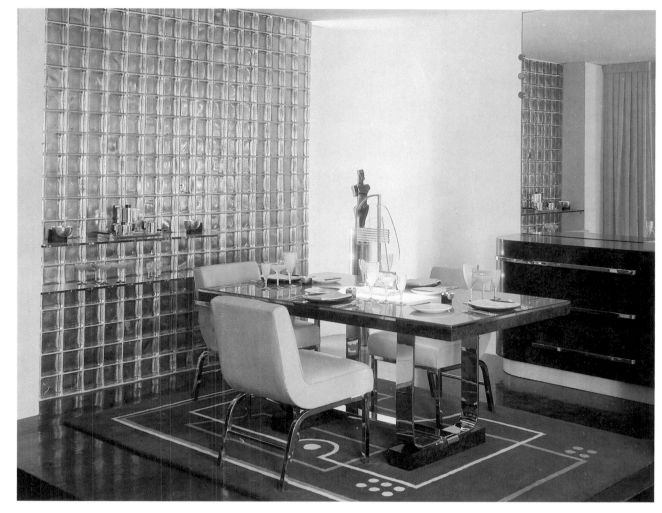

RIGHT: *Donald Deskey's 1934 Dining Room for* Contemporary American Industrial Arts *exhibit at Metropolitan Museum of Art in New York.*

BELOW: *Eliel Saarinen's Room for a Lady at the same exhibit.*

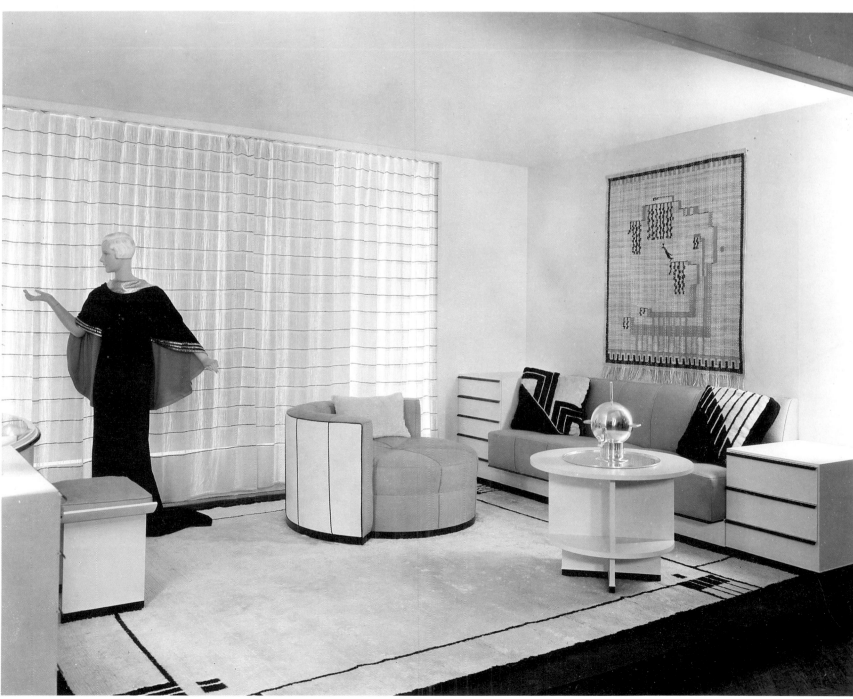

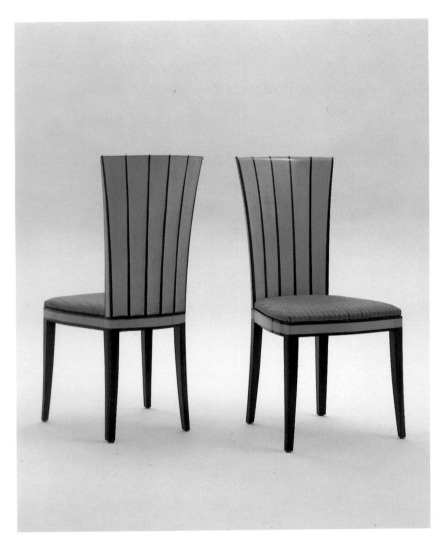

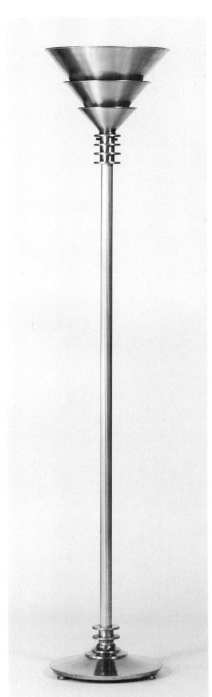

FAR LEFT: *Eliel Saarinen's side chairs (1929-30) originally designed for his residence at Cranbrook.*

LEFT: *Walter von Nessen's torchère floor lamp (c 1928) of brushed chrome over brass.*

ABOVE RIGHT: *Eliel Saarinen's peacock andirons for his residence at Cranbrook.*

Another speciality was clear glass that was etched, sandblasted, painted or embossed with designs. The panels designed by Edgar Miller for the clerestory of Chicago's Diana Court were characteristic of this kind of work. Their classically-derived imagery echoed Sidney Waugh's Steuben Glass designs and Art Deco architectural relief sculpture. The versatile Miller designed architectural glass, made sculptures and executed murals for churches, restaurants and clubs. Maurice Heaton made a striking contribution in this field with his glass murals for interiors designed by Eugene Schoen. Heaton's illuminated *Amelia Earhart* mural for Rockefeller Center's RKO

BELOW LEFT: *Chromed metal and black lacquer desk lamp by Donald Deskey.*

BELOW RIGHT: *'Animal Carpet' (1932) designed by Maja Andersson Wirde and woven by Studio Loja Saarinen of linen and wool.*

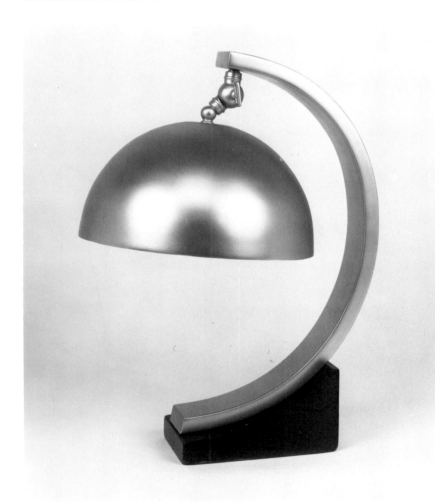

Theater was the most impressive. He also made smaller handcrafted art glass items sold in Schoen's and Rena Rosenthal's galleries. Interior designers used glass decoratively in other ways as well. Textured glass, glass block, geometrically leaded clear glass, mirror tiles, and black, blue and peach glass were used to create glamorous milieus, and reflected the persistent Art Deco fascination with dramatic lighting effects.

Electric light fixtures, both as architectural elements and as domestic necessities, were inventively interpreted. Frank Lloyd Wright and Alfonso Iannelli were among the many important Art Deco personalities who designed modernistic lighting fixtures. Those created by Donald Deskey varied in type from a rectilinear glass box on a fluted base to a hemispherical Cubist-inspired desk lamp allied to Bauhaus ideas. One of the most typical Art Deco lights was the torchere, a freestanding columnar lamp that provided indirect illumination by aiming the machine-age shade at the ceiling. The Art Deco torchere was a reinterpretation of a classical style lighting standard. Probably one of the most elegant versions was created by Walter von Nessen, although many others – among them Russel Wright and Eliel Saarinen – designed torcheres. Nessen, who initially supplied architects with lighting fixtures and metal furnishings, expanded his design studio during the 1930s to sell functionalist furnishings to retailers. In architecturally installed lighting, the fixtures drew upon the whole range of Art Deco motifs from the geometric shapes to the stylized figurative forms of the chromed bronze masks created by lighting specialist Walter Kantack for the RKO Theater. Decorative animal motifs were used by W Hunt Diederich for a more old fashioned light fixture, the chandelier.

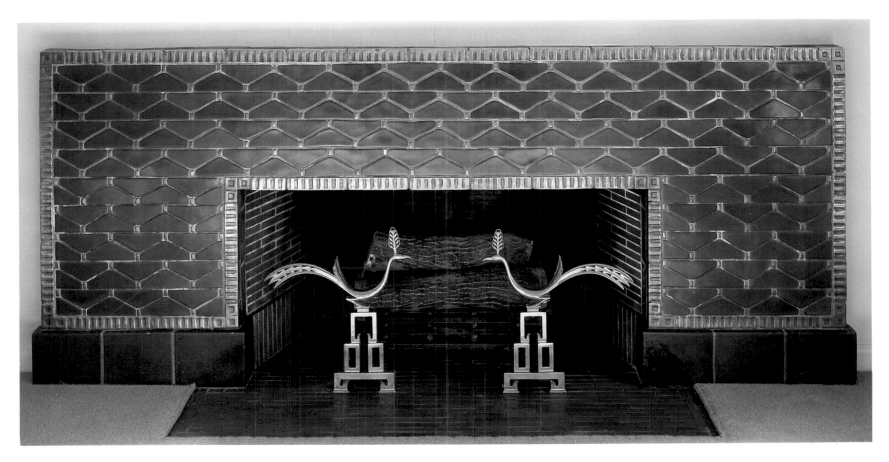

The skillful metalwork required to produce such fixtures was also employed in the creation of other interior accessories. Diederich designed firecreens embellished with graceful silhouetted greyhounds. Eliel Saarinen, too, was involved in the design of decorative metalwork, not only for the gates to Cranbrook Academy, but also the elegant peacock andirons for his fireplace there. The French-born designer Jules Bouy who headed Ferrobrandt, Inc – the New York outlet for Edgar Brandt – designed such pieces as an ornate wrought-iron mantelpiece. Among the other accessories sold by Ferrobrandt were lamps, fire screens, andirons, tables and mirror frames, all ornamented with graceful Art Deco motifs in the French style. Elegant metalwork was also executed by Oscar Bach for Radio City Music Hall and the Daily News, Chrysler and Empire State buildings, sometimes to the design of others.

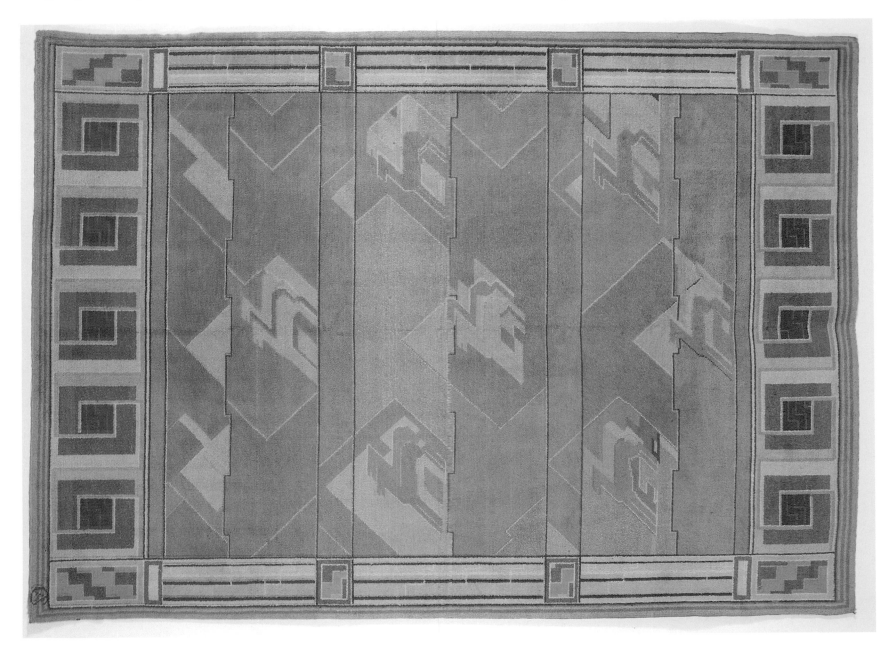

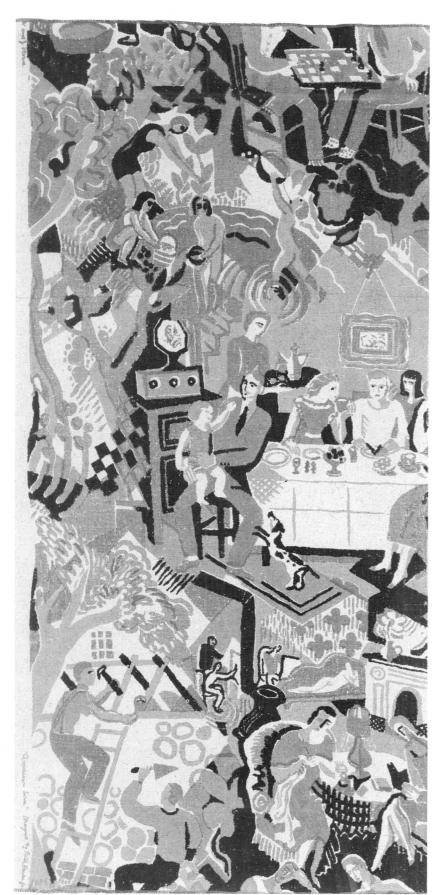

An important component of the co-ordinated Art Deco interior were textiles and carpets. Characteristic of the multidisciplinary activity of the artists and designers of the era were the textile and rug designs created by Ely Jacques Kahn, photographer Edward Steichen, photographer and precisionist painter Charles Sheeler and sculptor John Storrs. The leading textile designers were Ruth Reeves, Henriette Reiss and Ilonka Karasz. Reeves, who had studied at New York's Pratt Institute and the Art Students' League, spent most of the 1920s in France where she studied with Fernand Léger. Her handblocked textile and rug designs reflected the Cubist ideas of Picasso and Léger. In 1930 W & J Sloane commissioned her to create 29 designs that ranged in content from rhythmic geometric abstraction to stylized vignettes of representational imagery evoking the American urban and social life of the era.

Handworked and embroidered textiles and wall hangings were also created for interiors. Among the more important interpreters of stylized Art Deco imagery in this medium were Marguerite Zorach; Mariska Karasz, sometimes in collaboration with her sister Ilonka; Lydia Bush-Brown; Arthur Crisp; and pioneering tapestry designer Lorentz Kleiser, who was fond of jungle motifs. Avant-garde artists participated as well. In his Parisian Cubist days, Thomas Hart Benton produced several handsome Art Deco style rugs. The motifs occasionally extended even to the folk art hooked rugs worked by anonymous craftspeople.

Room-sized and wall-to-wall carpets for domestic and public interiors were much in demand. Chinese Art Deco rugs were imported, a new appreciation developed for Navaho rugs, and designers often created unique patterns for special settings such as Rockefeller Center or Oakland's Paramount Theater.

Eliel Saarinen's wife Loja headed a workshop that produced a remarkable series of sophisticated Art Deco carpets and textiles, primarily for Cranbrook Academy. Most were designed by Loja Saarinen, at times in collaboration with her husband, or by accomplished resident weavers such as Sweden's Maja Andersson. Deco geometric, zigzag, skyscraper, animal and other motifs were used in a way that harmonized subtly with their interior settings. The muted coloring of these works was a contrast to the garishness of many American commercially produced carpets.

LEFT: *'American Scenes' textile design by Ruth Reeves.*

BELOW: *'Rug No. 2' (1928-29) designed by Eliel and Loja Saarinen.*

RIGHT: *Chanin Building, New York, executive bathroom designed by Jacques Delamarre (1929).*

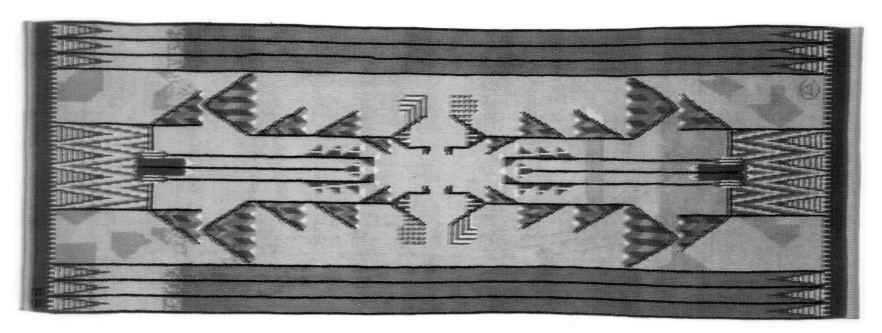

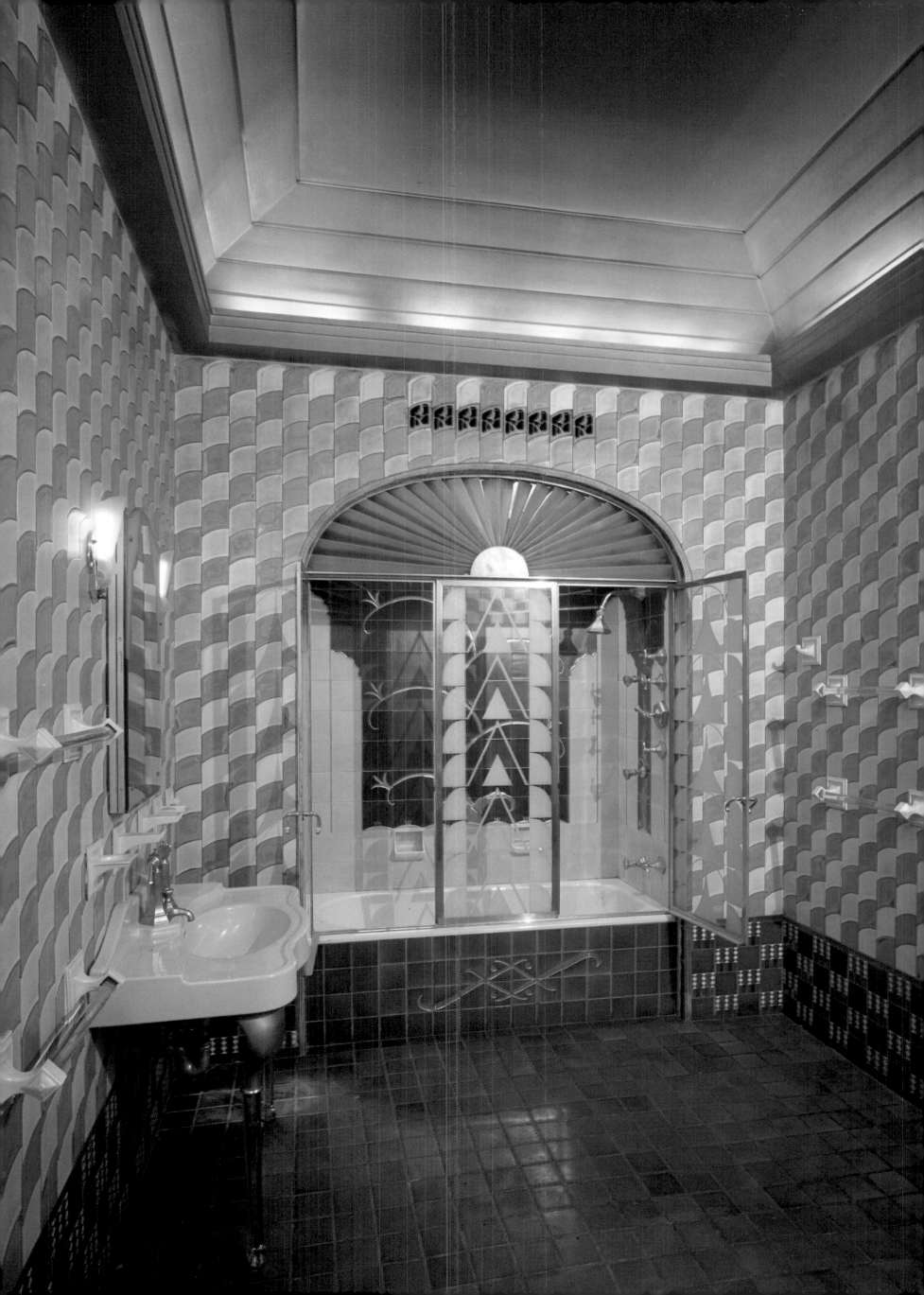

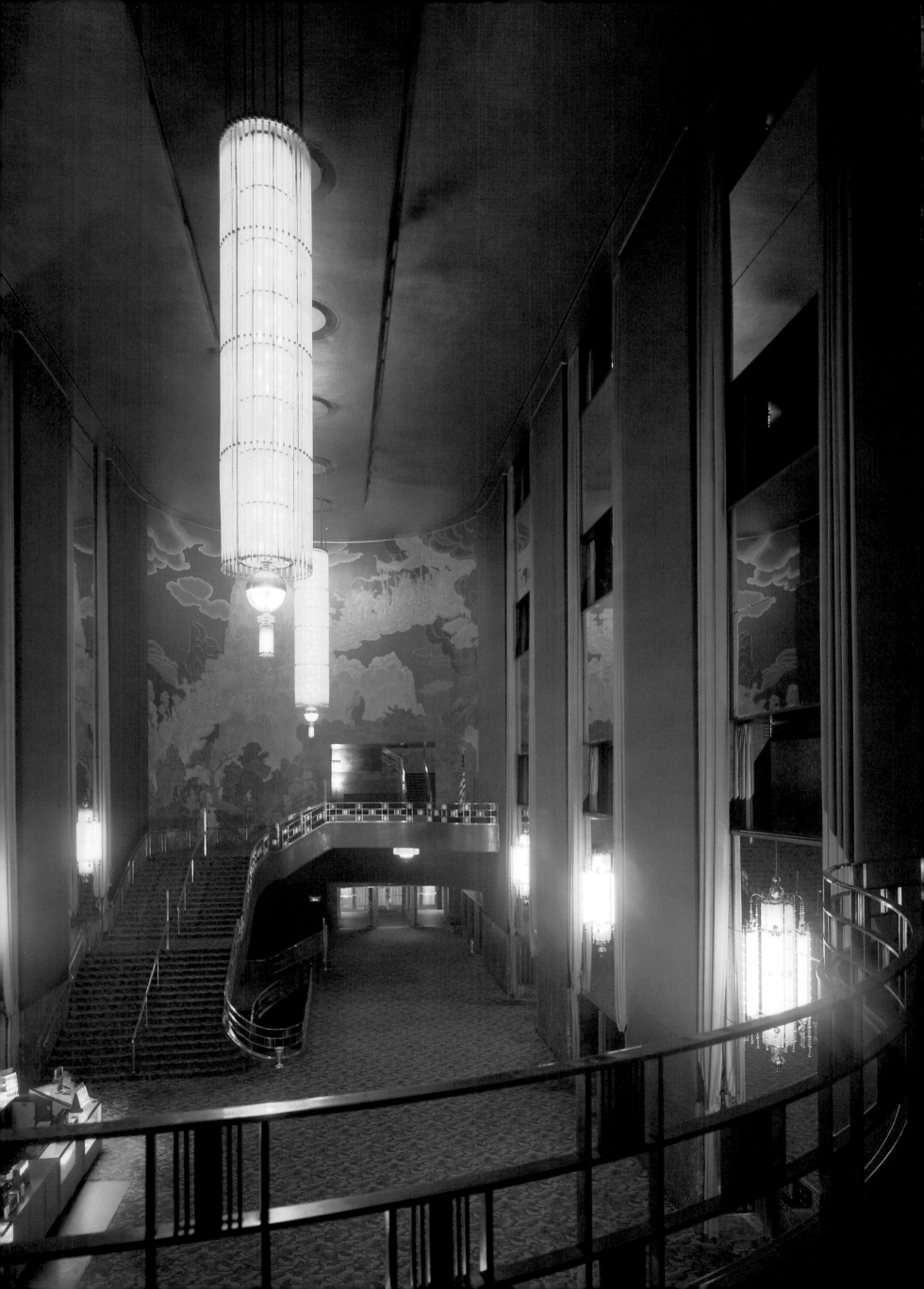

LEFT: *The lobby of the Radio City Music Hall at Rockefeller Center, New York with Ezra Winter's mural,* The Fountain of Youth.

RIGHT: *Yasuo Kuniyoshi's murals in Radio City Music Hall's ladies powder room.*

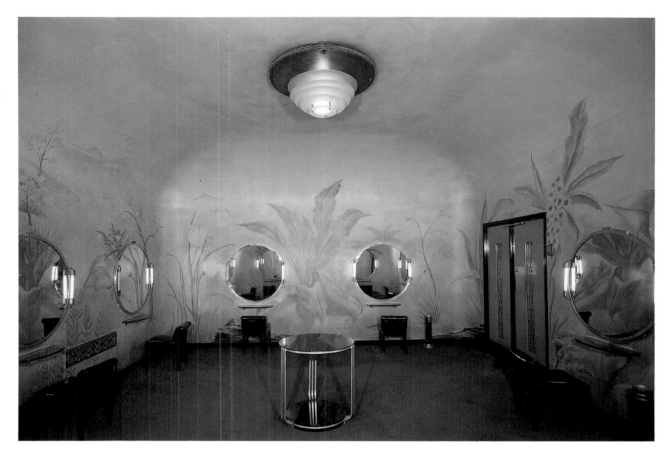

BELOW LEFT AND RIGHT: *From Radio City Music Hall, men's room 'Nicotine' wallpaper, and 'Jazz' pattern carpet.*

The stylish modernist quality of the Art Deco environment was distinctively seductive. Department stores had recognized the style's power of attraction early on by hiring the likes of John Vassos, Norman Bel Geddes, Louis Lozowick, Frederick Kiesler, Donald Deskey and even avant-garde sculptor Alexander Archipenko to create striking window displays. Ely Jacques Kahn transformed the interiors of the Broadmoor Restaurant and Rutley's Restaurant with stylized cloud murals on the ceilings and walls. John Mead Howells concocted an Art Deco aura for the tower lounge of New York's Panhellenic Building. Others conjured up exotic settings for Harlem's racially segregated night clubs. Even such sedate institutions as banks placed a high value on style; Hildreth Meiere's red and gold mosaics enveloped the main banking room of New York's Irving Trust building, while Detroit's Union Trust Company building, by architect Wirt Rowland was virtually unequalled in the splendor of its American Indian style decor.

The best known Art Deco environment, of course, was that created for Rockefeller Center, in particular the co-ordinated interior design of the Radio City Music Hall supervised by Donald Deskey, where the machine-age aesthetic of streamlining harmonized with the luxurious, stylized nature imagery of the earlier zigzag style. Actually Radio City was one of the last of the palatial movie theaters, and provided a fitting close to an era marked by such Art Deco milestones as Catalina's Avalon Theatre, the Pantages Theater in Los Angeles and, most dramatically, by Timothy Pflueger's Oakland Paramount. This magnificent combination movie-vaudeville theater conjured up a spectacular dream world of zigzag-style pattern, imagery and lighting effects.

Throughout the Depression, Hollywood films and vaudeville regaled the public with settings of vicarious luxury by Paul Iribe, Erté and many others. Art directors provided such films as *Top Hat, Grand Hotel* and Ernst Lubitsch's sophisticated romantic comedies with elegant Art Deco decor. A distinctive Hollywood specialty in both films and movie star homes was the 'white look,' which photographed so effectively in black and white. The stage settings of vaudeville dance extravaganzas also drew on the modernistic stylization of Art Deco. A recently uncovered archive of scenic renderings by Anthony Nelle, a choreographer, production designer and one-time partner of Anna Pavlova, who created stage sets for New York's Roxy Theater and for the Fox theaters in Detroit, St Louis and San Francisco, showed such typical Art Deco devices as oblique diagonals, ray lines, soaring skyscrapers and streamlined transport.

These celluloid fantasies provided a necessary, if illusory, escape from the troubles of the Depression; the escape that finally did come was quite different. The economic Depression ended with the outbreak of World War II; the symbolic close of a unique era of modernist design came in 1942, when the archetypal masterpiece of opulent French Art Deco interior design, the *Normandie,* ignominiously sank in New York harbor after fire broke out as it was being refitted for service as a military troop transport.

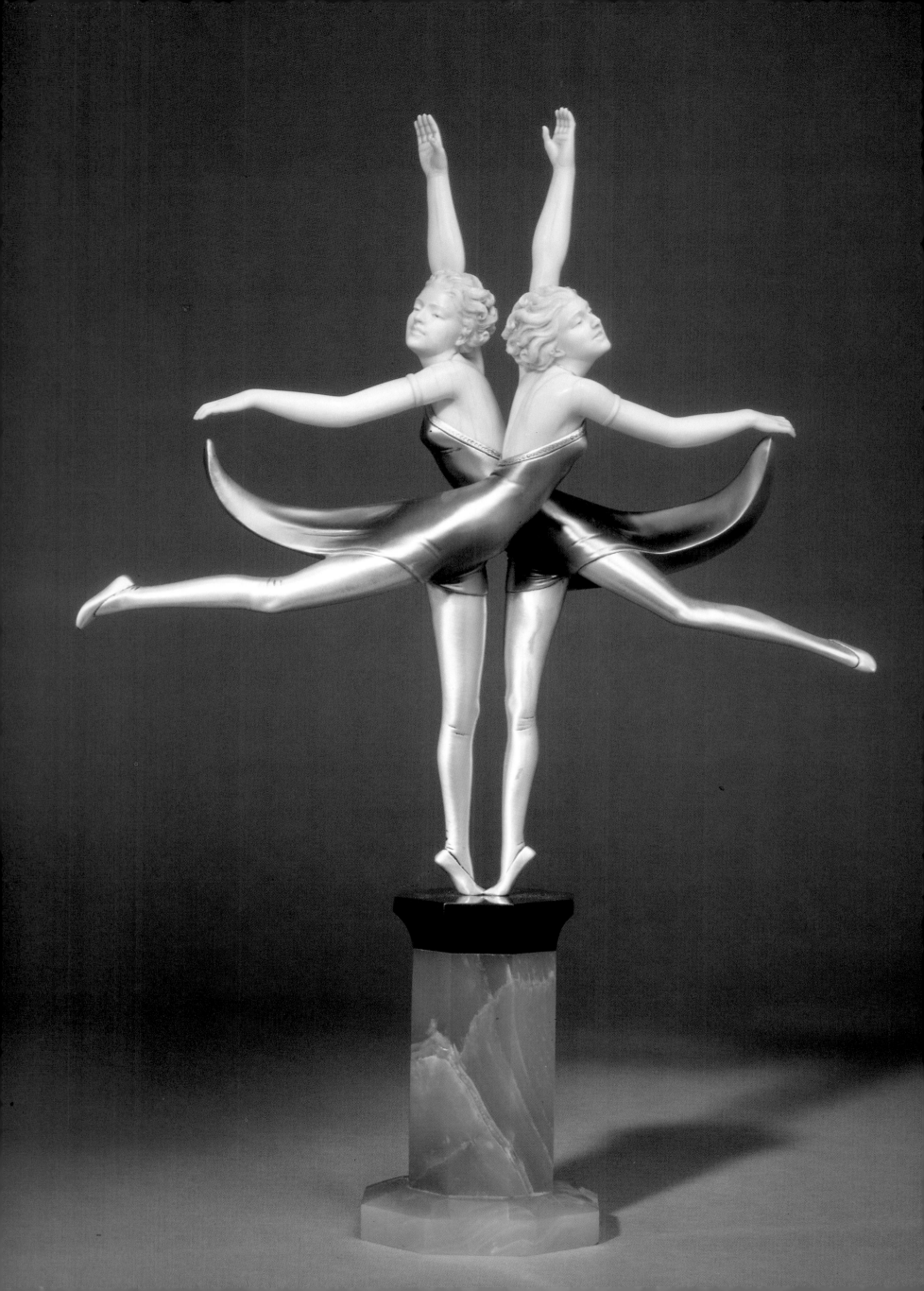

Sculpture, Painting and Photography

LEFT: Butterfly Dancers, *a silver, patinated bronze and ivory group by Ferdinand Preiss.*

Sculpture and painting played an integral role in the creation of the totally designed Art Deco environment. The deco variant of these arts was distinct from the works of avant-garde artists not only in that it was a more conservative adaptation of modernist trends, but primarily in that it was an art specifically intended to embellish architectural surfaces and settings, many of them public. Hence Art Deco sculpture includes the reliefs adorning building interiors and exteriors, and attached or accompanying statues in the round, as well as the sculpture produced for monuments, memorials, fountains, gardens and parks. Similarly, Art Deco painting is usually limited to murals, screens and panels, and may include works preferred or commissioned by interior decorators.

The form and content of the radical art movements of the early twentieth century inspired their more decorative counterparts. From Cubism came stylization and geometric abstraction, while the vibrant colors of Art Deco were shared with Fauvism, Orphism and Synchromism. Art Deco shared with Futurism and Vorticism a fascination with dynamic movement, expressed by means of diagonal ray lines and zigzags, as well as the imagery of machine technology and the modern city – an imagery also explored by the American Precisionists. From primitivism came the use of exotic natural materials; an interest in tropical settings and exotic plants and animals; and the adaptation of motifs from African, South Pacific, pre-Columbian and American Indian cultures as well as those of ancient Egypt, Assyria, Minoan Crete and archaic Greece. Like Constructivism, Art Deco experimented with innovative combinations of industrial materials, with an emphasis on mass production and a collaborative effort to create an aesthetically unified environment responsive to modern needs; its underlying spirit was utopian or propagandistic.

A far more traditional foundation of the Art Deco visual arts were the perennially persistent classical revival styles that had been explored by sculptors of the preceding decades. As in architecture, neoclassicism provided important precedents, which went back to the late eighteenth century and the elegant linear illustrations and rhythmically stylized funerary reliefs of British artist John Flaxman. The ideas of Flaxman were taken up during the first half of the nineteenth century by the enormously successful Danish sculptor Bertel Thorwaldsen, who was revered by his contemporaries for what they saw as his archaeological correctness, although modern tastes now prefer the livelier and more inventive sculptures of Jean-Antoine Houdon and Antonio Canova.

In the late nineteenth century, a reaction to the increasing looseness and naturalism of style that was to culminate in Rodin's work was led by German sculptor and theorist Adolf von Hildebrand. In his book *Problems of Form*, Hildebrand promoted a stylized, abstracted monumentality and the harmony of architecture and sculpture, particularly through the use of low reliefs flattened by an invisible frontal plane. Several major proto-Art Deco sculptures in the Germanic re-

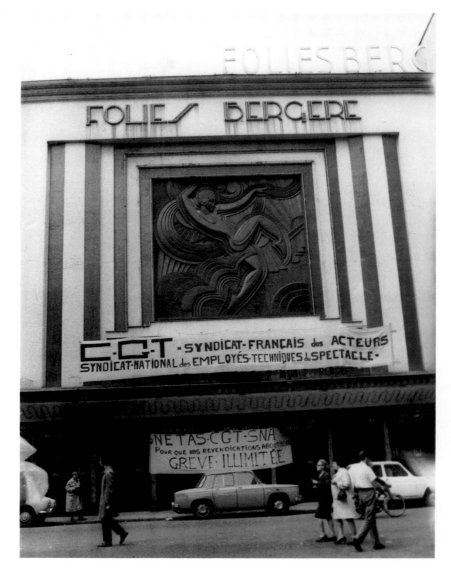

gion embodied von Hildebrand's ideas, including the Secessionist Franz Metzner's Leipzig memorial to the *Struggle of the Nations* (1902-13) and Hugo Lederer's medievalistic *Bismarck* memorial (1906) in Hamburg. In the years preceding Cubism, the ideas advanced by the Vienna, Munich and Berlin *Sezession* groups promoted symbolic stylization in architectural sculpture.

ABOVE: *Relief by Georges Picot (c 1925).*

BELOW: *Antoine Bourdelle's* Aphrodite *relief for Marseilles Opera (1924).*

RIGHT: *Alexander Archipenko's* Woman Combing Her Hair.

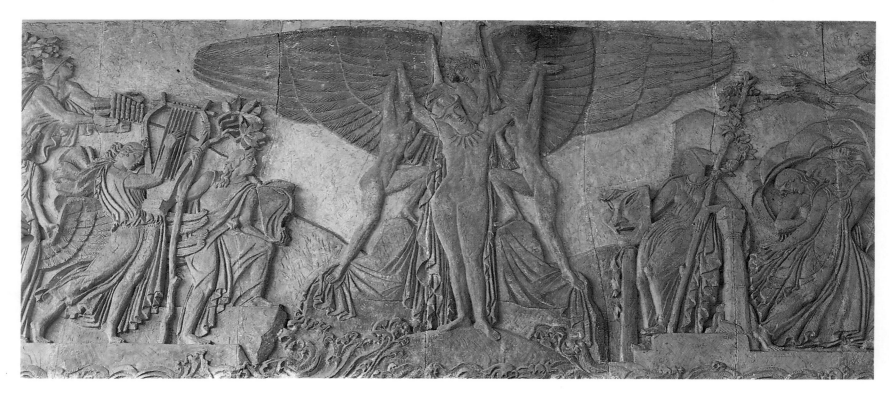

In France this trend was paralleled by the influential new classical abstraction of Paul Bartolomé, notably in his Paris *Monument to the Dead* (1899). Bartolomé, who opposed Rodin's modernism as well as the rigid canon of academicism, also produced decorative reliefs for private homes. In content, nevertheless, the typical allegory and didacticism of Art Deco sculpture continued a vital tradition of the academic art of previous centuries. In Belgium, meanwhile, the sculptor and early socialist Constantin Meunier began in the 1880s to produce bronze statues and reliefs of heroic laborers, a theme that was to become central to the Art Deco sculpture of the 1930s.

What is now considered by many as the pioneering Art Deco sculpture – the 'first great architectural sculpture done in the modern spirit' – was executed in Paris by an assistant of Rodin, paradoxically enough. Émile-Antoine Bourdelle's 1913 reliefs for Perret's *Theatre de Champs Elysées* suitably depicted the various arts in stylized rhythmic compositions based on ancient Greek prototypes. Soon to become a model for later Art Deco sculptors, Bourdelle's 21 relief panels and interior frescos included graceful dancing figures based on the iconoclastic Isadora Duncan, who was a source of inspiration to artists and dancers alike. The gala opening of the *Elysées* theater was recalled in 1975 by Erté as the most brilliant event he ever attended. Although Bourdelle also produced works in a more impressionistic mode, many of his subsequent public commissions continued this early Art Deco stylization. This duality of private and public styles was characteristic of many Art Deco sculptors. Art Deco was, in effect, a universal style aesthetically and symbolically accessible to the public, and eminently appropriate to its architectural settings in that its sharp contours and smoothed surfaces generally made it easily legible from afar.

In France the leading and probably most prolific creators of Art Deco sculpture were the twin brothers Jan and Joel Martel who experimented in all the new materials, including aluminum, glass and steel, and whose Cubist-influenced reliefs and sculptures embellished villas, theaters, architecture by Robert Mallet-Stevens and the Debussy monument in Paris. Major commissions arose from the international expositions and prompted the Martels' most memorable work, such as their Cubist 'trees' at the 1925 exposition.

Numerous other French sculptors worked on this and the later expositions. The most ambitious projects were the 1937 *Palais Chaillot* and the Museums of Modern Art, which were encrusted with reliefs and surrounded with freestanding sculptures erected by a large number of artists, many of whose names are unfamiliar today. Perhaps one of the better known was Alfred Janniot, who also created sculptures for other expositions of the era.

Various smaller, stylized pieces by sculptors of the French avant-garde were also related to Art Deco, as such works were frequently chosen as fashionable accessories for modernistic interiors. In line with the elegant abstraction initiated by Brancusi with his *Sleeping Muse* heads were the works of Elie Nadelman and Gaston Lachaise, while Cubism inspired the more geometrically angular works of Alexander Archipenko, Joseph Csaky, Henri Laurens, Jean Chauvin, Gustave Miklos and Jean Lambert-Rucki. Lambert-Rucki often worked with Jean Dunand, as seen in his exotic surface treatments, as well as for architects such as Robert Mallet-Stevens, Henri Pinguisson and even Le Corbusier. Many of these mainstream sculptors had been attracted to Paris from Russia, Poland, Hungary and other parts of eastern Europe. A number, including Archipenko, Nadelman and Lachaise later moved on to the United States.

A large output of graceful and frivolous figurines was produced for the more popular or nouveau riche tastes of the era. Many were freestanding pieces while others formed parts of lamp fixtures or other tabletop accessories. Popular subjects included Amazon women, flappers, dancers and acrobats, as well as animals. While some were made of blown glass or ceramic, the most costly wares were of chryselephantine, an exquisitely detailed combination of bronze and ivory. Among the leaders of this craft were D H Chiparus, Ferdinand Preiss, Alexandre Kelety, Bruno Zach, Pierre Le Faguays, Gerdago, and Josef Lorenzl. Chryselephantine work first became successful in Austria and Germany, although firms producing these goods were later opened in Paris.

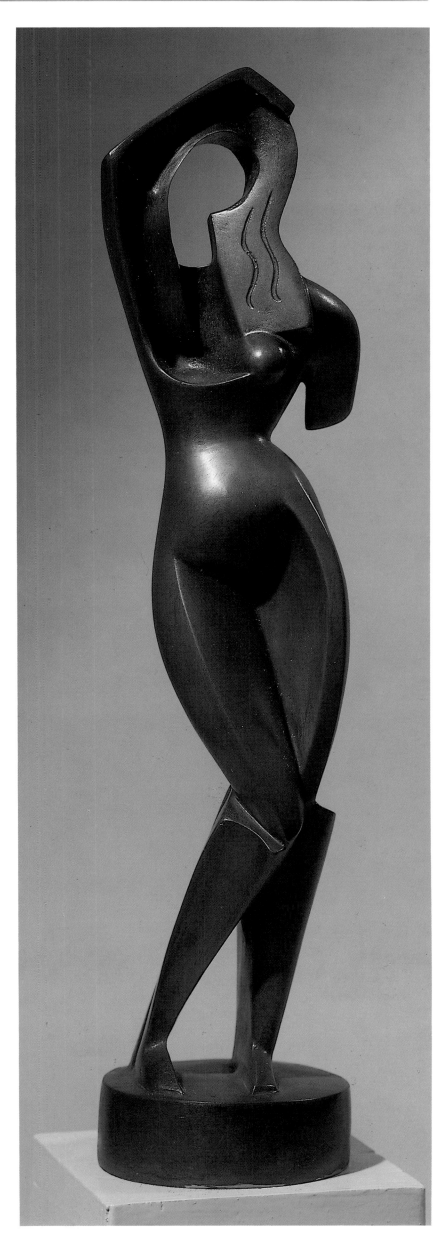

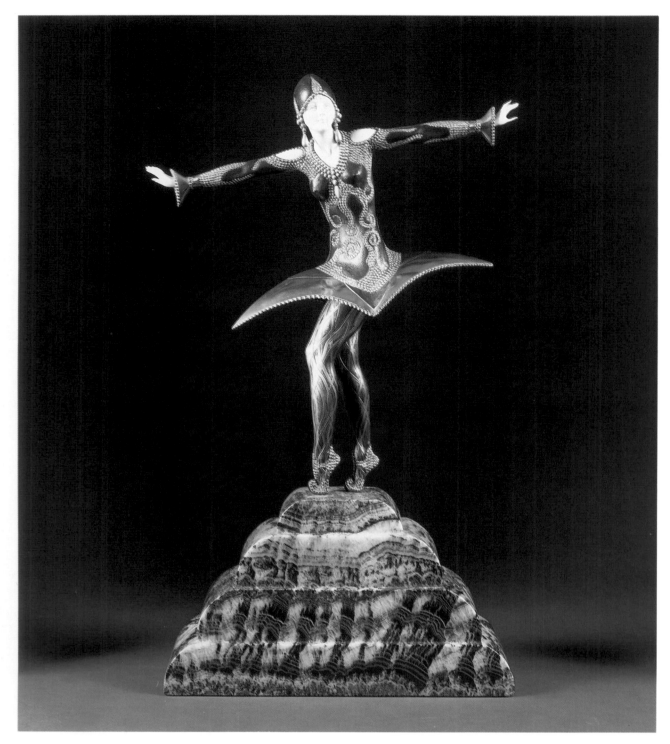

LEFT: Kora, *the figure of an exotic dancer designed by Demetre Chiparus.*

RIGHT: Testris, *a chryselephantine figure on a marble base, by Chiparus. Chryselephantine work combined ivory with patinated bronze to produce a sumptuousness that was characteristic of much Art Deco.*

In the early decades of the twentieth century, architectural sculpture in Germany and Austria was used symbolically to accent relatively austere building façades and courtyards; the work of Josef Riedl and Otto Hofner at Vienna's *Karl Marx Hof* is typical of this school. In northern Germany, under the influence of Expressionism and a tradition going back to Gothic art, the sculpture tended more toward the grotesque. This was changed, however, with the accession of the Nazis; idealized male nudes, propagandistic superman symbols of state power and Aryan purity, arose everywhere to inspire and intimidate the populace. Among the leading practitioners of this genre were Josef Thorak and a disciple of Maillol, Arno Breker, who returned in 1934 from Paris to find favor with the new regime and to produce stylish classicist male nudes for the new Reich Chancellery.

In the Soviet Union, stylized heroic workers became the norm in the 1930s. The most characteristic was the stainless steel *Worker and Collective Farm Woman* by Vera Mukhina, who had studied with Bourdelle. Mounted atop the 1937 Soviet pavilion in Paris, this work was later displayed in various sizes throughout the USSR. The Italian sculptures of the fascist era were somewhat more inventive. Stylized columnar fasces, militaristic paraphernalia, political allegories and, yes, heroic workers and athletes, embellished the new buildings, memorials, monuments and triumphal arches. In some cases classicist stylization gave way to crude cubistic planes symbolizing raw power, as in the work of Mario Sironi, the chief fascist sculptor, and even to the quasi-caricature of Mussolini in Ferucchio Vecchi's *The Empire.* The heroic workers of the totalitarian countries were paralleled in America in the relief and freestanding sculptures produced by artists

working in the government-subsidized and politically-motivated New Deal public building programs.

In England sculptors balanced Cubist emanations from Paris with the more staid, stylized classicism of Scandinavia. Perennially at the center of controversy was Jacob Epstein, whose modernistic architectural and monumental commissions inevitably resulted in a public uproar. The reaction to his Oscar Wilde tomb in Paris (1911-12) was typical. An exotic amalgam of Assyrian and archaic Greek motifs, the work was seen as scandalously erotic and was covered by a tarpaulin for two years. (This assimilation of alternative historicist decorative motifs from Egyptian, Assyrian, Cretan and archaic Greek sources became a strong current of Art Deco early in the history of the style.) A harsher fate met Epstein's series of niche figures on the theme of procreation for the British Medical Association building façade (1907). Some 30 years later, the building's new tenant had the figures mutilated. Vehement criticism in the press also met his Rima memorial to the writer W H Hudson (1925) and his primitivistic figures of Night and Day for the London Transport building. Architect Charles Holden, his frequent and enthusiastic sponsor, was offered the London University commission solely on the condition that he did not employ the controversial sculptor. Epstein received no public commissions for over 20 years and subsisted mainly on his Rodinesque portrait heads.

Holden's London Transport building also featured allegorical reliefs of the four winds by other leading sculptors, among them Eric Gill, Henry Moore and Eric Aumonier. Gill, who had trained as a stonemason and, like many other sculptors working in the Art Deco

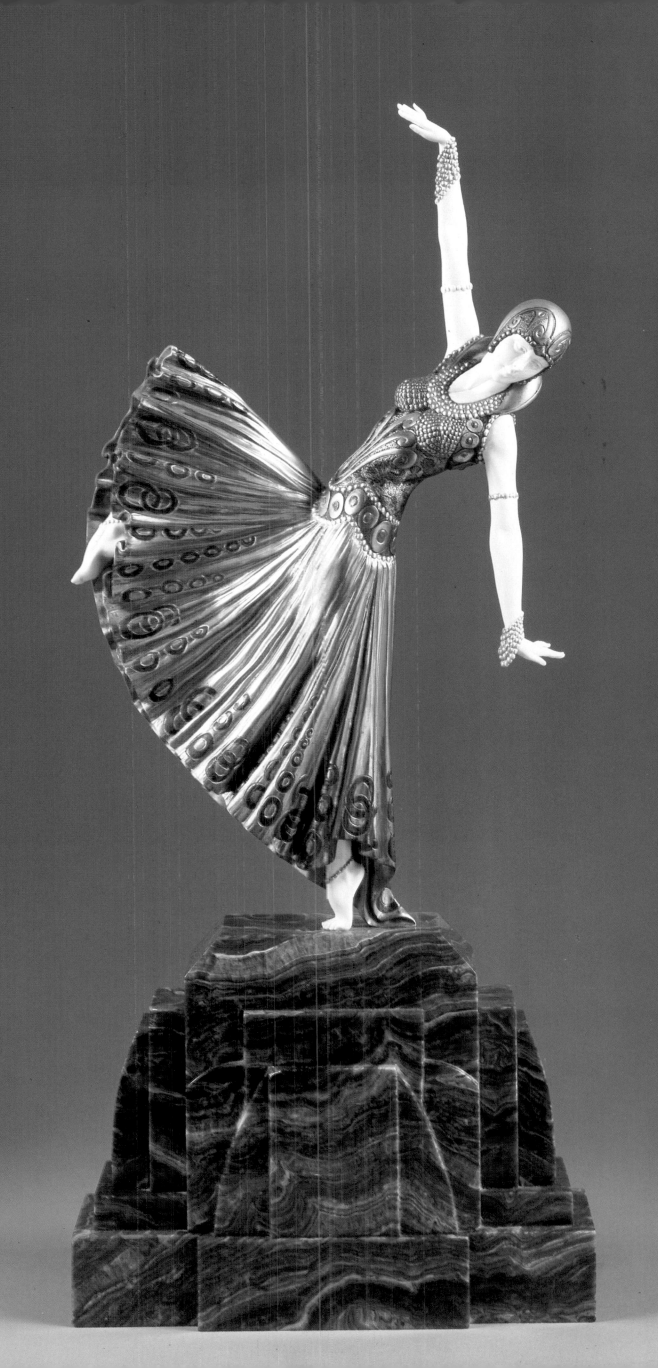

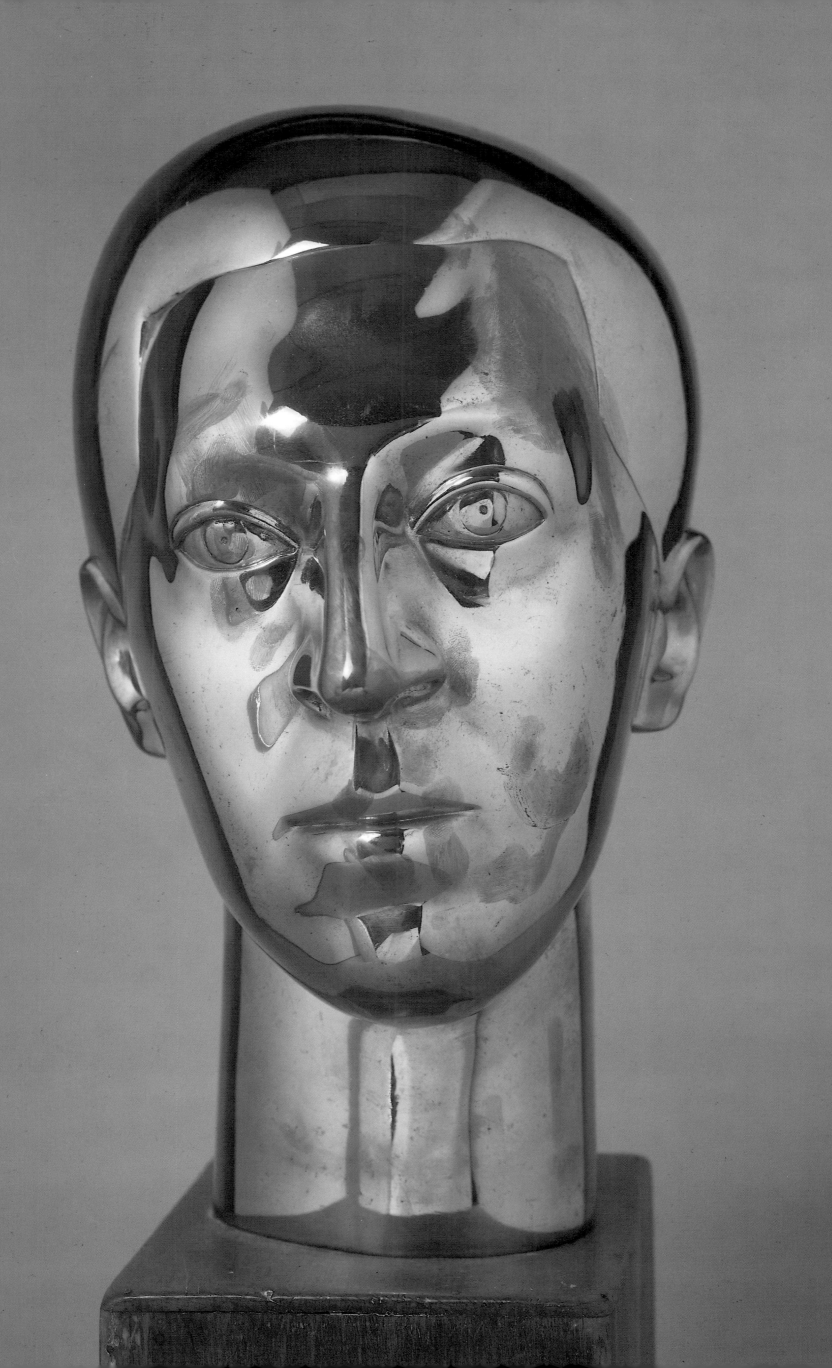

LEFT: *Frank Dobson's head of Osbert Sitwell.*

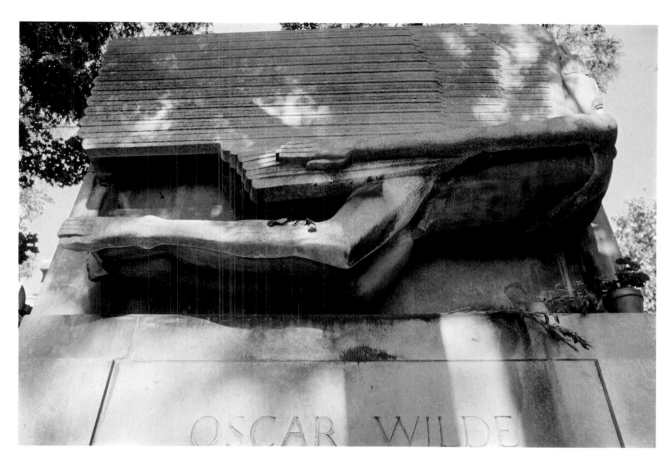

RIGHT: *Jacob Epstein's sculpture for Oscar Wilde's tomb (1912) in Paris.*

mode, was an advocate of direct carving, also produced Ariel and Prospero reliefs for the BBC building and an Odysseus and Nausicaa panel for Oliver Hill's Midland Hotel in Morecambe. Gill received commissions for the Palestine Museum in Jerusalem and for the League of Nations building in Geneva, as well as various religious commissions, for which he produced medievalistic sculptures. And the numerous World War I memorials raised during the era provided work for Gill and other sculptors. Aumonier also executed the Empire relief panels for the Daily Express building.

A sculptor popular with the Bloomsbury set was Frank Dobson, whose polished brass head of Osbert Sitwell reflected the fashion for stylized and elegant portrait heads, as did Jacques Lipschitz's *Gertrude Stein* (1920) and Matisse's *Henriette II* (1927). Though Dobson also completed a sculptural panel of reliefs in gilded faience for London's modernistic Hays Wharf Building, his career went into eclipse in the 1930s. A far more disturbing head was the cubistic *Hieratic Head of Ezra Pound* (1914) by the tragically short-lived Henri Gaudier-Brzeska, who also produced stylish woodwork designs for Omega Workshops and was active in the vorticist movement.

Numerous British sculptors studied in Paris and went on to produce graceful sculptures for the domestic and public setting. Typical of this output were the elegant dancer figurines produced by Antony Gibbons Grinling, though Grinling had a wider range of activity because of his collaboration with Serge Chermayeff. An important public commission resulted in his relief for the Cambridge Theatre.

The most public of the era's sculptures were the World War I memorials raised throughout the British Isles and the rest of Europe. Among the British examples, a quintessential one was the Hyde Park Corner Royal Artillery Memorial executed by Charles Sargeant Jagger and noteworthy for its Assyrian motifs combined with zigzag Art Deco rhythms. Jagger also sculpted the Cambrai Memorial in Louveral, France. One of the finest British memorials in France was Eric Kennington's Soissons monument. Kennington modeled his Battersea Park Memorial (1924) on his friend Robert Graves, and carved the T E Lawrence tomb (1939) with Lawrence of Arabia as a medievalistic recumbent effigy. Another major commission led to the carved reliefs of modern allegories of treachery, war and love for the façade of the new Shakespeare theater.

RIGHT: *Jacob Epstein's Rima memorial (1925) in London's Hyde Park.*

RIGHT: *Isamu Noguchi's portrait head of Buckminster Fuller (1929).*

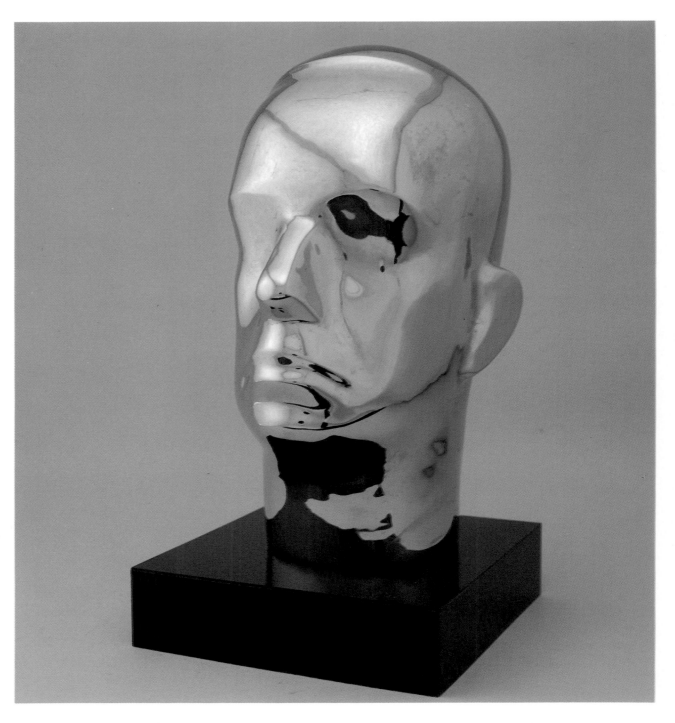

In the sculpture of Scandinavia, as in its architecture, a stylized classicism ruled. The *Guardians of Transportation* by Emil Wikström for Saarinen's Helsinki railroad station, however, probably owed their folkloric primitivism to the ideas of the Germanic Secessionists and to Expressionism. Far more typical was the work of Gustav Vigeland, whose ambitious grouping of over 150 sculptures for Oslo's Frogner Park constituted the largest European governmental commission of the era. Though his earlier fountain bronzes, which he began producing in 1906, were allied to Art Nouveau and Expressionism, the later idealized granite figural groups – seen by some contemporaries as too overtly erotic, and by others as the outpourings of a megalomaniac – owed much to classicism.

Although Vigeland was little known outside of Norway, Sweden's Carl Milles achieved international reknown and became one of the most successful sculptors of the Art Deco era. The master of numerous fountain groupings, garden and courtyard figures, Milles had worked for a time as an assistant to Rodin. Following his European triumphs, he moved to the United States to teach at Cranbrook Academy under Saarinen. Milles's major works included his *Europa* fountain (in Sweden, at Cranbrook and the Chicago Art Institute), the *Diana* fountain for Chicago's Michigan Square building, the *Orpheus* fountain in front of Tengbom's Stockholm Concert Hall, the Aztec-style *Peace Monument* for St Paul City Hall and the *Meeting of the Waters* fountain in St Louis.

The international reputation of Milles was equalled only by that of the versatile and prolific Yugoslav Ivan Mestrovic, who had studied with Otto Wagner and others of the Vienna *Sezession*. In the years immediately before and during World War I, Mestrovic's stylized but distinctively expressive sculptures – some inspired by archaic Greek art, others by Rodin – were seen in major exhibitions in Vienna, Rome, Paris and London, leading to important commissions for public monuments at home and abroad. Most characteristically Art Deco were his bronze equestrian Indians for Chicago's Grant Park (1926-27), and the *Monument of Gratitude to France* and the *Tomb of the Unknown Soldier*, both in Belgrade. Mestrovic also produced many religious works, some of which were related in style to Gothicism, while others could be classified as Art Deco. His carved wood relief cycle of the Life and Passion of Christ, and his commissions for the Vatican were particularly impressive. After World War II Mestrovic moved to the United States where he continued to produce his by now conservative works, which were still eagerly sought after by such well-endowed patrons as the Mayo Clinic and Washington's National Shrine of the Immaculate Conception.

In the United States the late nineteenth-century Gilded Age decades known as the American Renaissance saw architectural sculptors achieve enviable status through the patronage of leading architects such as Richard Morris Hunt and McKim, Mead & White, who worked with Augustus Saint-Gaudens, Daniel Chester French, Frederick MacMonnies and others. The era's crowning achievement, the Boston Public Library (1887-97), was profusely decorated by a collaborating team of pre-eminent painters and sculptors.

One of the first public monuments to display modernistic stylization was New York's *Carl Schurz Memorial* (1913); its reliefs by Karl Bitter were indebted to archaic Greek art. A Viennese sculptor who had arrived in 1887, Bitter had worked with Richard Morris Hunt on Biltmore, the palatial Vanderbilt estate, and on the facade figures of the Metropolitan Museum of Art, among other major public and private architectural commissions.

Frank Lloyd Wright was undoubtedly the first American architect to use geometrically stylized sculpture, sometimes after his own design. Sculptor Richard Bock, who arrived for the 1893 Chicago World's Fair and who had worked for Adler & Sullivan, spent some 20 years working closely with Wright. Among the projects in which he participated were the 1903 Dana House, the Larkin Building, the Unity Temple and Midway Gardens. Bock's sculpture, along with that of Alfonso Iannelli, who also worked on Midway Gardens, is reminiscent of the architectural sculpture of the Amsterdam School. As did Bock, Iannelli later collaborated with other Prairie School architects, including Purcell & Elmslie and Barry Byrne, on courthouses, schools and churches. A major commission for Iannelli was the sculptural embellishment of Chicago's Adler Planetarium.

Some leading sculptors of the era were able to balance avant-garde experimentalism with public commissions in the Art Deco style. John Storrs, who had studied with Rodin and stayed on in France with frequent trips back to New York and Chicago, produced Cubist figural studies, along with elegant nonobjective explorations of new material combinations, coloristic effects, and geometric motifs; among his most typical work were the 'skyscraper' sculptures, which resembled abstracted architectural models. His interest in Bourdelle's *Elysées* reliefs and in Joseph Stella's futuristic paintings was reflected in his designs for public monuments, particularly in his polished cast aluminum *Ceres* (1929) for the top of Chicago's Board of Trade building. This streamlined machine-age colossus has been called the 'ultimate Art Deco goddess.'

Equally versatile was the young Isamu Noguchi, who had studied with Gutzon Borglum of Mount Rushmore fame and in Paris with Brancusi. The influence of Brancusi could be seen in his gleaming machine-like head of Buckminster Fuller (1929). The Oscar statuette of the Academy Awards by art director Cedric Gibbons was Hollywood's counterpart of Noguchi's intellectual 'superman.' Noguchi also produced a tribute to another of the era's cultural stars in his stylized head of George Gershwin. Elegant depersonalized mask-like heads became a popular Art Deco motif, and were produced by Elie Nadelman, Gaston Lachaise, William Zorach and Sargent Johnson, among others. Noguchi's large-scale public works included the 10-ton stainless steel depiction of heroic newspaper workers for Rockefeller Center's Associated Press building, and a 72-feet long re-

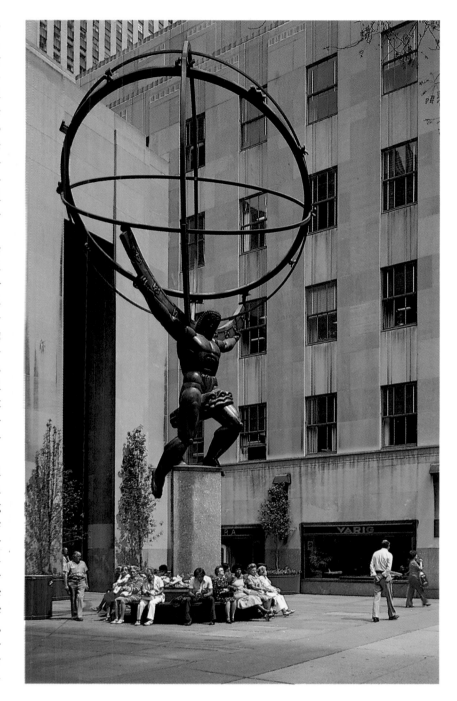

ABOVE RIGHT: *Lee Lawrie's sculpture of* Atlas *at Rockefeller Center.*

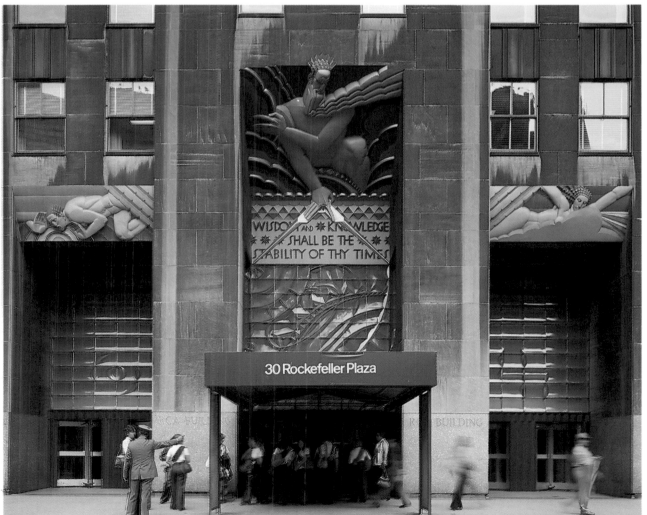

RIGHT: *Lee Lawrie's* Wisdom *relief at Rockefeller Center.*

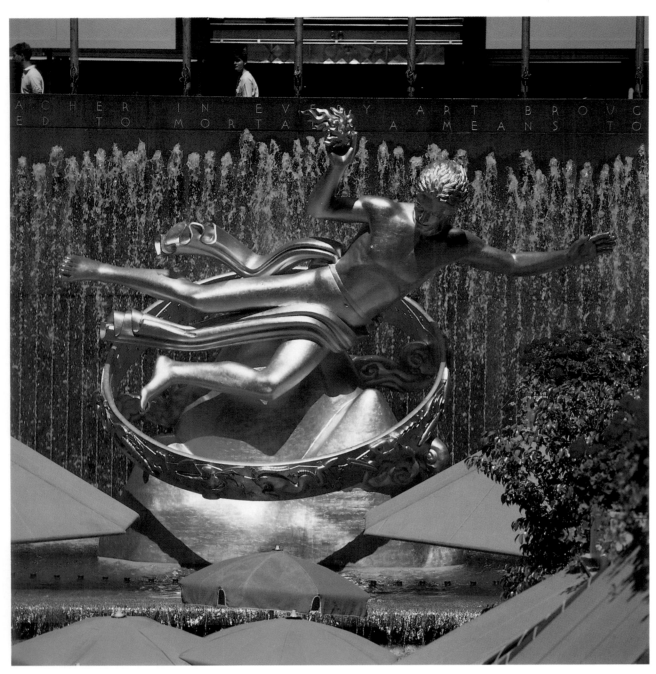

LEFT: *Paul Manship's* Prometheus *at Rockefeller Center plaza.*

BELOW LEFT: Oscar *(c 1929) designed by Cedric Gibbons.*

BELOW: *Paul Manship's* Day *(1938), bronze on marble base.*

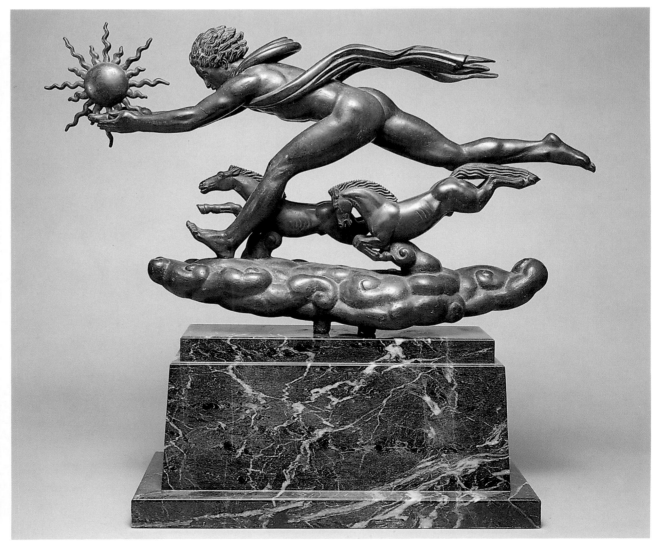

lief of polychrome cement, *The History of Mexico* (1935-36). In a more constructivist vein were his *Chassis Fountain* for the 1939 New York World's Fair, and the 1933 competition design, *A Bolt of Lightning: A Memorial to Benjamin Franklin*, which was finally erected in Philadelphia some 50 years later.

The American building boom of the era offered wide opportunities for architectural sculptors and was a magnet for European artists. German-born Lee Lawrie, who worked with architect Bertram Goodhue on the Nebraska State Capitol and other projects, became known as the 'dean' of American architectural sculptors, not only for his impressive body of work but also for his teaching of other sculptors. Key examples of Lawrie's work are the 1922 Chicago *Fountain of Time* and Rockefeller Center's *Atlas*.

The major sources of architectural sculpture commissions were the zigzag skyscrapers of the 1920s, the classical moderne civic and governmental buildings of the 1930s, the complex of new federal buildings in Washington, the various international expositions, and Rockefeller Center. A vast army of sculptors was kept at work, and the stylistic variations ranged from the lively, graceful imagery of the 1920s French style to a more pompous allegorical and heroic imagery based on classical roots, and encompassed primitivistic works inspired by Aztec, Indian, African or oriental motifs.

Among the busiest sculptors were those who had studied at the American Academy in Rome, and foremost among them was Paul Manship, an accomplished producer of elegant decorative interpretations of classical mythology, with linear stylization that drew on ancient Mediterranean art. His fellow graduates of the American Academy included Sidney Waugh (who also had studied with Bourdelle), Carl Paul Jennewein, Edmond Amateis and Leo Friedlander. And this American sculpture boom kept many other sculptors busy, including the prolific René Paul Chambellan, Lorado Taft, John Gregory and Edgar Miller. The European modernists who arrived in the United States did not devote themselves exclusively to the larger architectural works; William Zorach, Robert Laurent, Boris Lovet-Lorski and W H Diederich also drew on Cubism, Futurism, the machine aesthetic and streamlining to create stylish works for fashionable interiors.

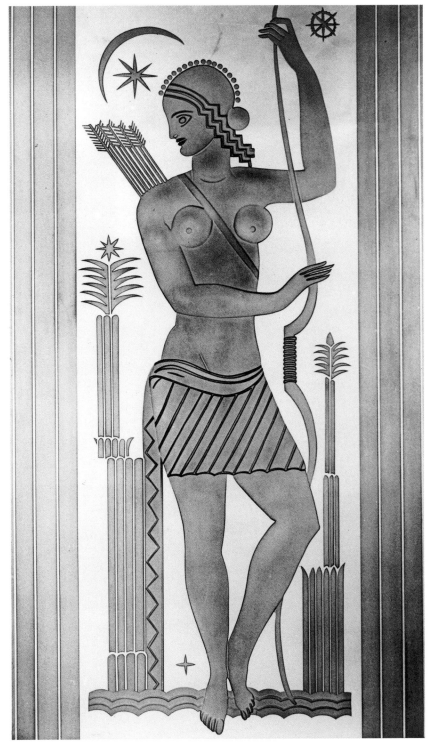

ABOVE RIGHT: *Edgar Miller's etched glass panel of the goddess Diana (1929-31) from the Diana Court of Holabird & Root's Michigan Square Building in Chicago.*

RIGHT: *Gutzon Borglum's colossal Mount Rushmore Memorial (1925-41) in South Dakota set the precedent for New Deal arts programs of the 1930s.*

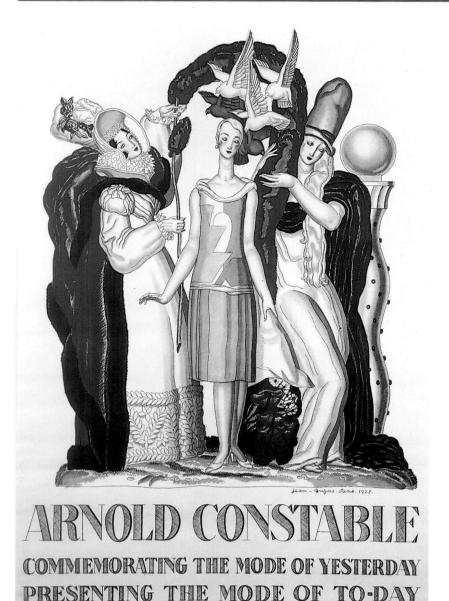

ARNOLD CONSTABLE

COMMEMORATING THE MODE OF YESTERDAY
PRESENTING THE MODE OF TO-DAY
FORECASTING THE MODE OF TO-MORROW

Art Deco painting shared many themes with sculpture. Since it was frequently employed in a less formal manner, however, it was able to present, in elegantly stylized and strikingly colored images, a vivid chronicle of the times. An important subject of the painting and graphic arts of the period were the hedonistic pleasures and fashionable entertainments of the frivolous 1920s: the liberated flappers with their chic clothes and accessories; the new open sexuality; sun worship; public cigarette smoking for women; cocktail parties; the popular sports; night club life; pulsating jazz music; the latest theatrical sensations; the intoxicating escapism of speeding automobiles, trains and planes; the allures of travel; the exoticism of the primitive; and above all, the quintessential activity of the jazz age, dance – that of Isadora Duncan, the Russian Ballet, the tango, the Charleston, the uninhibited Josephine Baker with her pet leopard and snakes, and the sophisticated Fred Astaire and Ginger Rogers.

In France, many of the leading decorative painters also produced illustrations and graphic works. The Bordeaux group formed the vanguard of this trend; its members included Jean Despujols, Robert Eugene Pougheon, Emile Aubry, Jean-Gabriel Dormergue, Raphael Delorme and, foremost, Jean Dupas. Also a major graphic artist, Dupas executed panels for Ruhlmann's 1925 exhibition pavilion and received major commissions to provide works for the ocean liners *Ile de France, Normandie* and *Liberté*. The consummate jazz-age woman, an idealized, sensual goddess, was depicted in portraits by the Russian emigré Tamara de Lempicka. Other artists producing decorative works and pieces designed to complement Art Deco interiors were Kees Van Dongen, Marie Laurencin, Tsuguharu Foujita, Jean Lambert-Rucki, Raoul Dufy (who also produced textile designs), André Lhote, Gustave Miklos and Auguste Herbin.

Some of the most splendid French Art Deco paintings were those executed for folding screens. The master of this genre was Jean

Dunand, who had come from Switzerland to Paris to study sculpture. He worked on the monumental winged horses of the Alexandre III bridge, and went on to specialize in exquisite lacquer work which elegantly interpreted the entire repertoire of Art Deco motifs. Dunand, who worked in metal as well as the lacquer adornment of panels, cabinets and tables, built up a workshop of nearly 100 artisans and designers. His most famous work was the colossal carved lacquer screen for the smoking room of the *Normandie*. Leon Jallot, François Louis Schmied and Charles Martin also produced some memorable Art Deco screens. Eileen Gray, a British designer working in France, executed some 20 screens in lacquer and also in metal, celluloid and cork. These screens displayed a more austere interpretation of Art Deco, and were intended as architectural adjuncts. Shop displays provided a ready market for painted screens and many important designers, including Robert Mallet-Stevens, co-ordinated such projects.

The participation of avant-garde artists in Art Deco projects underlines the fact that the demarcation line between the fine arts and the decorative arts was at times tenuous. Robert Delaunay, a central figure in the development of Simultaneism and Orphism, worked closely with Mallet-Stevens to provide appropriate paintings for exposition pavilions of the 1920s, and 1930s. Delaunay also produced stylish portraits such as the one of Mme Heim wearing a dress and scarf designed by Sonia Delaunay, his wife. Together Robert and Sonia Delaunay completed several painted screens. Fernand Léger, a pivotal figure in Cubism, was intensely interested in mural painting, seeing himself as a 'destroyer of dead surfaces.' He was eager to integrate art and architecture by collaborating with architects to create an art that could be enjoyed by all social strata. Léger's work – stylized, colorful, hieratic, relief-like and informed by the machine aesthetic – was appropriate for the adornment of domestic and public modernist settings. Similarly, some of the output of the Futurists was

FAR LEFT: *Jean Dupas, the leading French Art Deco painter, was known for his elongated tubular women, as seen in this 1928 poster.*

LEFT: *Dupas also executed glass panels for the liner* Normandie.

BELOW: *Tamara de Lempicka's painting* Romana de la Salle *(oil on canvas, 95"×27", 1929).*

LEFT: Claire de Lune, *a five-fold lacquer screen by Jean Dunand.*

RIGHT: Praxitella *(1921), a portrait of Iris Barry by Wyndham Lewis.*

BELOW: Battle of the Angels: Crescendo and Pianissimo *(1925-26), a pair of three-panel screens lacquered by Jean Dunand, with figures designed by Seraphin Soudbinine.*

quite decorative in quality. The Italian artist and designer Fortunato Depero, for example, created striking geometrically stylized wall hangings, cabaret and restaurant interiors, theater sets, furniture and graphics, all of which were allied to Art Deco.

Vorticism, the iconoclastic British response to Futurism and Cubism, was another source of decorative work. The movement's leading spirit, Wyndham Lewis, produced not only elegantly cubistic portraits, but also vibrant red murals for Ford Madox Ford's London study, murals for the Rebel Art Centre, and a 'Vorticist Room' for the *Restaurant de la Tour Eiffel*. Lewis also collaborated on the decor of London's first avant-garde night club, the Cabaret Theatre Club,

which was opened in 1912 by the divorced wife of August Strindberg. There, modernistic murals depicting dance, outdoor sports and tropical scenes by Lewis, Charles Ginner and Spencer Gore were accompanied by the sculptures of Jacob Epstein and Eric Gill.

In 1913 Lewis produced a painted screen of dancers and acrobats for the opening of Roger Fry's Omega Workshops, an enterprise that sought to apply Cubist and Fauvist principles to the decorative arts. Among Omega's mural projects were those by Duncan Grant, Frederick Etchells and others for Borough Polytechnic, and interior work for the Cadena Cafe. While Lewis, Gaudier-Brzeska and others seceded from the group, Duncan Grant, Vanessa Bell and Fry went on

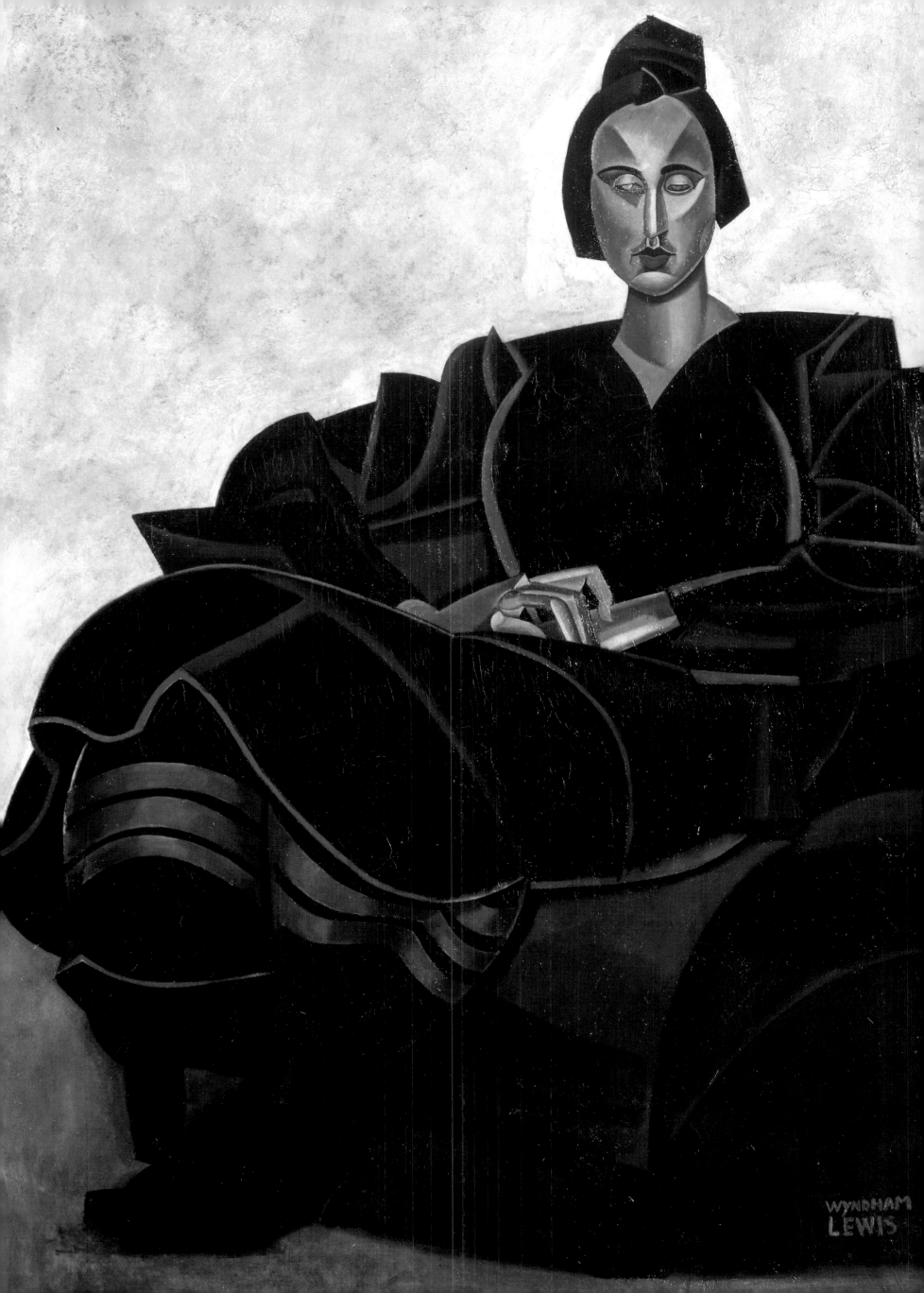

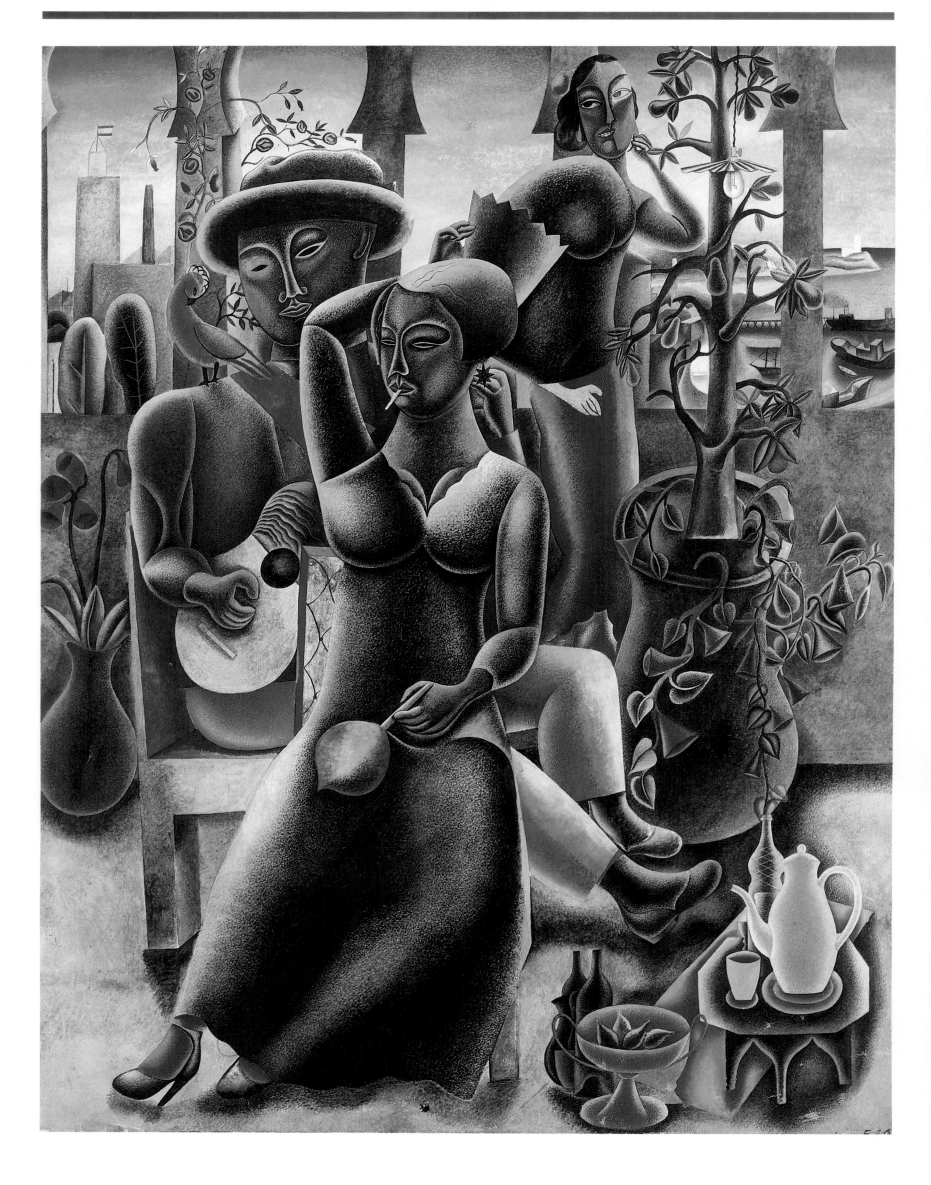

ABOVE: *The decorative stylization of*
Art Deco is seen in The Terrace
(gouache, 23"×18", 1929) by
British painter Edward Burra.

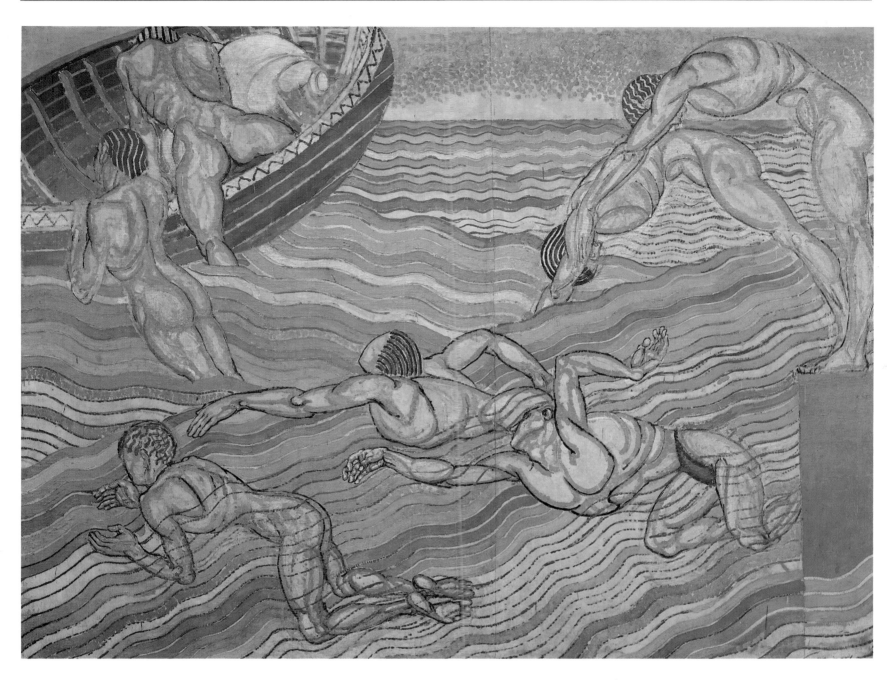

to execute some handsome modernistic screens and painted furniture panels. Some years later, Grant's large panels for the *Queen Mary* were rejected.

Frank Brangwyn, whose work was often reminiscent of the Arts and Crafts era, was active throughout the Art Deco years, designing furniture and creating screens and murals. A major project were the 18 panels commissioned by the House of Lords in memory of the peers lost in World War I. The stylized paintings glorifying the British empire were rejected after considerable controversy, and later placed in the guildhall of Swansea, Wales. In England, the Depression hit artists particularly hard and many turned to designing china, screens and decorative paintings for private clients and shops, not just in the Art Deco style but in the whole range of revival styles, as well as those reflecting Impressionism and Surrealism.

A characteristic of the American avant-garde painters of the early decades of the twentieth century was their inherently conservative response to the European artistic experiments: Man Ray's interpretation of Cubism, Joseph Stella's version of Futurism and Louis Lozowick's Constructivist creations all possessed decorative qualities similar to those seen in the work of the later French Cubists. The emphasis was on distinctively American subject matter; skyscrapers, bridges and factories were glorified in the work of Charles Sheeler, Elsie Driggs and other Precisionists.

Much of this subject matter and stylistic technique was adapted, together with the elegant motifs from French Art Deco, by the numerous decorative painters at work on the nightclubs, hotels, restaurants, theaters and movie palaces of the era. Of the private projects that provided commissions, Rockefeller Center was the most ambitious; there, the murals of leading decorative painters were combined with the work of Art Deco sculptors to produce interiors of unequalled stylishness. Many of the same painters, some 33 in all, went on to produce 105 murals for the New York World's Fair, just as

ABOVE: *Duncan Grant's* Bathing *mural for Borough Polytechnic (c 1913).*

BELOW: *Vanessa Bell's screen* Bathers in Landscape *(1913) showed the influence of Cubism.*

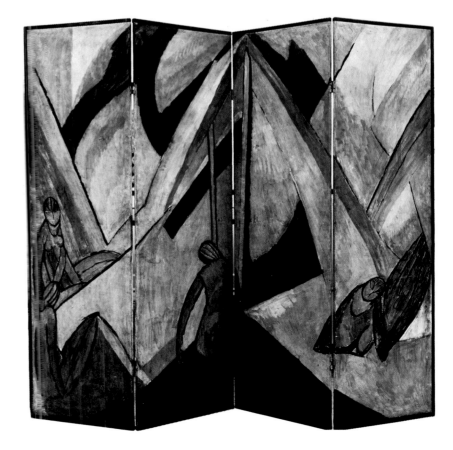

LEFT: *Eileen Gray's lacquer screen*
Le Destin *(c 1913).*

BELOW LEFT: *A screen by Charles
Baskerville (1932).*

BELOW RIGHT: *A screen of inlaid
woods by Frank Brangwyn.*

they had provided mural decoration for other expositions of the decade. Some of the leading names were Hildreth Meiere, Winold Reiss, Witold Gordon, Ezra Winter, Henry Billings, Boardman Robinson, Yasuo Kuniyoshi, Alfred Tulk and Pierre Bourdelle (son of the French sculptor).

As in Europe, painted screens were sought after as accessories to Art Deco interiors. In his earlier days, Donald Deskey painted a number of screens with abstracted and geometric designs, and at times incorporating leather and silver or bronze leaf. Thomas Hart Benton, in his pre-regionalist years as a Cubist, completed several attractive screens, including one with an abstract motif of waves and clouds. Among the more prolific decorative screen painters were Robert Winthrop Chanler, whose best Art Deco screens were of stylized tropical and jungle scenes, and Charles Baskerville, who completed many screens and murals for private houses. Many of his screens depicted exotic animal and plant motifs, and some of them were executed in lacquer work. Baskerville's most important commissions were panels of Everglades scenes for the ship *SS America*, for which Pierre Bourdelle also executed mosaic and linoleum murals.

The Depression years brought a more serious tone to architectural mural painting. To allay the economic catastrophe, President Roosevelt's administration initiated a vast and unprecedented experiment in government patronage of the arts. Thousands of artists, designers and architects were kept employed by the various New Deal programs. The beneficiaries of this largesse included decorative, conservative and avant-garde artists. Some artists who were allied to Art Deco, including Ruth Reeves, Sargent Johnson and Elsie Driggs, became administrators of the programs, while others worked at easel paintings and murals to adorn post offices, libraries, schools, hospitals, courthouses, prisons, government buildings, air terminals and other public structures. Some 4000 murals were executed, most of

ABOVE: *An abstract painted screen (c 1929) with metal leaf by Donald Deskey.*

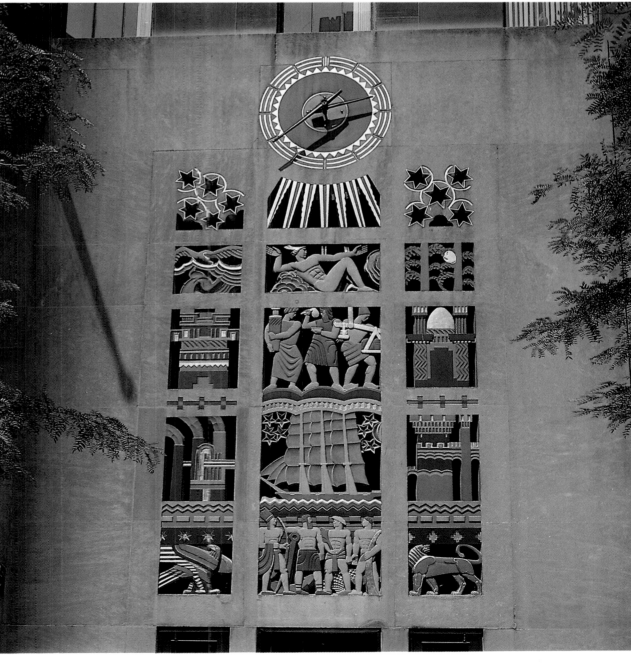

RIGHT: *Decorative mural reliefs at Rockefeller Center.*

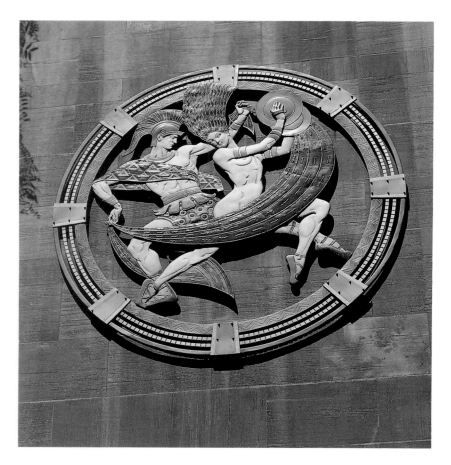

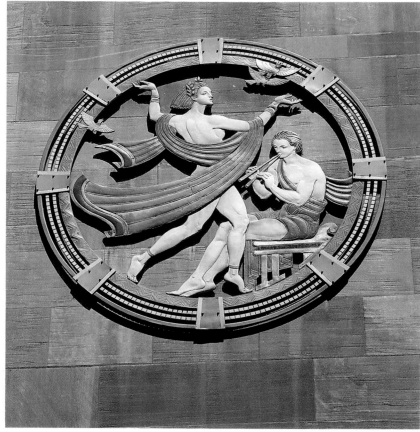

which still survive. Because of the conservatism of popular taste, especially in rural areas, radically innovative art was overshadowed by stylized representational imagery incorporating many of the Art Deco motifs dealing with transportation, communications, dynamic energy and allegorical heroic figures. A particular favorite were pompous panoramas of the progress of civilization, of national and regional history and legend, and of technological evolution, in which the present era was the self evident culmination of all that had come before. The New Deal murals, in their content and their reassuringly classicist style, reflected national aspirations for recovery, stability and endurance. The preferred works were optimistic, inspiring and didactic, celebrating civic virtues and human achievements, rather than those which criticized social and political conditions. Overtly or subtly inserted socialist, Marxist or anti-American messages inevitably led to controversy and frequently to censorship, as at San Francisco's Coit Tower, with Rockwell Kent's Washington Post Office mural, and with the privately commissioned Rockefeller Center mural by the Mexican revolutionary painter Diego Rivera.

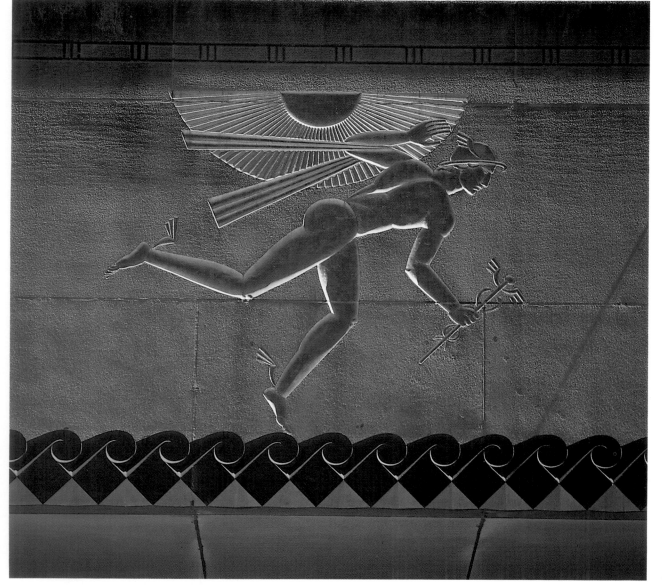

ABOVE: *At Rockefeller Center's Radio City Music Hall the decorative plaques celebrating Dance (left) and Song (right) were designed by Hildreth Meiere.*

LEFT: *A gilded Mercury at Rockefeller Center.*

RIGHT: *In the RCA building lobby in New York, José Sert's murals replaced Diego Rivera's controversial pro-Marxist design.*

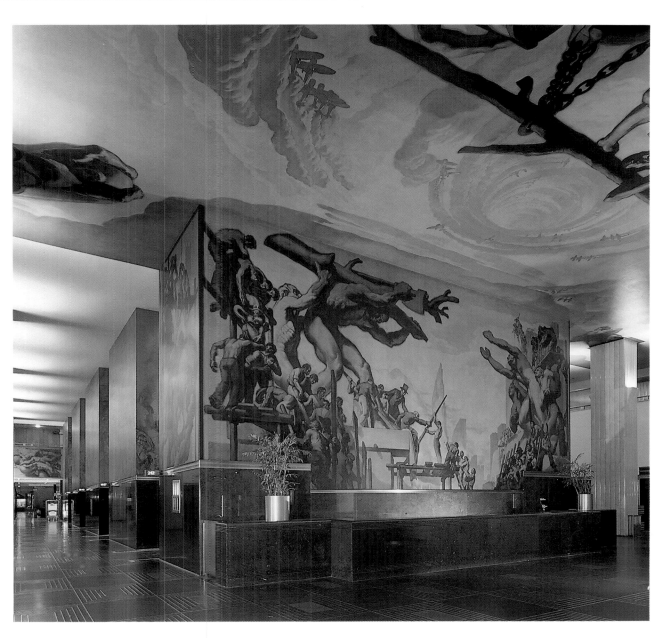

BELOW: *Diego Rivera's* Detroit Industry *(1932-33), a wall of his mural program at the Detroit Institute of Arts.*

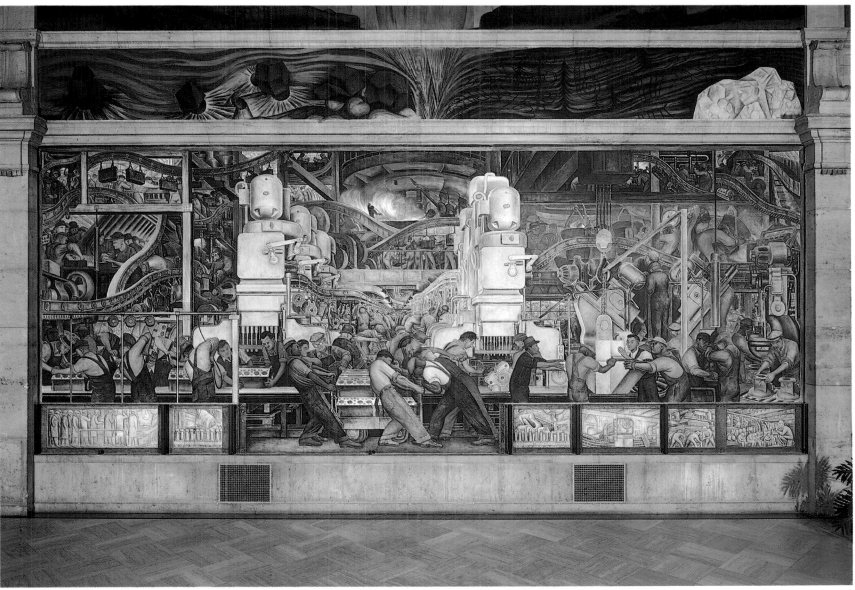

worked for *Vogue* and *Vanity Fair* magazines, also producing a remarkable series of portraits of celebrities of the era. Through the use of brilliant lighting and dramatic dark shadows, he brought the angular diagonals and decorative abstraction of Art Deco to many of his sophisticated fashion layouts and to his elegant portraits.

Among others exploring these avenues of fashion illustration and portraiture were Horst P Horst, George Hoyningen-Huene, George Platt Lynes, Baron Adolf de Meyer, Martin Munkacsi and Nicholas Muray, famous for his portraits of glamorous Hollywood film stars. Steichen's pioneering advertising works was paralleled by the activities of Victor Keppler. In England, stylish experiments in technique and image were carried on by Emile Otto Hoppé, whose speciality was theater photos, and the flamboyant Cecil Beaton, who sometimes obtained Art Deco effects through the inventive use of appropriate props and painted backdrops.

The glorification of machines, factories, bridges and skyscrapers that was characteristic of Futurism and American Precisionism, and also reflected in Art Deco, was a prominent feature of industrial photography during the 1920s and 1930s. Powerful examples were produced by Charles Sheeler, Margaret Bourke-White, Edward Weston, Andreas Feininger, Walter Peterhans, Germaine Krull and by Berenice Abbott, who came back to the United States from France to document New York during the height of its skyscraper building boom. Lewis Hine participated by documenting heroic laborers in his book *Men at Work* (1932). President Calvin Coolidge summed up

Many politically radical New Deal muralists revered, and some even had worked as apprentices to, the Mexican master Diego Rivera. Such a cult developed around Rivera and his compatriots that many artists with socialist and Marxist leanings considered it a vital part of their artistic education to travel and study in revolutionary-era Mexico, where official patronage of the arts gave rise to an impressive body of public murals. After his early years as a Cubist in Paris, Rivera had returned to Mexico to find inspiration in pre-Columbian art for his own stylized, primitivistic and propagandistic frescoes, which also incorporated motifs from technology. Some of Rivera's finest work was executed in the United States where, ironically, the 'Raphael of Communism' received major commissions from leading capitalists for the San Francisco Stock Exchange, for Rockefeller Center and for what is probably his finest work, the mural cycle sponsored by Edsel Ford for the Detroit Institute of Arts. In 1931 New York's Museum of Modern Art granted its second ever solo exhibition to Rivera (the first had gone to Matisse) in tribute to his central role in the modern mural movement.

Nor did photography remain unaffected by the Art Deco style. The revolution in the fine and decorative arts initiated by Cubism had a significant impact on the advertising, fashion, and portrait images produced by leading photographers of the 1920s and 1930s. Motifs from the Art Deco repertoire were highlighted, and its stylistic characteristics emphasized by means of specific camera and darkroom techniques. Typical was the use of dynamically oblique or diagonal camera angles; the use of dramatic close-ups; the use of strong contrasts of light and shadow; the use of silhouetting and mirroring effects; the exploitation of decorative or flattened geometric patterning; and the deliberate compositional selection and cropping of images to enhance rhythmic repetition, to create artistically abstract images from machine parts, or to give a powerful emphasis to diagonal structural elements.

The way in fashion and advertising photography was led by the American Edward Steichen, who had started out as a painter and pictorialist photographer specializing in hazy romantic effects. During duty in World War I as an aerial photographer he was required to produce images of the utmost clarity. The results of his aerial work were such a revelation that Steichen systematically set out to relearn the fundamentals of photographic technique. From 1923 to 1938 he

ABOVE LEFT: *This portrait of Noël Coward (1932) by photographer Edward Steichen captures the spirit of the artist and the era.*

BELOW: *Cecil Beaton used painted props to evoke Art Deco in his unconventional portrait of Lady Milbanke (1927).*

RIGHT: *Margaret Bourke-White's NBC photomural at Rockefeller Center included the panel,* Loudspeakers in Factory at Camden, NJ.

the quasi-religious nature of this 'industrial mythos' when he stated that 'the man who builds a factory builds a temple, (and) the man who works there worships there.'

The aesthetic stamp of approval was imprinted on such subject matter in 1932 when New York's Museum of Modern Art organized its *Exhibition of Photographic Mural Design*, which included designs by Abbott and Steichen as well as Charles Sheeler's montage triptych based on images from his seminal *River Rouge* portfolio, the publication of which had brought him worldwide recognition. In the following year, an architectural context was provided for such work when Rockefeller Center commissioned photomurals from both Bourke-White and Steichen. Bourke-White created a grouping of panels for the lobby of the new NBC offices composed of a series of juxtaposed and enlarged close-ups of technological components used in the broadcasting industry. Steichen executed a photomural based on the history of aviation for the men's lounge of the now demolished Roxy

Theater. In the same year, the Chicago exposition featured a colossal photomural.

Some of the more interesting photographic analogies to Art Deco came from the experimentalists of the avant-garde. The pioneering Czech photographer František Drtikol relied on relatively conventional means to evoke the Art Deco style. He combined large geometric wooden shapes, echoing Cubist forms, with carefully posed female nudes. Notable were the cameraless prints of opaque objects laid on light-sensitive photographic paper. While Moholy-Nagy named them photograms, Man Ray called them rayographs. Solarization, which became a favorite technique for Man Ray, Maurice Tabard and others, involved the exposure of negatives to light during the development process, thus bleaching out the intermediate tones. The result was imagery resembling silhouetted silvery flattened reliefs, an elegant photographic equivalent of the stylized, depersonalized figures of Cubism and Art Deco.

Index

Page numbers in *italics* refer to illustrations

Aalto, Alvar 66, 78
Abbott, Berenice 108, 109
Adler, Rose 61
American Indian art 85
Amsterdam School architecture 23, 39, 95
Archipenko, Alexander 85, *88*, 89
Art Nouveau 8, 22, 58, 59
Arts and Crafts Movement 42, 45, 58, 103
Asplund, Erik Gunnar 41
Astaire, Fred 98
Aumonier, Eric 90, 93
Australia
 architecture 22
Austria
 sculpture 90
 see also Sezession, *Wiener Werkstätte*
automobiles 13, 14, 30, 63
aviation 30, 47

Bach, Oscar 81
bakelite 78
Baker, Josephine 98
banks 23, 38, 85
baroque style 58
Bartolomé, Paul 89
Baskerville, Charles *104*, 105
Battersea Power Station 46, *46*
Bauhaus 39, 62, 76, 77, 80
Beaton, Cecil 108, *108*
Beaux-Arts tradition 13, 22, 23
Behrens, Peter 39
Belgium
 sculpture 89
Bell, Vanessa 100, *103*
Benton, Thomas Hart 82, 105
Berkeley, Busby 15
Bernard, Oliver 51
Biedermeier style 58, 68
Bijvoet, Bernard 41
Binder, Joseph 16
Bitter, Karl 94
Bock, Richard 95
Boileau, Louis *9*
Bonfils, Robert 63
Borglum, Gutzon 95, *97*
Bourdelle, Emile-Antoine 39, *39*, *88*, 89, *90*, 95
Bourdelle, Pierre 26, 105
Bourgeois, Djo 11, 41
Bourke-White, Margaret 109, *109*
Bouy, Jules 81
Brancusi 89, 95
Brandt, Edgar 8, *9*, 11, 51, *52*, 63-64, *65*, 81
Brangwyn, Frank 103, *104*
Breker, Arno 90
Breuer, Marcel 55
Britain
 architecture 22, 42, 45
 furniture 66, 68
 interior design 69-70
 painting 100, 103
 photography 108
 sculpture 90, 93
Broadcasting House, London *44*, 46, 93
Burnet, Sir John 46
Burra, Edward *102*
Byrne, Barry 31, 33, 95

cabinets *11*, *61*, *63*, 76
Canadian architecture 22, *31*, 38, *38*
Capey, Reco 59, 70
Carlu, Jean 11
carpets *62*, 63, *69*, 70, *71*, *81*, 82, *82*, 85
Cassandre, A M 11, 18
chairs *63*, *64*, 66, 72-73, *72*, 76, *76*, 77, 78, *79*, *80*
Chanler, Winthrop 105

Chareau, Pierre 9, 10, 41, 60, 61, 63, 64
Chermayeff, Serge *54*, 55, 68, 70, *71*, 93
Chiparus, Demetre *90*, *91*
Chocol, Josef 39, 66
Chrysler Building, New York *25*, 27, 81
churches 31, *31*, 32, 51
cinemas 30, 39, 42, 51, *51*, 85
classical moderne style 11, 18, 22, 23, 24, 26, 37, 39, 41, 42, *44*, 46, 97
Coard, Marcel 10, 60, 61
Colin, Paul *1*
Constructivism 88, 97, 103
Coward, Noël 68, *108*
Cret, Paul Philippe 12, 13, 26
Crombie, R 51
Cubism 8, 10, 13, 18, 26, 41, 53, 60, 61, 66, 70, 72, 75, 82, 89, 90, 95, 97, 98, 100, 103, *103*, 105, 108, 109
Czarkowski, Joseph *10*

Daily Express Building, London 46-47, *47*
Daily News Building, New York 27, *27*
de Lempicka, Tamara 98, *99*
de Stijl group 22, 77
Delamare, Jacques *28*, 64, *83*
Delaunay, Robert 10, 11, 98
Delaunay, Sonia 8, 63, 98
department stores 8, 30, 33, 39, *40*, 51, *52*, 53, 59, 60, 70, 72, 73, 85
Depero, Fortunato 100
Depression era, United States 15, 18, 26, 77, 85, 105
Derrah, Robert 35, *35*
Deskey, Donald 16, 73, 76, 77, *79*, 80, *80*, 85, 105, *105*
desks 58, *72*, 75, 77, 78, *80*
Desny, Donald 64
Deutscher Werkbund 8
Diederich, W Hunt 80, 81, 97
dinanderie 60
Dobson, Frank *92*, 93
Domergue, Jean-Gabriel 98
Dorn, Marian *69*, 70, *70*, *71*
Drew, Jacob 66
Dreyfuss, Henry 16
Driggs, Elsie 103, 105
Drtikol, František 109
Dudok, Willem 39, 42
Dufrêne, Maurice 9, 59, 60, *62*
Dufy, Raoul 62, 63, 98
Dunand, Jean 9, 10, 11, 60, 66, 89, *100*
Dupas, Jean *65*, 66, 98, *98*
Dutch architecture 22-23, 39

Emberton, Joseph 51, 53, 70
Empire State Building, New York *20*, 27, 81
Epstein, Jacob 45, 90, *93*, 100
Erté 58, 62, 85, 89
Esherick, Wharton 76
Etchells, Frederick 51, 100
exhibitions
 1929 *The Architect and the Industrial Arts*, New York 74
 1932 *Photographic Mural Design*, New York 109
 1934 *Contemporary American Industrial Art*, New York 77, 79
expositions
 1925 *Exposition Internationale des Arts Décoratifs et Industriels*, Paris 8-10, *9*, *10*, *11*, *12*, 63, 64, 73
 1931 *Exposition Coloniale Internationale*, Paris 10-11, 60
 1933 *Century of Progress*, Chicago 12-14, *12*, *13*, *14*, *15*, 77, 109
 1937 *Exposition Internationale des Arts et Techniques*, Paris 11-12, 41
 1939 *Golden Gate International Exposition*, San Francisco 14-15
 1939 *World of Tomorrow Fair*, New York *6*, 12, *15*, 16, *16*, *17*, 18, *18*, 35, 97, 103
Expressionists 23, 26, 35, 39, *39*, 76, 90, 94

Faidy, Abel 75, *76*
fashion 62
 photography 108

Fauvism 88, 100
Ferriss, Hugh 16, 27
films 85
Flaxman, John 88
Follot, Paul 9, 11, *11*, 59, 60, *61*, 68
Fouilhoux, J André 18
France
 architecture 39, 41
 furniture 58-63
 metalwork 63-64
 painting 98
 sculpture 89
 textiles 63
Frankl, Paul 15, 73, 75, *75*, 76, 77, 77
Fry, Maxwell 51, 55
Fry, Roger 68, *68*, 100
functionalism 8, 18, 22, 41, 55, 59, 63, 68, 76, 77, 78
Futurism 8, 35, 88, 97, 98, 100, 103, 108

Garnier, Tony 41
Gaudí, Antonio 22
Gaudier-Brzeska, Henri 68, 93, 100
Geddes, Norman Bel 12, 16, 18, 85
Germany
 architecture 39
 furniture 58, 66
 Nazism, effect of 76, 90
 sculpture 88, 90 *see also Deutscher Werkbund*, Expressionists, Secessionists
Gibbons, Cedric 95, *96*
Gill, Eric *44*, 45, 46, 53, 90, 93, 100
Gill, Vernon *44*, 46
Glasgow Art School 22, 42
glass
 interior design usage of *24*, 78, 80
 panels 30, 66, 70, 80, *97*, *98*
Gocar, Josef 39, 66
Goff, Bruce 31
Goodhue, Bertram 23, 24, 26, 33, 97
Grant, Duncan 68, 100, 103, *103*
Gray, Eileen 60-61, 62, 63, *63*, *64*, 98, *104*
Griffin, Walter Burley 32-33
Grinling, Antony 93
Gropius, Walter 22, 51, 55
Groult, André 9, 11, 59, 60

Harrison, Wallace 18
Havinden, Ashley 70
Herbst, René 63
Hill, Oliver 53, *53*, 55, 70, 93
Hine, Lewis 108
Hoffmann, Josef 8, 10, 22, *22*, 58
Holden, Charles 42, 45, 90
Hood, Raymond 12, 13, *13*, 27, *27*, 35, 73, 74
Hoover factory, London 47, *49*
Hoppé, Emile Otto 108
hotels 22, 30, 34, 51, 53, 55, *56*, 68, 70, *71*, *72*, *73*, 75, 76, *79*, 93
Howe, George 35
Howells, John Mead 27, 85

Iannelli, Alfonso 32, 80, 95
International Style 18, 22, *27*, 36, 37
Ionides, Basil 70
Iribe, Paul 59, 61, 62, 63, 85
Italy
 Fascism, effect of 90
 sculpture 90

Jackson, Pilkington 46
Jagger, Charles Sargeant 93
Jensen Georg 9
Joel, Betty 68, 70
John Sowden house 32, *32*, *33*

Kahn, Albert 13, 16, 18, 23, 31
Kahn, Ely Jacques 16, 18, 27, 30, 33, 73, 74, 76, 82, 85
Kantack, Walter 80
Karasz, Ilonka 73, 82
Kauffer, E McKnight 70
Kaye, Stewart 46
Kennington, Eric 46, 93
Kent, Rockwell 106
Kinuyoshi, Yasuo *85*
Kleiser, Lorentz 82

Lachaise, Gaston 89, 95
Lalique, René 8, *9*, 11, 33, 59, 64, 66, 68
lamps *60*, 63, 64, *65*, 66, 80, *80*
Lanvin, Jeanne 61, 62, 64
Lawrie, Lee 12, 26, *95*, 97
Le Corbusier 10, 22, 35, 41, 55, 62, 89
Léger, Fernand 63, 82, 98
Legrain, Pierre 10, 60, 61, *63*
Leleu, Jules 10, 11, 59
Lepape, Georges 62, *114*, 116, 117
Lescaze, William 18, 35, 73
Lewis, E Wamsley *50*, 51, *52*
Lewis, Wyndham 100, *101*
lighting
 effects *18*, *29*, 30, *31*
 fixtures 64, 72, 76, 80
 see also lamps
liners *see* ocean liners
Loewy, Raymond 16
London Transport *42*, *43*, 45, 46, 90
Loos, Adolf 35, 41
Lozowick, Louis 85, 103
Lubetkin, Berthold *53*, 55
Lutyens, Sir Edwin 45
Lyle, John 38

McGrath, Raymond 46, 51, 68, 70
Mackintosh, Charles Rennie 22, 42, 46, 66
Mackmurdo, Arthur 42
Majorelle, Louis 58, 59, 64
Mallet-Stevens, Robert 10, 11, *40*, 41, *41*, *42*, 51, 63, 89, 98
Man Ray 103, 109
Manship, Paul *96*, 97
Mare, André 59, 60, *60*, *61*, 66
Margold, Josef Emanuel 66
Martel, Jan and Joel 10, 63, 89
Martin, Charles 98
Matisse, Henri 93
Maugham, Syrie 68
Mayan style 14, 32-33, *33*
Meiere, Hildreth *2*, 26, 85, 105, *106*
Mendelsohn, Eric 35, *54*, 55
Mestrovic, Ivan 94
metal
 furniture 62
 wares 81
 work 63-64, 81
Metropolitan Museum of Art, New York 73, 74, 76, 94
Mexico
 architecture 22, 27
 murals 108
Mies Van der Rohe, Ludwig 22
Miklos, Gustave 61, *62*, 98
Miller, Edgar 80, 97, *97*
Milles, Carl 94
Milne, Oswald *69*, 70
modernism 13, 53, 88, 89
Moholy-Nagy, Laszlo 55, 70, 109
Moore, Henry 45, 90
Mukhina, Vera 90
murals *14*, 26, *65*, *84*, 85, *85*, 88, 98, 100, 103, *103*, 105, *105*, 106, *107*, 108
 photomurals 109, *109*
Museum of Modern Art, New York 18, 76, 108, 109
Myer, Val *44*, 46

Nadelman, Elie 89, 95
Nash, Paul 70, *70*
Nelle, Anthony 85
neoclassicism 8, 11, 22, 58, 66, 70, 72, 76, 88
New Deal program 23, 90, *97*, 105-06, 108
Noguchi, Isamu *94*, 95

ocean liners 35, 64, *65*, 66, *66*, 67, 85, 98, *98*, 105
office furniture 72, *72*
Olbrich, Josef 22
Omega Workshops 68, *68*, 93, 100
Orphism 88, 98
Orrefors glass company 9
Oscar Wilde tomb, Paris 45, 90, *93*

Patou, Pierre *11*, 41, 51, 66
Paul, Bruno 58, 66, 73

Perret, Auguste 39, *39*, *40*, 89
Pflueger, Timothy 15, 30, 85
photomurals 109, *109*
Poiret, Paul 8, 58, 61, 62
Ponti, Gio 9, 66
posters 8, 16, *98*, *112*
Prague Art Workshop 66
Prairie School 23, 32, 72, 95
Precisionists 88, 103, 108
Preiss, Ferdinand *86*, 89
Primitivism 10, 14, 60, 61, 75, 88, 108
Pueblo deco 33-34
Puiforcat, Jean 10

Radio City Music Hall, New York *2*, *28*,
 81, *84*, 85, *85*, *106*
railways 26
 stations 22, *23*, 26, *26*, 39, 41, 94
 see also trains
Rateau, Armand-Albert 62, 64
Reeves, Ruth 73, 82, *82*, 105
Reiss, Winold 26, 73, 75, 105
RIBA building, London 46, *47*
Richter, Charles A 68
Rivera, Diego 106, *107*, 108
Rockefeller Center, New York 28, 76,
 80, 82, 85, *95*, *96*, 97, 103, *105*,
 106, *106*, 108, 109, *109 see also*
 Radio City Music Hall
rococo style 58
Rodin, Auguste 88, 89, 94, 95
Rohde, Gilbert 15, 16, 73, 76, 77, 78
Rosenthal, Rena 15, 73, 80
Rousseau, Clement 59, 61
Rowland, Wirt 31, 85
Rowse, Herbert 46
Ruhlmann, Jacques-Emile 8, 10, 11, *11*,
 58-59, *58*, *59*, 60, *60*, 64, 66, 98

Russian Ballet 8, 26, 62, 98

Saarinen, Eliel 22, *23*, 26, 27, 41 73, 74,
 76, 77, *79*, 80, *80*, 81, *81*, 82, *82*,
 94
Saarinen, Loja 82, *82*
Sant'Elia, Antonio 35
Sauvage, Henri 41
Scandinavia
 architecture 22, 41-42
 furniture 66
 sculpture 94
Schinkel, Karl Friedrich 22, 58
Schoen, Eugene 73, 74, 76, 80
Schulze, Paul *174*, 184
Scott, Adrian Gilbert 31, *31*
Scott, Sir Giles Gilbert 46, *46*, 154
screens 11, 60, 61, 77, 88, 98, *100*, 103,
 103, *104*, 105, *105*
sculpture 88-97, *88-97*
Secessionists 58, 88, 94
Semper, Gottfried 26
Sert, José *107*
Sezession 22, 58, 73, 88, 94
Sheeler, Charles 82, 103, 109
Simonson, Lee 78
Simultaneism 63, 98
skyscraper style 13, 14, *21*, 22, 23, 26,
 27, 38, 75, 76, *76*, 97, *124*
skyscrapers 16, *20*, 23, 24, *25*, 26-27,
 27, 30, 34, 35, 36
Soviet Union
168
 sculpture 90
Stacey-Judd, Robert 32
Steichen, Edward 78, 82, 108, *108*, 109
Stella, Joseph 95, 103
Steuben company 80

Storrs, John 31, 82, 95
streamline style 14, *15*, 16, 18, 22, 23,
 26, 35-36, *36*, 37, *37*, 51, *51*, 76,
 85, 97
style paquebot, le 35, 41
Subes, Raymond 11, 63, 66
Süe, Louis 11, 59, 60, *60*, *61*, 66
Sullivan, Louis *12*, 13, 23, 27
Synchromism 88

Tabard, Maurice 109
tables 61, *68*, 76, 77, *77*, *78*, 79
Tack, Augustus Vincent 26
Tait, Thomas 46
Talbot, Suzanne 61, 62
Taut, Bruno 8, *8*, 39, *39*
Teague, Walter Dorwin 14, 16
textiles *62*, 63, 70, *70*, *71*, 82, *82*
theatres 23, 33, 39, *39*, 46, *50*, *52*, 70,
 75, 89
Thomas, Sir Percy 46
Thorak, Josef 90
Thorwaldsen, Bertel 88
totalitarianism 18, 23
Townsend, C H 42
trains 14, *15 see also* railways
tropical deco 36-37, *37*
Trost, Henry 34

United States
 architecture 22-37
 furniture 72-78
 interior design 78, 80-82
 painting 103-08
 photography 108, 109
 sculpture 90, 94-97
 see also Depression era, New Deal
 program

Urban, Joseph 73, 74, 75, *78*

Van Alen, William *25*, 27
Van Dongen, Kees 98
Vanity Fair magazine 108
vases 60
Vassos, John 85
Vecchi, Ferucchio 90
Vigeland, Gustav 94
Vogue magazine 108
von Hildebrand, Adolf 88
von Nessen, Walter 73, 80, *80*
Vorticism 88, 93, 100

Wagner, Otto 22, 94
Walker, Ralph T 12, 27, 30, 4
Wank, Roland Anthony 26
war memorials 26, 45, 93
Waugh, Sidney 97
Weber, Kem 15, 73, 76, 77, 77
Weedon, Harry 51
Wiener Werkstätte 8, 9, 26, 39, 73
Williams, Owen 45, 47, *47*, *48*
Winter, Ezra *84*, 105
Wirde, Maja Andersson 81
Wood, Edgar 42
Wornum, Grey 46, *47*
Wright, Frank Lloyd 14, 23, *24*, 30, 31,
 32, *32*, *33*, 34, *34*, 35, *35*, 72-73,
 72, *73*, *74*, 80, 95
Wright, Lloyd 32, *32*, *33*
Wright, Russel 16, 80

zigzag style 8, 14, *20*, 22, 23, *25*,
 26, 27, 30, 31, 32, 33, 34,
 35, 36, 37, 38, *38*, 41, 46,
 47, 72, 76, 88, 93, 97
Zorach, William 95, 97

Acknowledgments

The publisher would like to thank Martin Bristow the designer, Chris Schüler the editor, Mandy Little the picture researcher, and Pat Coward for preparing the index.

Picture Credits

Ampas: page 96(bottom left)
Art Institute of Chicago: Gift of Fred and Harvey Goldberg: page 97(top)
Architectural Press: page 47(both)
Association of American Railroads: page 15(top)
Baltimore & Ohio Railroad Museum: page 26(top)
Cecil Beaton Archive/Sotheby's, London: page 108(bottom)
Alan & Sylvia Blanc: page 23(left), 24(top), 32(top, 33(both), 38(both)
British Architectural Library, RIBA: pages 9(top), 23(right), 39(top), 41(both), 51, 52(bottom), 55(both)
Richard Bryant/ARCAID: pages 22, 32(bottom), 49(top and bottom left), 73
Martin Charles: pages 43, 45(both), 47(bottom), 48, 54
Chicago Historical Society: pages 12(bottom), 13(both), 14(bottom), 16(top), 76
Christies Colour Library: pages 58, 60(both), 61(top), 62(top), 65(bottom),

72(both), 86, 90, 91, 98(both)
Cincinnati Art Museum, Gift of the Estate of Mrs James M Hutton II: page 75
Cooper Hewitt Museum, Smithsonian Institution/Art Resource, NY: page 104(bottom left)/Gift of Charles Payson
Cranbrook Academy of Art/Photo Dirk Bakker: page 80(top left), 81(both), 82(bottom)
Design Council: pages 64(both), 66
Detroit Institute of Arts, Founders Society Purchase, Edsel B Ford Fund and Gift of Edsel B Ford: page 107(bottom)
Everson Museum of Art, Syracuse: pages 30
Courtesy of Barry Friedman Ltd, NY: pages 99
Philippe Garner: page 104(top)
General Electric Company: page 14(top)
Greater London Photograph Library: pages 50, 71(top both)
Lucien Herve: pages 39(bottom), 40, 42(top)
Angelo Hornak: pages 2, 11(bottom), 20, 28(all four), 29(all four), 44, 49(bottom right), 53(bottom), 65(top), 68(top), 69, 83, 85(all three), 96(top), 105(bottom right), 105(bottom), 106(all three)
Johnson Wax Company: page 35(top)
Keystone Collection: page 46, 67(top), 88(top)

Lauros – Giraudon, © ADAGP 1989: page 88
Leeds City Art Gallery: page 101
London Transport Museum: page 42(bottom)
Lords Gallery, London: pages 1, 17, 18(all three)
Photograph Courtesy of the Lefevre Gallery: page 102
John Margolies/ESTO: pages 35(bottom), 36(both), 37(both)
Peter Mauss/ESTO: page 25
© Norman McGrath: page 27
The Metropolitan Museum of Art: pages 24(bottom)/purchase, 1967 Edward C Moore, Jr Gift & Edgar J Kaufmann Charitable Foundation Gift; 78(top), 79(both)/Emil Blasberg Memorial Fund, 1978; 100(bottom)/Gift of Mrs Soloman R Guggenheim, 1950
Mitchell Wolfson Jn, Collection of Decorative & Propaganda Arts: page 77(top)
Musée des Arts Decoratifs Paris/Photo Sully Iaulmes: page 61(bottom), 62(bottom), 63(top)
Museum of City of New York: pages 16(bottom), 19
Museum of London: page 52(top)
Collection, The Museum of Modern Art: pages 108(top)
National Museum of American Art, Smithsonian Institute, Gift of Paul Manship: page 96(bottom)
National Park Service, USA: page

97(bottom)
Rheinisches Bildarchiv: page 8
© Roger-Viollet: pages 9(bottom), 10(both), 11(top), 12(top)
Royal Pavilion Museum, Brighton: pages 59, 71(bottom), 100(top)
Savoy Hotel Public Relations: page 56
Alex Siodmak: pages 6, 15(bottom)
Jessica Strang: page 53(top)
Tate Gallery, London: pages 89, 92, 103
Ezra Stoller/ESTO: pages 17, 34(both), 74, 84, 95(both), 107(top)
Topham Picture Library: page 93(top)
University Archives, University of Liverpool: page 67(bottom)
University of California at Santa Barbara: page 78(bottom)
University Museum, Southern Illinois University, Carbondale: page 94(top)
Victoria & Albert Museum, London: pages 63(bottom), 68(bottom), 70(both), 82(top), end papers
Virginia Museum of Fine Arts, Richmond, Gift of Sydney Francis Lewis Foundation/Katherine Wetzel: pages 105(top)
George Waterman III: page 77(bottom)
Westinghouse Historical Collection: page 18
Stuart Windsor: page 93(bottom)
Yale University Art Gallery/Enoch Vine Stoddard and Marie Antoinette Slade Funds: page 80(top right)